Roman Ondák

 W9-AGU-735

Roman Ondák

Kölnischer Kunstverein
Verlag der Buchhandlung Walther König, Köln

Inhalt/Content

Die Vervielfältigung von Zeit
Igor Zabel

Viele Arbeiten Roman Ondáks könnte man als Situationen beschreiben. Der Be-
trachter ist konfrontiert mit einer Konstellation von Dingen, Menschen und Räumen,
die im Kern von dem abweicht, was erwartet und als selbstverständlich vorausge-
setzt wird. Solche Situationen kommen oftmals scheinbar einfach und nie spektakulär
daher. Manchmal sind sie sogar beinahe unsichtbar. Als der Künstler in seinem Projekt
SK Parking (2001) auf der undefinierten Fläche hinter der Wiener Secession ein
paar alte Skodas mit slowakischen Nummernschildern abstellte, die sich zwei Monate
nicht von der Stelle bewegten, richtete sich diese Situation vielleicht eher an Men-
schen, die regelmäßig an dem Ausstellungsgebäude vorbeikommen, als an die Besu-
cher der Ausstellung. Die Passanten werden vermutlich die Autos anfangs gar nicht
bewusst wahrgenommen oder besonders auf sie geachtet haben. Doch mit der Zeit
könnte ihnen etwas eigenartig vorgekommen sein, eine leichte Veränderung am Stand
der Dinge, etwas nicht ganz Normales, und manche fingen vielleicht an darüber nach-
zudenken.

Ein interessanter Aspekt diverser Arbeiten Ondáks ist, dass sie nicht unbedingt
als Kunstwerke verstanden werden müssen. Auch wer die Situation bemerkt, sie aber
nicht als gewollt, als Kunstwerk erkennt, kann sie lesen. Allein schon, wenn man das,
was man sieht, bedenkt und sich darüber Fragen stellt, entfaltet man das dichte Ge-
flecht von Bedeutungen und Andeutungen, das die Situation in sich birgt. Tatsächlich
geben solche Situationen mehrere mögliche Reaktionsebenen vor. Man könnte sie
gewissermaßen halbbewusst erleben, vielleicht als kleine Störung am Rande gewohn-
ter Verhältnisse – wie eben die slowakischen Autos hinter der Secession. Eine wei-
tere Reaktionsebene könnte sein, den Eingriff oder die Unregelmäßigkeit deutlich
wahrzunehmen und zu erkennen. Und daraufhin könnte man beginnen, die Situation
zu lesen, ihre Themen zu identifizieren, die Fragen zu stellen, die sie einem nahelegt:

Was machen so viele Autos auf dem Areal hinter dem Ausstellungsgebäude? Warum stehen sie so lange offensichtlich herrenlos dort herum? Warum nur alte Skodas? Ein aufgeschlossener Beobachter könnte nun die in dieser Situation enthaltene Bedeutungsvielfalt und emotionale Aufladung entdecken. Das Wesen des Autos ist Fahren, und doch wurden diese Autos über Wochen hinweg reglos an dieser Stelle belassen, wie eingefroren in der Zeit. Dabei waren sie in einem gewissen Sinn durch Zeit und Raum gereist, da sie ja einer anderen Ära und Sphäre angehörten.

Solche Arbeiten als Kunst zu erkennen, ist, glaube ich, Gewinn und Verlust zugleich. Der Verlust liegt darin, dass man sich ihrer von vornherein bewusst ist, dass man die Situationen nicht unvorbereitet erlebt und deshalb die ganzen subtilen, unvermittelten Erfahrungsabstufungen einbüßt. Dafür gewinnt man jedoch einen Kontext, der es einem ermöglicht, sie eingehender und aufmerksamer zu entziffern, mehr Bedeutungen an sie zu knüpfen und ihre metaphorischen und poetischen Potenziale leichter zu verstehen. Besucher der Ausstellung in der Secession hatten keine Gelegenheit, sich von den geparkten Autos im Hof überraschen zu lassen, konnten dafür jedoch die Arbeit eigens im Kontext der Ausstellung lesen, der die Situation mit mehr Bedeutung auflud, bzw. – in direktem Zusammenhang mit dem Titel der Ausstellung, „Ausgeträumt..." – im Kontext des Schwindens jenes Optimismus, der anfangs auf den Fall der Berliner Mauer folgte. Ondáks Arbeiten stehen stets unterschiedlichen oder gegensätzlichen Interpretationen offen. Dennoch können auch sie ihre Bedeutung und Wirkung nicht ausschöpfen; sie steigern die Komplexität des Werks, ohne es je vollständig zu erklären.

Wenn der Künstler jedoch direkt mit den Galerieräumlichkeiten und ihren Bedingungen arbeitet (anstatt einfach Werke oder Projekte in sie hineinzutragen), ermöglicht er es dem Besucher, die ganze Bandbreite an Reaktionen (in verhältnismäßig kurzer Zeit) zu erleben: von der direkten Ansprache durch die Situation bis hin dazu, sie als Kunstwerk zu erkennen und das darin eingefaltete Geflecht von Bedeutungen und Verweisen zu entdecken. Mehr noch: Diese Arbeiten sind so angelegt, dass sie aktiv Besucher ansprechen. Wenn ich „ansprechen" sage, meine ich damit nicht, dass sie versuchen, aggressiv Aufmerksamkeit zu erwecken oder mit Werbestrategien zu wetteifern. Eher im Gegenteil: Ihre Anziehungskraft ist deshalb stark, weil sie so zurückhaltend und subtil ist.

Ich sagte schon, dass Ondáks Arbeiten oft auch dann lesbar sind, wenn sie nicht als Kunstwerke erkannt werden. Mehr noch, vielfach setzt er Kunst als Mittel ein, unsere Aufmerksamkeit für das Alltagsleben und darin vorkommende Situationen zu schärfen, die nicht selten zugleich lesbar, metaphorisch und poetisch sein können. Die beiden „Stadtführungen" in Zagreb und Zadar waren vielleicht das klarste Beispiel für eine derartige Strategie. In solchen Arbeiten wird der Kunstraum häufig als etwas wahrgenommen, was uns von der gewohnten Realität trennt und uns gleichzeitig

(vielleicht gerade wegen dieser Distanz) dazu verhilft, diese klarer zu sehen und ihre Komplexität besser zu erfassen. In einigen seiner Projekte stellt Ondák buchstäblich seine Anstrengung aus, die Galeriewände zu durchbrechen, um zu sehen, was dahinter liegt. In den Stadtführungen (*Guided Tour*, 2002 und *Guided Tour (Follow Me)*, 2002) ließ er die Galerieräume leer und zeigte den Besuchern die umliegende Stadt. In *Through the Eye Lens* (1999) bohrte er ein Loch durch die Wand des Ausstellungsraumes, sodass die Besucher in die dahinter liegende Küche blicken (sie allerdings nicht betreten) konnten. Die Besucher mussten im Raum der Kunst bleiben, bekamen aber Gelegenheit, eine verborgene Wirklichkeit aufmerksamer und genauer in Augenschein zu nehmen. Wie der Titel bereits anzeigt, ist die Verbindung zwischen den beiden Räumen nicht unmittelbar physischer, sondern visueller und distanzierter Art. Kunst ließe sich vielleicht als so etwas wie ein Auge beschreiben, und die Sicht ist das Instrument sowohl von Nähe als auch von Distanz. (Nur der Künstler hat es gewagt, die Grenze zu überschreiten, in das „exotische" Gebiet der Küche einzudringen und einige Artefakte und Gegenstände mitzubringen. Es war eine Aktion, die sich mit anthropologischer Feldforschung oder, wie der Künstler selbst sagte, archäologischen Ausgrabungen vergleichen ließ – womit abermals das Thema „Zeit" angeschnitten ist. Denn im Grunde bilden parallele Räume parallele Zeiten, was sich nicht nur auf die beiden verschiedenen Bereiche der Ausstellungshalle bezieht, sondern auch, in einer sehr viel breiteren Perspektive, auf unterschiedliche, parallele Kulturen).

In *Teaching to Walk* (2002) schlug Ondák die entgegengesetzte Strategie ein. Anstatt ein Loch aus dem Galerieraum nach draußen zu bohren, ließ er einen kleinen Teil Realität in die Galerie herein, als er einer jungen Mutter erlaubte, dort ihrem Kind das Laufen zu lehren – nicht als lebende Skulptur, sondern als ein Vorgang, der auf ganz normale Weise stattfand. Allerdings ist dies nur ein Teil (wenn auch ein wesentlicher) dessen, was der Künstler mit seinen Projekten erreichen will; er zielt nicht nur darauf, uns die Realität in ihrer Komplexität und Poesie sehen zu lassen, sondern auch darauf, dicht gewebte konzeptuelle Strukturen von Bedeutungen und Beziehungen aufzubauen.

Seine Situationen sind somit lesbar. Doch in der Wahrnehmung des Besuchers bringen sie nicht einfach Bedeutungsketten hervor, die einmal klar und offenkundig, dann wieder assoziativ und vielleicht sogar willkürlich erscheinen. Vielmehr greift Ondák bei der Herstellung dieser Bedeutungen und Beziehungen oft zu Verschiebungen und Verdrehungen, Parallelismen, Paradoxien, Wiederholungen usw., um einzelne Elemente miteinander in Verbindung zu bringen und sie im Gebäude der neuen Struktur einzusetzen. Ich glaube, dass ihm die Komplexität und Präzision der konzeptuellen Struktur wichtiger ist als die Vollkommenheit der visuellen Form, wenngleich seine Arbeiten auch unter dem visuellen Gesichtspunkt stets sorgfältig konstruiert sind.

Ich habe einmal den Begriff „Symmetrie" angeführt, um das Gleichgewicht und die Präzision von Ondáks Arbeiten zu beschreiben, die aus der ausgewogenen und mitunter buchstäblich symmetrischen Natur der Beziehungen in seinem Werk rührt. Der Künstler hatte jedoch Vorbehalte gegen diesen Begriff. Tatsächlich scheint die Idee der Symmetrie vielleicht allzu formal, allzu visuell sogar, und ist andererseits nicht offen und flexibel genug. Den Künstler interessiert nicht in erster Linie eine klare und schöne Form als solche, sondern eher eine Komplexität von Bedeutungen und Beziehungen im Prozess der Rezeption und in den Erfahrungen des Betrachters. Und diese Komplexität reicht natürlich weit über jegliche formale Symmetrie hinaus. Und doch ist immer etwas formal Vollendetes in der Art, wie Ondák seine Systeme von Entsprechungen, Parallelismen, Gegensätzen und Widersprüchen aufbaut.

Ein geeigneterer Begriff zur Beschreibung dieser Beziehungen wäre vielleicht „Spiegelung". Analogien und Metaphern sind manchmal so irreführend wie verlockend. Doch ist das Konzept der Spiegelung vielleicht flexibel genug, um einen erheblichen Teil von Ondáks künstlerischen Strategien zu beschreiben. Die Idee der Spiegelung impliziert Trennung und enge Verbindung zugleich. Ein Spiegelbild ist verkehrt herum und kann stark verändert sein. Andererseits gelingt uns über das Spiegelbild das Unmögliche, nämlich uns selbst zu sehen (und über uns zu reflektieren).

Ondák versetzt häufig eine Situation in einen anderen Kontext, wobei er die Beziehungen zwischen der ursprünglichen Konstellation und ihrem Spiegelbild im Klaren lässt. In *SK Parking* zum Beispiel wurde eine Situation, die in Bratislava, sechzig Kilometer weiter, nicht ungeläufig gewesen wäre, „eingefroren" und in einen neuen Kontext in Wien verlagert bzw. neu darin verortet. Diese Operation kann ebenfalls als eine Spiegelung oder Projektion verstanden werden. Wichtig ist hier, dass solche Gedankenverbindungen unsere Aufmerksamkeit auf die unsichtbare Achse lenken, welche die Spiegelungs- und Projektionszusammenhänge bestimmt. Ondáks Werk legt somit durch seine gleichgewichtige konzeptuelle (wie auch formale) Struktur entscheidende und oftmals unsichtbare Achsen frei, die für die Gesellschaft, die menschlichen Beziehungen, den Charakter von Raum und Zeit – kurz, die Konstruktion des eigenen Selbst und Seins – ausschlaggebend sind.

Sehr deutliche Beispiele für diesen Ansatz sind die Arbeiten, die sich mit Raum beschäftigen. Der Künstler führt unerwartete, paradoxale Elemente ein, kleine und nicht sehr offenkundige mitunter, die aber den Charakter des Raums grundlegend verändern und die herkömmliche Auffassung von ihm vor eine Herausforderung stellen. Eine Strategie dieser Art besteht darin, Klüfte, Verlagerungen und Verschiebungen in die Ordnung der Dinge einzuführen, die wir für selbstverständlich halten. In *Descending Door* (1997) und in *Retreating Door* (1997) zum Beispiel hat er jeweils ein Element im Raum leicht verschoben und damit die ganze Ordnung, auf der unser Verständnis und unsere Auffassung von Raum beruhen, beeinträchtigt. Eine andere

solche Strategie besteht in der Wiederholung und Verdoppelung räumlicher Elemente. Darüber hinaus spielt der Künstler oft mit Räumen verschiedener Typologie und Ordnung und erschafft neue, hybride Raumsituationen aus zwei oder mehr heterogenen oder sogar unvereinbaren Räumen. Ein schönes Beispiel dafür ist die räumliche Struktur zweier gänzlich unterschiedlicher Räume, eines Hotelzimmers und eines Vogelhäuschens, in *Sharing the Room* (1998). Die Arbeit beruht auf einem Spiel von Innen und Außen, von gemeinsamem und geteiltem Raum und schließlich von zwei völlig verschiedenen Welten, der menschlichen Gesellschaft und der Tierwelt. Noch komplexer ist die Situation in *Museum/Storage* (1999). Hier benutzte der Künstler den Ausstellungsraum selbst, um eine neue Miniaturkombination physischer und sozialer Hintergründe zu gestalten, die sämtlich mit der Galerie zusammenhängen. Über das Medium des Kunstprojekts konnte er das System rational angeordneter Unterteilungen und Trennungen zeigen, auf dem das Kunstmuseum als Institution, aber auch als Raum beruht. Das Loch in der Wand, das den Ausstellungsraum und den gewöhnlich verborgenen Raum der Küche verbindet (*Through the Eye Lens*), könnte ebenfalls in diesem Zusammenhang verstanden werden. Erneut interessiert Ondák sich für heterogene Räume, die getrennt werden müssen, um funktional miteinander verknüpft zu sein.

Ich denke, es ist klar, dass Ondák Raum nicht bloß als physikalisch-materielle Einheit versteht. Soziale Normen, Unterteilungen und Regulierungen formen Raum und unsere Wahrnehmung von ihm. Auch ist unsere Wahrnehmung nicht absolut objektiv und zeitgleich. Sie ist sozusagen durchtränkt von Wissen, Gefühlen, Interessen und, besonders wichtig, Erinnerungen. Außerdem ist Raum nicht statisch. Er ist bestimmt durch Bewegungen, räumlich wie auch zeitlich. Raum ist deshalb nicht bloß physisch, sondern wesentlich zeitlich. Er existiert in der Zeit, was bedeutet, dass er sich ständig verändert und verwandelt und dass die Konstruktion seiner Identität nicht ohne Erinnerung auskommt. Es ist daher kein Zufall, dass Ondáks Arbeiten Raum zumeist über eben diesen Gesichtspunkt der Zeit und der Erinnerung verhandeln.

Die Verwendung von Wiederholungen zum Beispiel ist eher mit Zeit und Erinnerung verknüpft als mit Vorstellungen von Simulakren oder Serienproduktion von Gütern. Eine Gruppe von Arbeiten aus dem Jahr 1998, in denen der Künstler sich mit Galerieräumen befasste, indem er sie leicht veränderte oder einige ihrer Elemente wiederholte, bezieht sich direkt auf das Thema Erinnerung. Die Titel verdeutlichen es: *Remind me again, If I don't forget, I remember this, I can't recall this* und *Is that the way it was?* Die Spanne zwischen einem Element und einem anderen (seiner Kopie) ist die Spanne der Zeit. Ihre Beziehung (und zwischen beiden können leichte Unterschiede bestehen) beruht auf Erinnerung.

Auch in *Tickets, Please* spielt Wiederholung eine wesentliche Rolle. Hier (wie in einigen anderen Arbeiten, die sich mit dem Galerieraum befassen) kehrte der Künstler

die übliche Perspektive um und verwandelte etwas, was normalerweise nur in seinem technischen Belang für die Galerie gesehen wird, zur Grundlage seiner Arbeit. (Die ganze Serie – *Tickets, Please* (2002), *This Way, Please* (1999) und *Silence, Please* (2004) – beschäftigt sich mit jenen Bestandteilen der Galerie, die wir zu übersehen neigen, insbesondere mit den Wächtern. In einigen jüngeren Projekten, *Another Day* (2003) und *Good Feelings in Good Times* (2003), in denen er mit einem Kartenschalter oder einer Warteschlange vor dem Museum arbeitet, ist Ondák zu solchen Themen zurückgekehrt.) Der Ausgangspunkt von *Tickets, Please* war ein Tisch am Galerieeingang, wo man für gewöhnlich einem älteren Herrn das Eintrittsgeld zu entrichten hat und wo man auch Kataloge kaufen kann. Ondák rekonstruierte die gleiche Situation im Obergeschoss der Galerie, wohin er den alten Mann versetzte, und stellte dessen Enkel zur Arbeit am Originaltisch ein. So mussten die Besucher die Hälfte des Eintrittsgeldes am Tisch im Erdgeschoss bezahlen (wobei sie sich sicher wunderten, dort einen kleinen Jungen bei der Arbeit anzutreffen), und wenn sie dann in die oberen Galerieräume kamen, waren sie um so perplexer, auf einen weiteren Tisch genau wie dem unten zu stoßen, mit der gleichen Art Stuhl, den gleichen Katalogen und Objekten darauf und einem weiteren Kartenverkäufer, der die andere Hälfte des Eintrittsgeldes forderte. Die Aufteilung war nicht nur eine physische (zwei Stockwerke, allerdings eines unter dem anderen), sondern auch eine psychologische, da ein Tisch mit einem jungen Burschen besetzt war und der andere mit einem alten Mann. Dies war ein hinreichend deutlicher Fingerzeig, dass der Unterschied zwischen den beiden Tischen auch ein Unterschied in der Zeit ist (repräsentiert durch die zwei Generationen, Großvater und Enkel). Wir sollten dies jedoch nicht allein symbolisch verstehen. Da es eine Weile dauert, um von einem Tisch zum andern zu gelangen, braucht die Spanne zwischen den beiden buchstäblich Zeit.

Vielleicht sollte erwähnt werden, dass Ondák häufiger unterschiedliche Generationen am selben Schauplatz einsetzt. Kinder, die Politiker verkörpern (*Tomorrows*, 2002), oder der Künstler selbst, der die Rolle seines Vaters im stürmischen Jahr 1968 übernimmt (*Bad News Is a Thing of the Past Now*, 2003), sprechen über einen unumkehrbaren zeitlichen Abstand, über Versuche, diesen Abstand durch Empathie zu überwinden, über Unterschiede, aber auch über Wiederholung. Kinder in der Rolle von Politikern sind nicht nur niedlich; im Grunde ist diese Szene zutiefst unheimlich. Eines Tages werden die Kinder solche Politiker sein und die Politiker waren ihrerseits einmal niedliche Kinder. Die Zeit verläuft unumkehrbar und linear, als eine endlose Veränderung, aber sie ist auch Wiederholung und Wiederkehr des Gleichen.

Kommen wir kurz auf die Arbeit *Through the Eye Lens* zurück. Der Titel weist auf einen Parallelismus zwischen Auge und Filmkamera hin. Die Wandöffnung war zugleich ein Auge, das in die Welt außerhalb des Gehäuses blickt, und Kameralinse, durch die hindurch ständig ein „Film" ablief, vielleicht eine Reality Show. Kamera und

Film sind in Ondáks Arbeit von großer Wichtigkeit. Film ist seinem Wesen nach eine visuelle Kunst, nicht minder aber auch eine Kunst der Zeit. Er kann Vergangenheit, Gegenwart und Zukunft in einer komplexen Einheit zusammenfassen. Von entscheidender Bedeutung ist dabei seine Länge, die faktische Zeit, die man benötigt, um ihn zu sehen. In seiner Schrift über die Fotografie, *Die helle Kammer*, spricht Roland Barthes über die Komplexität (und emotionale Kraft) von Zeitstrukturen in fotografischen Bildern. „Er ist tot und er wird sterben", sagt er über den in der Todeszelle von Alexander Gardner fotografierten jungen Mann. Obwohl die Struktur des Films aufgrund der Montage, der Schnitte, der Aufnahmerhythmen usw. weitaus komplexer ist, beruht auch er nach wie vor auf derselben Beziehung zwischen Anwesenheit und Abwesenheit, Vergangenheit und Zukunft. Diese zeitliche Struktur hat eine Parallele in der räumlichen Struktur: Die im Film repräsentierte Realität ist sowohl sehr nahe als auch unendlich weit entfernt. Aufgrund der Kraft des Filmbildes ist man gleichzeitig hier und dort, am tatsächlichen Ort und – auf dem Wege der Empathie – in der abgebildeten Welt. Mehrere Arbeiten Ondáks hängen mit solchen Filmstrukturen zusammen. Der Raum der Kunst ermöglicht eine Distanz zur Realität, aus der man sie wie durch die „Linse" klar und überraschend detailreich, aber auch aus der Ferne sehen kann. Viele seiner Projekte handeln von Distanz, Vorstellung und Empathie; einige sind wie Storyboards, Filmsequenzen, regiegeführte Erzählungen aufgebaut.

Die Erfahrung der Distanz in Ondáks Werk ist also räumlich und zeitlich zugleich. Durch die Kraft von Erinnerung, Empathie und Vorstellungsgabe ist man imstande, solche Distanzen zu überwinden und damit in einem gewissen Sinn auch das Hier und Jetzt mitzubegründen. Dies liegt beispielsweise auch in der Arbeit zutage, die der Künstler mit einigen Bekannten unternahm, die nicht gern reisen (er nannte sie „Antinomaden", und im Projekt *Antinomads* reisten nun anstatt ihrer selbst ihre Bilder in Form von Postkarten um die Welt). In *Common Trip* (2000) zum Beispiel fertigte eine größere Gruppe seiner Freunde und Verwandten anhand seiner Beschreibungen Bilder von fernen Orten, die sie nie besucht hatten. Dabei bleibt die Persönlichkeit des Künstlers der Brennpunkt dieser Arbeiten: Menschen aus Ondáks Umkreis stellten sich die Orte vor, die er besucht hatte; sie stellten ihn sich auf den Straßen ferner Städte vor (*Slowed-down Journey,* 2003) oder beim Reisen im Zug (*Untitled Journey,* 2003). Dies ist kein Egozentrismus, sondern eher die Erfahrung der Vielheit und des fließenden Charakters des Selbst. Ich meine, in diesen Arbeiten erscheint das eigene Selbst als etwas, das nicht stabil ist, sondern wesentlich unter den Mitmenschen verankert ist und auf (häufig neu formulierten und veränderten) Erinnerungen wie auch auf Vergessenem oder Verdrängtem beruht. Es hängt nicht nur von der Sicht von „innen" ab, sondern auch von den vielfältigen Sichten und Vorstellungen, die von „außen", von anderen kommen.

Time and Its Copy
Igor Zabel

Very often, Roman Ondák's works could be described as situations. The beholder is confronted with a constellation of things, people and spaces that is essentially different from what one expects and takes for granted. Such situations are often seemingly simple and never spectacular. Indeed, they are sometimes all but invisible. When the artist, in his project *SK Parking* (2001), left several old Skoda cars with Slovak license plates on the yard behind the Secession in Vienna, motionless for two months, this situation was perhaps intended for people who regularly pass by the gallery rather than the visitors of the exhibition. We can assume that the regular passers-by at the beginning did not really notice the cars or pay any special attention to them. But in time they might have noticed something irregular, a small change in the state of things, something not quite normal, and perhaps some of them started to think about that.

An interesting aspect of several of Ondák's works is that they do not necessarily need to be understood as works of art. Even someone who does notice the situation but doesn't recognise it as intended, as a work of art, is able to read it. Simply by thinking about what one sees and by asking oneself questions about it one already unfolds the dense networks of meanings and allusions that the situation implies. Such situations, in fact, indicate several possible levels of reaction. They could be experienced somehow half-consciously, perhaps as a small, marginal intrusion into an established routine. We can assume that many passers-by, even if they did not pay any special attention to the Skodas parked in the back yard of the Secession, felt that something was not quite right – even if they were not able to say precisely what. Another level of response could be to perceive and recognise the intrusion or irregularity clearly. And after that, perhaps, one can start to read the situation, to identify the issues, ask the questions it suggests. What are so many cars doing in the back yard of the exhibition hall? Why are they standing there, seemingly abandoned, for so long?

Why only old Slovak Skodas? A sensitive observer could then start to discover the complexity of meanings and the strong emotional charge embodied in this situation. The essence of the car is travel, yet these cars were left sitting motionless – as if frozen in time – for weeks. They had in a sense, however, travelled through both time and space, since they belonged to a different era and place.

To be able to read such works as art is, I believe, both a gain and a loss. The loss lies in the fact that you are in advance aware of them, that you don't meet the situations unprepared and thus lose all the subtle and immediate gradation of experiences. What you gain, however, is a context that enables you to read them in a more intense and attentive way, to connect them with more meanings, and to understand more easily their metaphorical and poetical potentials. Visitors to the exhibition at the Secession did not have the opportunity to be directly addressed by the parked cars in the back yard, but they could also then read the work particularly in the context of the exhibition, which charged the situation with more meanings, or – in direct connection to the exhibition's title 'Ausgeträumt…' (End of Dreaming) – in the context of the disappearance of the initial optimism following the fall of the Berlin Wall. Ondák's works always remain open to many different or opposing interpretations. Even so, such interpretations cannot exhaust their meaning and impact; they add to the works' complexity, while never fully explaining them.

When, however, the artist works directly with the gallery spaces and their conditions (rather than just bringing pieces or a project into them) he creates a possibility for the visitor to experience (in a relatively short time) the whole range of reactions, from being addressed directly by the situation to recognising it as a work of art and discovering the network of meanings and references implied in them. Moreover, these works are constructed in such a way that they actively address visitors. If I say 'address', I do not mean that they try aggressively to attract people's attention or to compete with advertising strategies. Quite the opposite, their appeal is strong because it is so restrained and subtle.

I said before that Ondák's works could often be readable even if they are not recognised as works of art. Even more, he sometimes uses art as a means to sharpen our attention to every-day life and to situations in it that can often be readable, metaphorical and poetic too. The two guided tours, in Zagreb and in Zadar, were perhaps the clearest example of such a strategy. In such works the space of art is often felt as something that separates us from the usual reality, and at the same time (perhaps even because of that distance) enables us to see it more clearly and better understand its complexity. In some of his projects Ondák displays literally his effort to break through the gallery walls to see what is beyond them. In the guided tours (*Guided Tour*, 2002 and *Guided Tour (Follow Me),* 2002) he left the gallery spaces empty and showed the visitors the city around them. In *Through the Eye Lens* (1999), he actually cut out

a hole, allowing visitors to see (although not to enter) the kitchen on the other side of the wall. Visitors had to remain within the space of art, but they had a chance to look at a hidden, or indeed overlooked, reality more attentively and precisely. As the title itself indicates, the connection between the two spaces is essentially visual and distanced, not immediately physical. Art could perhaps be described as an eye of some sort, and the view is the instrument both of closeness and of distance. (Only the artist himself dared to cross the border, entering the 'exotic' territory of the kitchen and bringing with him different artefacts and objects. It was an action that could be compared to anthropological fieldwork or, as the artist himself said, archaeological excavations – which again brings forth the issue of time. In fact, parallel spaces embody parallel times, which refers not only to the two different areas of the exhibition hall, but, in a much broader view, to different, parallel cultures.)

In *Teaching to Walk* (2002) his strategy was the opposite. Instead of making a hole out of the gallery space, he let a small part of reality into the gallery, when he invited a young mother to teach her child to walk there, not as a living sculpture, but something that simply took place there on a regular basis. Nevertheless, this is only a part (albeit an essential one) of what the artist aims to achieve with his projects; he aims not only at making us see 'reality', but also at constructing the densely knitted conceptual structures of meanings and relations this reality is built upon.

His situations are thus readable. But in the visitor's reception they do not simply produce chains of meanings, sometimes clear and obvious and sometimes associative and perhaps arbitrary. To construct these meanings and relations Ondák often works with shifts and turns, parallelisms, paradoxes, repetitions etc. to connect individual elements and use them in the building of the new structure. I think that complexity and precision of the conceptual structure is more important for him than the perfection of the visual form, although his works are always carefully constructed from the visual point of view too.

I once suggested the term 'symmetry' to describe the balance integrated into Ondák's works because of the balanced and sometimes literally symmetrical nature of relations in his works. The artist, however, had reservations about the use of the term. Indeed, the idea of symmetry seems to be perhaps too formal, even too visual, and, on the other hand, not open and flexible enough. The artist is not primarily interested in a clear and beautiful form as such, but rather in a complexity of meanings and relations, in the process of reception and in the spectator's experiences. This complexity, of course, reaches far beyond any formal symmetry. And yet there is always something formally perfect in the way Ondák builds his systems of correspondences, parallelisms, oppositions and contradictions.

A more appropriate term to describe these relations could perhaps be mirroring. Analogies and metaphors are sometimes as misleading as they are tempting. But the

concept of mirroring is, maybe, flexible enough to describe an important part of Ondák's strategies. The idea of mirroring implies separation and close connection at the same time. A mirror image is reversed and can be greatly changed. On the other hand, it is through the mirror image that we can do the impossible, i.e. see ourselves (and reflect about ourselves).

Ondák often transposes a situation into another context, keeping the relations between the original constellation and its mirror image clear. In *SK Parking*, for example, a situation that would not be unusual in Bratislava, sixty kilometres away, was 'frozen', displaced and re-located into a new context in Vienna. This operation can also be understood as mirroring or projection. What's important here is that such associations turn our attention to the invisible axis that determines the relations of mirroring and projection. Ondák's work, therefore, through its balanced conceptual (and also formal) structure discloses essential and often invisible axes that cross and determine society, human relations, the character of space and time – in short, the construction of one's self and being.

Very clear examples of this approach are the works dealing with space. The artist introduces unexpected, paradoxical elements, sometimes small and not very obvious, that essentially change the character of the space and challenge the established ways of understanding it. One such strategy is introducing gaps, shifts and displacements in the order of things we take for granted. In *Descending Door* (1997) and in *Retreating Door* (1997), for example, he slightly displaced an element in a room, thus affecting the whole order on which our understanding and perception of space are based. Another such strategy is his use of repetition and reduplication of spatial elements. Furthermore, the artist often plays with spaces of different type and order, creating new, hybrid spatial situations out of two or more heterogeneous or even incompatible spaces. A nice example is the spatial structure of two very different spaces, a hotel room and a birdbox, in *Sharing the Room* (1998). The work is based on a game of interiors and exteriors, of common and divided space, and finally of two completely different worlds, human society and the animal world. Even more complex is the situation in *Museum/Storage* (1999). Here the artist used the exhibition space itself to create a new, miniature combination of physical and social backgrounds that are all connected to the gallery. The medium of the art project enabled him to present the system of rationally arranged divisions and separations on which an art museum as an institution, but also as a space, is based. The hole in the wall connecting the exhibition space and the usually hidden space of the kitchen (*Through the Eye Lens*) could also be understood in this context. Again, Ondák is interested in heterogeneous spaces that have to be separated to be functionally connected.

It is, I think, clear that Ondák does not understand space merely as a physical material entity. Social norms, divisions and regulations shape them and our understanding

and perception of them. Nor is our perception absolutely objective and simultaneous. It is, so to speak, soaked in knowledge, emotions, interests and, which is particularly important, memories. Space is, furthermore, not static. It is defined with movements, through space and, for the same token, through time. Space is therefore not merely physical, but essentially temporal. It exists in time, which means that it constantly changes and transforms, and that memory is vital for constructing its identity. It is no coincidence, then, that most of Ondák's works deal with space precisely through the point of view of time and memory.

The use of repetition, for example, is connected to time and memory rather than to the ideas of simulacra or serial production of goods. A series of works from 1998, where the artist dealt with gallery spaces, changing them slightly or repeating some of their elements, refers very directly to the issue of memory. This is obvious from their titles: *Remind me again*, *If I don't forget*, *I remember this*, *I can't recall this* and *Is that the way it was?* The gap between one element and another (its copy) is the gap of time. Their relation (and there can be slight differences between both) is based on memory.

In *Tickets, Please*, too, repetition plays an essential role. Here (as in several other works that deal with the gallery space) the artist turned the usual perspective, transforming something that is usually considered just of technical importance for the gallery, into the basis of his work (the whole series of works, *Tickets, Please* (2002), *This Way, Please* (1999), and *Silence, Please* (2004), deals with those elements of the gallery space that we tend to overlook, especially with the gallery's attendants. In some of the more recent projects, *Another Day* (2003) and *Good Feelings in Good Times* (2003), where he works with a ticket counter or queue in front of the museum, Ondák returned to such issues). The starting point of *Tickets, Please* was a table near the entrance to the gallery where one usually had to pay the entrance fee to an elderly gentleman and where one could also buy catalogues. Ondák reconstructed the same situation in the upper floor of the gallery, moved the old man there and employed his grandson to work at his original table. So the visitors had to pay one half of the fee at the table downstairs (where they must have been surprised to find the young boy working), but when they came into the upper galleries, they were even more puzzled to discover another table, just like the one downstairs, with the same type of chair, the same catalogues and objects on it, and another ticketseller who asked for the second half of the fee. The division was not only physical (they were on two floors, albeit one below the other), but also psychological, since one table was occupied by a young boy and the other by an old man. This was a clear enough indication that the difference between the two tables is also a difference in time (represented by the two generations, the grandfather and the grandson). But we should not understand this merely symbolically. Since one needs time to go from one table to the other, the gap between the two very literally takes time.

One should perhaps mention that Ondák actually uses different generations in identical settings often. Children impersonating politicians (*Tomorrows,* 2002), or the artist himself, assuming the role of his father in the tumultuous year 1968 (*Bad News Is a Thing of the Past Now,* 2003), speak about an irreversible temporal distance, about attempts to cross this distance through empathy, about difference, but also about repetition. Children in the role of politicians are not only sweet; the scene is, in fact, deeply uncanny. The children will one day be such politicians, and the politicians themselves were once sweet children. Time runs irreversibly and linearly, as an endless change, but it is also repetition and a returning of the same.

Let us return now briefly to the work *Through the Eye Lens.* The title indicates a parallelism between the eye and the film camera. The opening in the wall was at the same time an eye, looking into the world outside the body, and a camera lens through which a 'film' was permanently running, perhaps a reality show. In fact, camera and film principles are very important in Ondák's work. Film is essentially a visual art, but no less an art of time. It is able to incorporate past, present and future in a complex unity. And of key importance is its length, the actual time one needs to see it. In his writing about photography in *Le chambre claire,* Roland Barthes speaks about the complexity (and emotional power) of time structures in photographic images. 'He will die and he is dead already', he says about the young man in the photography of Alexander Gardner. Although the structure of the film is much more complex because of editing, cuts, the rhythm of shots, etc., it is still based on the same relation of presence and absence, past and future. This temporal structure has a parallel in the spatial structure: the reality represented in films is both very close and endlessly distant. Because of the power of the film image, one is at the same time here and there, on the actual spot and – through empathy – in the depicted world. Several of Ondák's works are connected to such film structure. The space of art makes possible the distance from the reality, where, as if through the 'lens', one can see it, clearly and in surprising details, but also distant. Many of his projects deal with distance, imagination and empathy; several are constructed like storyboards, film sequences, directed narratives.

The experience of distance in Ondák's work is thus both spatial and temporal. It is through the power of memory, empathy and imagination that one is able to cross such distances and thus, in a sense, also co-establish the here and now. This is evident, for example, also in the work that the artist did together with a number of his acquaintances who do not like travelling (he called them 'antinomads', and in the project with this title their images travelled around the world instead of them in the form of postcards). In *Common Trip* (2000), for example, a broader community of his friends and relatives made pictures of far-away places they have never visited based on his descriptions. Still, the artist's own personality remains the focus of these works: people from Ondák's circle imagined the places he had visited; they imagined him on

the streets of distant cities (*Slowed-down Journey,* 2003) or travelling on the train (*Untitled Journey,* 2003). This is not some kind of egocentricity, but rather the experience of the plurality and fluidity of the self. I think that in these works one's self appears as something that is not stable, but essentially based among others, on memories (that are often re-worked and changed) and on things forgotten or suppressed. It depends not only on the view from 'inside', but also on the multiple views and ideas that come from 'outside', from others.

Was die Bilder sagen
Ein paar Worte über Roman Ondáks poetische Nicht-Ereignisse
Georg Schöllhammer

1

„Zeichne mich, wie ich gerade in Jeans und Jacke und mit meiner Tasche durch die Stadt gehe." *Slowed-down Journey* (2003) nennt Roman Ondák die Serie von Zeichnungen seiner Freunde und Bekannten, die aus dieser Anweisung entstanden ist. Ein wenig ungelenk, sichtbar aus Amateurhänden, naiv wirken die Blätter in Reihe verschieden gerahmt an der Galeriewand auf den ersten Blick. Doch dann, schon beim ersten Versuch einer Interpretation, drängt sich ein Schwarm von Assoziationen und Fragen auf. Fragen über Autorschaft und Identität, über Performativität und Repräsentation, über das Medium Stadt und das Medium Zeichnung, und über diese nur scheinbar einfache Anweisung, die sich allmählich der Interpretation zu entziehen beginnt.

Welche Figur ist dieser post-situationistische Dérivé, der seinen Weg durch die Stadt von Dritten in Zeichnungen der Stadt beschreiben lässt? Was zeichnet da wie absichtslos die Stadt und eine Geographie ihrer Benutzung? Wer imaginiert wen an welchem Ort? Hier – wie in vielen von Roman Ondáks Erkundungen von Orten, Situationen und Beziehungen – geht es um mehr als darum, die affektive Dimension des Raums hervorzuheben, die Sozialität der Topographie und deren Konstruiertheit freizulegen. Ihren Ausgangspunkt findet die *Slowed-down Journey* in einer spielerischen Aktivität mit den Medien der Repräsentation, im „Umherschweifen" zwischen Zeitlichkeit und Fixierung im Medium. In ihre Reisetätigkeit bezieht *Slowed-down Journey* eine Vielfalt kulturellen Materials mit ein, begibt sich an die Grenze zwischen Realität und deren Re-Inszenierung, dem einzigartigen unvorhersagbaren Moment und der Wiederholung, der erwartbaren Geste, dem spontanen Spiel und der Brüchigkeit und Fragilität

von kulturellen Mustern. *Slowed-down Journey* repräsentiert sowohl den *wahrge-nommenen* Raum, die kollektive Produktion von Realität, den *vorgestellten* Raum, der durch Wissensformen, Zeichen und Codes gestaltet ist, wie den *erlebten* und *erlitte-nen* Raum, den „Raum der Repräsentation" – wie er durch die begleitenden Bilder und Symbole hindurch von den Benutzern und Benutzerinnen alltäglich erfahren wird.

Für eine andere Arbeit, *Common Trip* (2000), hat Ondák einer Reihe von Leuten von den Orten erzählt, an die er gereist war, Leuten, die selbst wenig reisen. Sie sollten nach seiner Erzählung Bilder zeichnen, Objekte bauen, die Orte entwerfen, an denen sie nie selbst waren. Aus diesen imaginierten Realien arrangierte Ondák dann einen realen Ort der Imaginationen.

2

In einem Essay mit dem Titel *Was Kinder sagen* vergleicht Gilles Deleuze die Aktivität der Kunst mit jenem Bezeichnen von Orten und Zeichnen von Karten, mit dem Kinder das Territorium entwerfen, die imaginäre Landschaft, in welcher die Szenen ihrer Ich-Findung stattfinden. Ein unablässiges Markieren von dynamischen Räumen, ein viel-faches Besetzen von Plätzen mit Bedeutungen, ein beständiges Entwerfen von Routen-plänen und Wegen, von Wegbeschreibungen, kennzeichne diese Aktivität. Personen spielten in dieser Welt „nur die Rolle von Türöffnern und -schließern, von Schwellen-wächtern, von Kontaktstellen oder Unterbrechern verschiedener Zonen". Die Landkar-tenspuren dieser Ich-Findung, die imaginierten Territorien sind vielfältig. Deleuze sagt, sie ähneln den Strategien der Kunst: auch „… die Kunst definiert sich als ein unper-sönlicher Prozess, in dem sich das einzelne Werk fast wie ein Cairn[1] zusammensetzt, wobei die Steine von verschiedenen Reisenden und Werdenden herbeigebracht sind, die von ein und demselben Autor abhängen oder auch nicht".[2]

Manchmal habe ich das Gefühl, Roman Ondák versetzt sich bei der Arbeit an sei-nen konzeptuellen Anweisungen, die auf den ersten Blick so klar und bestimmt wirken, in diesen vor-rationalen Erfahrungsraum zurück – einen Raum voll von Verschiebungen, Schwellen und Sackgassen, aber auch von Durchbrüchen und unerwarteten Aus-blicken. Die Situationen und Orte, die Ondáks Konzepte konstruieren, die Orte, die sie transformieren – oft werden sie zu Schauplätzen geheimer, unvorhersehbarer, zufälliger poetischer Verhaltensweisen. Sie zeugen von einer fast kindlichen Lust am Ort – einer Lust an dem, was sich in ihm zufällig ergibt und ergeben kann.

In einigen von Ondáks Arbeiten spielen Kinder tatsächlich eine Hauptrolle: Auf sie wird der Blick gelenkt, sie sind die Stellvertreter einer Situation, ihre Bewegungen und Haltungen bestimmen den Raum der Arbeiten. In *Tickets, Please* (2002) zum Beispiel: „Der Enkel des Kartenverkäufers wurde eingeladen, mit seinem Großvater in der Aus-stellung Eintrittskarten zu verkaufen. Während er den ursprünglichen Platz seines Großvaters im Erdgeschoss einnahm, zog dieser eine Etage höher in eine originalge-

treue Replik der Arbeitsumgebung im Erdgeschoss. Die BesucherInnen kauften zunächst eine Eintrittskarte beim Enkel im Erdgeschoss und dann, wenn sie ein paar Minuten später ins Obergeschoss kamen, noch einmal eine bei dessen Großvater. Der Preis der Eintrittskarte war dabei jeweils auf die Hälfte reduziert. Die Öffnungszeiten der Galerie richteten sich danach, wann der Enkel Zeit hatte."

Aus den Realitäten von Verwandtschaftsbeziehungen, den Zeitregimes, denen Kindheit unterworfen ist, der Wegzeit der BesucherInnen identifiziert diese Installation die Struktur einer Kunstinstitution. Die Rückbindung durch die räumliche Verdoppelung entzaubert die scheinbare Unmittelbarkeit der Szene durch den Hinweis auf ihre Zeitlichkeit. Ondák erzeugt eine paradoxe Verbindung zwischen dem Außen der Institution und dem, was sie als das „Andere", als „Ort des Außergewöhnlichen" darzustellen gezwungen ist.

Teaching to Walk (2002) verlegt das Konzept der Performanz, der bewegenden Be- und Festschreibung, in die Aufführung eines Mikrodramas: Eine Mutter lehrt täglich zur selben Zeit im Galerieraum ihr einjähriges Kind Gehen. Sie erscheint anderen Besuchern als normale Besucherin, die sich allerdings nicht der Ausstellung zuwendet, sondern den Handlungen ihres Kindes. Während der Ausstellungsdauer lernt das Kind immer besser, seine Bewegungen beim Gehen zu koordinieren.

Dieser kleine performative Akt verwandelt den Galerieraum von einem Ort, der entweder die Spuren von künstlerischer Aktivität ausstellt und enthält oder der leere Ort ist, in dem ein Event, eine Performance, ein theatralisches Ereignis stattgefunden hat, zu einem Ort, der eine Tätigkeit als Objekt enthält. Dieses Objekt ist in keinem Sinn statisch oder wird räumlich nur wiederholt, sondern ist selbst als sich verändernde Tätigkeit konstituiert. Die zeitliche Bewegung stellt eine Materialität des Objekts her, von einem vorherigen zu einem späteren Zustand. Die Verräumlichung des Ereignisses erfolgt durch die Zurückführung ihrer Variation auf einen unveränderlichen Kern, der ein internes Element der vorgegebenen Struktur ist, eine Art Landkarte. Natürlich handelt es sich bei dieser Arbeit auch um eine Kritik an der „Repräsentationen des Raumes", sprich, an der Konstruktion der Kunstinstitution, die den Raum in einzelne Elemente zerlegt und wieder neu „zusammenmontiert".

Guided Tour (2002) wiederholt das in die postkonzeptualen Strategien der Gegenwartskunst eingeführte Format der touristischen Führung und nimmt den Galerieraum als Ausgangsort. Als Führer agierte in Zadar (*Guided Tour (Follow Me)*, 2002) ein pubertierender Junge, der spontan seine Tour durch die touristischen Stereotypen, die er sich als Einheimischer angelernt hatte, mit Ausführungen zur meist unbesehenen Alltagsgeographie junger Stadtbewohner mischte.

In *Through the Eye Lens* (1999) stellt Ondák im Budapester Museum Ludwig durch eine Öffnung in der Wand eine räumliche Verbindung zwischen dem Ausstellungsraum und der Küche des Museumsrestaurants her, durch die gleichsam unbemerkt Objekte

aus dem Küchenalltag zu wandern scheinen und durch die man die Arbeit in der Küche beobachten kann. Geschützt und bezeichnet ist die Öffnung durch ein Zelt, wie man es für Biwaks bei Extremwanderungen verwendet. Hier wanderten die Dinge sozusagen aus ihrer gewöhnlichen Welt metaphorisch in ihren Ausnahmezustand.

Mit schon in den Objekten selbst konservierter, gespeicherter Zeitlichkeit und als Gleichzeitigkeit aufgespanntem historischem Raum arbeitete Ondák auch in der Installation *SK Parking* (2001) anlässlich der Ausstellung „Ausgeträumt...", in der es um die verlorenen Utopien Ost-Europas nach dem Mauerfall ging. Auf dem ein wenig undefinierten Freiraum hinter der Wiener Secession, mitten an einem der verkehrs-reichsten Punkte im Zentrum Wiens, an dem Parken sonst verboten ist und allenfalls ein Auto einer Zulieferfirma oder eines Mitarbeiters abgestellt wird, standen während der Ausstellungsdauer eine Reihe von Skodas mit slowakischem Kennzeichen. Die Autos – alle stammten aus jener Produktdesignwelt, in der das tschechoslowakische Design parallel zu westlichen Modernismen lief – stellten in vielfacher Weise Wahrnehmungs-hindernisse auf. Ihr Ungewohntes, ja Befremdliches hatte mit der Aufhebung von Distanz zu tun. Dem Kunstpublikum erschien Ondáks Arbeit als eine einfache Skulptur im öffentlichen Raum, die Kraft aus einer Kontextverschiebung zog: die Form, insbeson-dere jedoch die Farbe (sowie natürlich die Nummerntafeln) der Skodas waren in dieser Konzentration im Wiener Stadtbild Misfits. Sie markierten eine kulturelle Zeitverschie-bung zwischen dem so genannten Osten und dem Westen Europas. Sie zeigten Male-rei mit den Fehlfarben einer aus der kapitalistischen Warenwelt ausgeblendeten Skala. Von diesen ästhetischen Verweisen kaum informiert, verstörten das Laufpublikum jedoch die sozialen Konnotationen dieses Transpositionsaktes – zum Beispiel auf den Schwarzarbeit- und Small-Job-Verkehr zwischen Bratislava und Wien, der meist über öffentliche Verkehrsmittel oder bis auf Parkplätze am Stadtrand transportiert. Derart demaskierte sich die latente Xenophobie vieler BetrachterInnen. Die Überführung der Skodas aus Bratislava ins Zentrum Wiens durch ihre Besitzer, die für das Überlassen und Stilllegen der Autos mit Honoraren bezahlt wurden, erweiterte den Raum der Aktion weg vom Ausstellungsort um eine unsichtbare figurative Spur.

Auf nahezu entgegengesetzte Weise findet eine solche kulturelle Strukturverschie-bung auch in *Announcement* (2002) statt. Allerdings wird hier die Immobilisierung durch die Aufforderung an die BesucherInnen ersetzt, sich in einer bestimmten Weise zu verhalten und durch diesen performativen Akt selbst ein Teil der Ausstellung, also Objekt, zu werden: „Ein Museumswärter hat ein Radio auf einen deutschsprachigen slowakischen Sender eingestellt, dessen Nachrichtensprecher in das Programm wie-derholt die Mitteilung liest: ‚Als ein Zeichen ihrer Solidarität mit den jüngsten Ereignis-sen in der Welt bitten wir Sie, die Tätigkeiten, die Sie gerade ausüben, für die nächste Minute nicht zu unterbrechen.'"

Eine dritte Möglichkeit mit dem Motiv von Mobilität und Ortsverbundenheit, mit einem paradoxen Motiv der Reise zu spielen, skizziert Ondáks Serie von Postkarten mit dem

Titel *Antinomads* (2000), die u.a. in einem Kiosk in Bratislava und an entfernten Aus-
stellungsorten angeboten wurden: Auf den Postkarten sind Menschen abgebildet, die
bewusst nicht reisen, die nicht reisen wollen, ortsfeste Charaktere, deren Bilder als
Veduten zu reisen bestimmt sind.

3

„Das Dritte Denkmal" (*Das Dritte Denkmal*, 2002) sprüht Ondák auf den Gehsteig
vor einer alten Park-Sitzbank unter einer Linde direkt an der stark befahrenen Bundes-
straße 1 im Marktflecken Erlauf, 100 km vor Wien. In Fraktur-Schrift, die in Österreich
bis heute als ein Typodesign-Marker für die Nazizeit gilt. Gegenüber stehen zwei
Denkmale, die sich der kleine Ort, in dem 1945 ein historischer Handschlag zwischen
amerikanischen und sowjetischen Generälen von der Öffentlichkeit unbemerkt das
Ende des Zweiten Weltkriegs besiegelte, von Jenny Holzer und dem sozialistisch-rea-
listischen Sowjetbildhauer Oleg Komov 1995 errichten ließ. Im Ort selbst sind wie
absichtslos Plakate verstreut affichiert, in denen Kinder wichtige Ereignisse aus der
Ortschronik (Eröffnungsfeiern, Vertragsabschlüsse etc.) in jenen Posen nachstellen, wie
sie auf den Festfotografien festgehalten sind: *Tomorrows* (2002).[3]
 Roman Ondáks künstlerische Kraft zeigt sich hier abermals in der Präzision, mit
welcher er aus verweisreicher Unbestimmtheit und dem Spiel mit Bedeutungen von
Raum, ein hochkomplexes Medium baut. Diese Idee der unaufhaltsamen Übertragung,
der ständigen und widersprüchlichen Transfers von Bedeutungen, ist eine der Grund-
bewegungen in Ondáks künstlerischem Denken. Doch diese Übertragung setzt auch
eine andere Bewegung in Gang: Ob es die Beobachtung dessen ist, was zwischen der
Beobachtung eines Zustands oder einer Handlung und ihrer Re-Inszenierung geschieht,
die Wiederholung desselben Bildes in verschiedenen Medien, oder das Einführen
unerwarteter Handelnder in einen von Erwartungen voll geschriebenen Ort – in Ondáks
Untersuchungen des Kunstwerks als Scharnier zwischen der Immaterialität der Reprä-
sentation und der Materialität gelebter Erfahrung erzeugt sich fast immer eine Intimität
der Situationen mit Menschen, die an ihnen als BetrachterInnen oder AkteurInnen
beteiligt sind. Ondáks Arbeiten beinhalten immer beides: einmal den realen Ort, sein
Double und den Nicht-Ort; und einmal die Handlung, den Rollentausch und die Stell-
vertretung. Ondáks Konzepte geraten fast zwangsläufig in produktiven Konflikt mit dem
Kontext, mit all den positiven, funktionalen Bedeutungen, die ein Raum, eine Handlung
oder ein Objekt haben kann. Die Konzepte erzeugen gegenüber diesen positiven, funk-
tionellen Bedeutungen poetische Nicht-Ereignisse.
 In diesem Sinne ist wohl auch das Plakat zu Lesen, das Ondák zur „Utopia Station"
der Biennale von Venedig 2003 (*Letter,* 2003) beigesteuert hat. Es zeigt den tatsäch-
lich abgesandten Brief an den Kulturminister der Slowakei, dessen Text nur aus einem
Satz besteht: „Dear Minister, could you support my intention to establish a Virtual
Museum of Contemporary Art?"

1 Eine Wegmarkierung aus Steinen
2 Gilles Deleuze, „Was Kinder sagen", in: ders., *Kritik und Klinik*. Frankfurt/M., 2000, (übersetzt von Joseph Vogl), S. 85–94 (franz.: Critique et clinique, Paris, Les Éditions Minuit, 1993)
3 Zwei Jahre zuvor hatte die Belgrader Künstlerin Milica Tomic hier in einer Fotoarbeit Komovs Denkmal uminterpretiert und jetzt steht eine Replika der Luxemburger Nationalheroine Gelle Fra, allerdings von Sanja Ivekovic als Schwangere verfremdet auf einer Stele unweit von Ondáks Satz. Die Arbeiten sind Teil eines „Kunst im öffentlichen Raum"-Projekts mit dem Titel Erlauf erinnert sich.

What Pictures Say
A few words about Roman Ondák's poetic non-events
Georg Schöllhammer

1

'Draw me as I am walking through the city in jeans and jacket with my bag.' *Slowed-down Journey* (2003) is the title Roman Ondák gives to the series of drawings by his friends and acquaintances that resulted from this instruction. At first glance, the pictures lined up on the wall of the gallery in different frames seem a little clumsy, visibly amateurish, naive. But then, as soon as one makes any attempt at an interpretation, a horde of associations and questions force themselves upon: questions about authorship and identity, about performativity and representation, about the medium 'city' and the medium of drawing – and about this instruction, only seemingly simple, that gradually begins to elude interpretation.

What kind of figure is this post-situationist dérivé that has his journey through several cities described by absent observers and their drawings of the city? What draws, seemingly without intention, the city and a geography of its use? Who is imagining whom in what location? Here – as in many of Roman Ondák's explorations of places, situations and relationships – more is involved than merely emphasising the affective dimension of the space and exposing the sociality of the topography and its constructedness. *Slowed-down Journey* takes its bearings from a playful activity with the media of representation, from the act of 'wandering' between temporality and fixation in the medium. *Slowed-down Journey* includes a variety of cultural material in its travel, walks at the border between reality and its re-presentation; between the unique, unpredictable moment and repetition, the foreseeable gesture; between spontaneous play and the brittleness and fragility of cultural patterns. *Slowed-down Journey* repre-

sents the *perceived* space – the collective production of reality – the *imagined* space, which is shaped by forms of knowledge, signs and codes, as well as the *experienced* and *suffered space*, the 'space of representation', as it is experienced on an everyday basis by users through the accompanying images and symbols.

For another work, *Common Trip* (2000), Ondák told a number of people – people who travelled little themselves – about the places to which he had travelled. They were asked to draw pictures, make objects, create a conception of places where they had never been themselves, based on the account he had given. Ondák then arranged a real place of imagination from these imagined realities.

2

In an essay with the title 'What Children Say', Gilles Deleuze compares artistic activity with the description of places and drawing of maps that children use to depict the territory, the imaginary landscape, in which the scenes of their self-discovery take place. This activity, he writes, is characterised by an unremitting delineation of dynamic spaces, a charging of places with multiple meanings, a constant conception of itineraries and paths, of route descriptions. According to Deleuze, in this world people only play 'the role of openers and shutters of doors, of watchers on the threshold, of contact points or interrupters of different zones.' The mapped traces of this self-discovery, the imagined territories, are manifold. Deleuze says they resemble the strategies of art: '…art [too] defines itself as an impersonal process, in which individual works are constructed almost like a cairn[1], with the stones being contributed by various travellers and developing personalities that may depend on one or the same author or not.'[2]

Sometimes it seems that Roman Ondák, while working on his conceptual instructions, which at first glance appear so clear and decided, moves back into this pre-rational space of experience: a space full of shifts, thresholds and dead-ends, but also revelations and unexpected outlooks. The situations and places constructed by Ondák's concepts, the places they transform, often become the arena for secret, unforeseeable, random poetical manners of behaviour. They seem to be driven by an almost childlike pleasure in places – a pleasure in what happens and can happen in them by chance.

In some of Ondák's works, children do indeed play a major role. The viewer's gaze is directed to them, they are the representatives of a situation, their movements and poses determine the space of the works. In *Tickets, Please* (2002), for example: 'Ticket seller's grandson was invited to sell tickets at the exhibition with his grandfather. He took his grandfather's original place on the ground floor and the grandfather moved up a floor to a precise replica of the ground floor environment. The visitor first bought a ticket from the grandson on the ground floor and again just a few minutes later when he got to the grandfather on the first floor. In both cases the ticket price was reduced by half. The gallery's opening hours were accommodated to when the boy was free.'

From the realities of family relationships, the timetabled regimes to which childhood is subject, the time taken by the visitors to get from one floor to another, this installation identifies the structure of an art institution. The connection through the spatial doubling prosaically undermines the apparent directness of the scene by indicating its temporal nature. Ondák produces a paradoxical link between the exterior of the institution and that which it is forced to present as the 'Other', as a 'place of the extraordinary'.

Teaching to Walk (2002) puts the concept of performativity, of moving description and enactment, into the performance of a micro-drama: every day, at the same time, there is a mother teaching her one-year-old child to walk in the gallery. To the other people at the exhibition, she seems like a normal visitor, who, however, is devoting her attention to what her child is doing and not to the exhibition. Over the time the exhibition is on display, the child learns to coordinate its walking movements better and better. This small performative act transforms the gallery space from a place in which the traces of artistic activity are displayed and contained or which is an empty space where an event, a performance or a theatrical happening has taken place, into a place that contains an activity as object. This object is not static in any sense, nor is it only repeated spatially: it is itself constituted as an activity in a process of transformation. The movement in time produces a materiality of the object, from a previous state to a later one. The spatialisation of the event results from the reduction of its variation to an unchanging core that is an internal element of the pre-determined structure: a sort of map. Of course, this work is also a critique of the 'representations of space', that is, of the construction of the art institution, which breaks up the space into single elements and 'reassembles' it.

Guided Tour (2002) repeats the format of sightseeing tours that has entered the post-conceptual strategies of contemporary art, taking the gallery space as its point of departure. In *Guided Tour (Follow Me)* (2002) in Zadar, an adolescent boy acted as tour guide. He, talking in the future tense, spontaneously mixed remarks on the everyday geography – unseen for the most part – of the young urban residents into his tour with the various touristic stereotypes which he had learnt as a native of the town.

In *Through the Eye Lens* (1999), at the Ludwig Museum in Budapest, Ondák made an opening in the wall at floor level to create a spatial connection between the exhibition space and the kitchen of the museum restaurant. Ordinary kitchen objects seemed to make their way through this opening as if unnoticed, and it was possible to look through it and observe the work being done there. The opening was protected and marked by a tent like the ones used for bivouacs on hikes in extreme conditions. Here, things wandered metaphorically from their usual world into a state of emergency, so to speak.

In the installation *SK Parking* (2001) at the exhibition 'Ausgeträumt…', which centred on the lost utopias of eastern Europe following the fall of socialism, Ondák also

worked with the temporality preserved and stored in the objects themselves and with historical space stretched out as simultaneity. Throughout the exhibition, on the rather undefined open space behind the Vienna Secession in the middle of one of the busiest places in central Vienna, where parking is otherwise not allowed (occasionally you will find a delivery van or an employee's car stationed there), stood a row of Skodas with Slovakian number plates. The cars, which all originated from a world of Czechoslovakian product design that ran parallel to western modernism, presented a variety of obstacles to perception. Their unusual, even disconcerting effect had to do with the removal of distance. The art audience saw Ondák's work as a sculpture in public space that drew its power from a shift in context: in this concentration, the shape, and particularly the colour (and, naturally, the number plates) of the Skodas were misfits in the Vienna landscape – they marked a cultural time difference between the so-called east and the west of Europe. They showed painting with colours that had been cut out of the spectrum used by the capitalistic commercial world. The viewers, barely informed about these aesthetic considerations, were disturbed, however, by the social connotations of this act of transposition – for example, the reference to the black-market and small-jobs traffic between Bratislava and Vienna, which mostly occurs on public transport or via car parks at the edge of the city. In this way, the latent xenophobia of many viewers was unmasked. The transport of the Skodas to the centre of Vienna from Bratislava by their owners, who were paid a fee for the loan and immobilisation of the cars, extended the space of the action by an invisible, figurative trail leading away from the exhibition location.

A similar cultural shift in structure also takes place in *Announcement* (2002), but in an almost opposite regard. In this case, the immobilisation is replaced by the request to viewers to behave in a certain way, thus making themselves a part of the exhibition – an object – through this performative act: 'There is a radio casually placed in the exhibition room and it is tuned to a Slovakian international broadcast. Its newsreader, while reading the daily news, keeps on repeating the following announcement: As a sign of solidarity with recent world events, for the next minute do not interrupt the activity you are doing at this moment.'

A third possibility of playing with the motif of mobility and rootedness, with a paradoxical motif of travel, is outlined by Ondák's series of postcards with the title *Antinomads* (2000), which were available, among other places, in a kiosk in Bratislava and in remote exhibition locations. The postcards show people who deliberately do not travel, who do not want to travel, characters rooted in a location, whose portraits are destined to travel as postcard scenes.

3

Using a stencil, Ondák sprayed 'Das Dritte Denkmal' (*Das Dritte Denkmal,* 2002) onto the pavement in front of two old park benches under a lime tree directly on the busy Route N° 1 in the market town of Erlauf, 100 km from Vienna. The words are written in Gothic script, which in Austria is still seen as a typical typographical indicator of the Nazi period. Opposite stand two monuments by Jenny Holzer and the socialist-realist Soviet sculptor Oleg Komov, which the small town – in which a historical handshake in 1945 between American and Soviet generals, unnoticed by the public, sealed the end of the Second World War – had put up in 1995. In the town itself, posters are distributed, seemingly without purpose, showing children acting out important events from the town's history (opening celebrations, treaty-signings, etc.) in the poses captured on the official photographs: *Tomorrows* (2002).[3]

Roman Ondák's artistic power is shown here once more in the precision with which he builds a highly complex medium from a vague wealth of references and by playing with the meanings of space. This idea of the incessant and contradictory transfer of meanings is one of the basic movements in Ondák's artistic thought. But this transfer sets another movement in motion as well: whether it is the observation of that which occurs between the observation of a state or an act and its re-presentation, the repetition of the same picture in various media, or the insertion of unexpected protagonists into a place full of established expectations – in Ondák's explorations of the art work as a hinge between the immateriality of representation and the materiality of lived experience, there almost always arises an intimateness of the situations with people that participate in them as viewers or actors. Ondák's works always contain both things: the real location and its double, the non-site; the action, and representation and the exchange of roles. Almost inevitably, Ondák's concepts enter into a productive conflict with the context, with all the positive, functional meanings that a space, an action or an object can have. In the face of these positive, functional meanings, the concepts produce poetic non-events.

The poster that Ondák made for the Utopia Station at the Venice Biennale in 2003 (*Letter,* 2003) is probably also to be read in this spirit. It shows a letter that was really sent to the Slovakian culture minister, whose text consists of only one sentence: 'Dear Minister, could you support my intention to establish a Virtual Museum of Contemporary Art?'

1 **Routemarkings out of stones**

2 **Gilles Deleuze. 'What the Children say.' In: _Essays Critical and Clinical_ (French: Critique et clinique, Paris, Les Éditions Minuit, 1993).**

3 **Two years previously, the Belgrade artist Milica Tomic had reinterpreted Komov's monument in a photographic work, and now a replica of the Luxembourgian national heroine Gelle Fra – albeit pregnant, in an alienation carried out by Sanja Ivekovic – stands on a stele not far from Ondák's sentence. The works form part of an 'Art in the Public Space' project with the title 'Erlauf erinnert sich' (Erlauf Remembers).**

Untitled, 1992
Tusche auf einer Buchillustration
Ink on a book illustration

Twins, 1992
Tusche auf Papier
Ink on paper

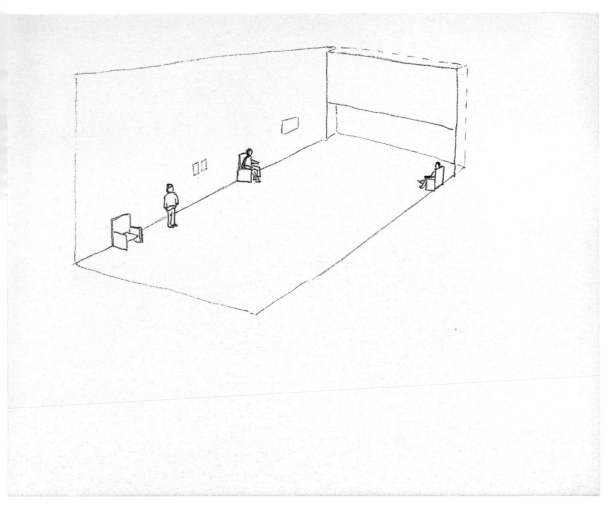

Waiting Room, 1997
Sitze für Ausstellungswächter, gefertigt aus einem
Teil der Holzwand der Galerie.
Entwurf für die Installation, Tintenstift auf Papier

Seats for attendants made from a section
of the gallery's wooden wall.
Proposal for the installation, pen on paper

Untitled, 1997
An die Wand geklebte Steckdosen-Attrappen.
(Detailansicht der Installation)

Fake electric sockets glued to the wall.
(a detail of the installation)

Untitled, 1998
Abmontierte Steckdosen, befestigt auf Metallstiften
(Detailansicht der Installation)

Dismounted electric sockets on metal rods
(a detail of the installation)

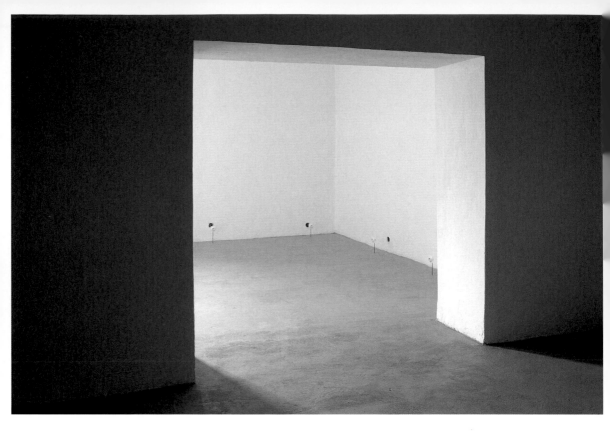

Closer to Each Other, 1997
Abmontierte Steckdosen, befestigt auf Metallstiften
Dismounted electric sockets on metal rods

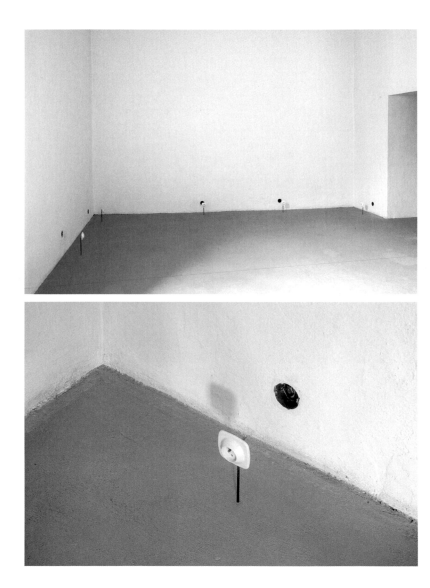

Descending Door
Retreating Door, 1997

2 C-Prints aus einer Serie von 4
2 C-prints from a series of 4

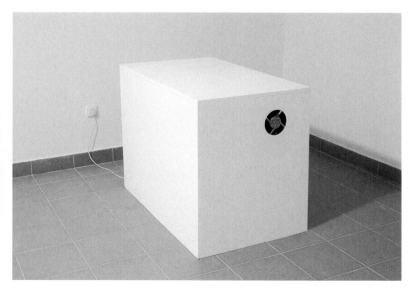

Unit, 1998
Sockel und elektrischer Ventilator
Pedestal and electric fan

Unit, 1998
Tintenstift auf Papier
Pen on paper

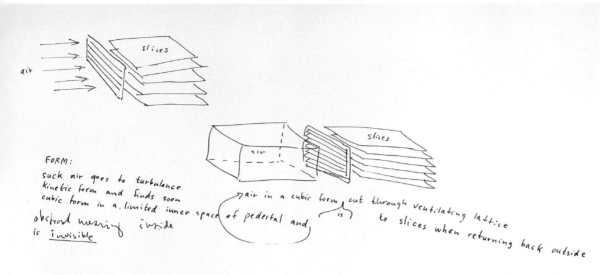

air

slices

slices

air

FORM:

suck air goes to turbulance
kinetic form and finds soon
cubic form in a limited inner space of pedestal and
obstond wearing inside
is _invisible_

air in a cubic form, cut through ventilating lattice
(is)
to slices when returning back outside

el. engine

turbulance

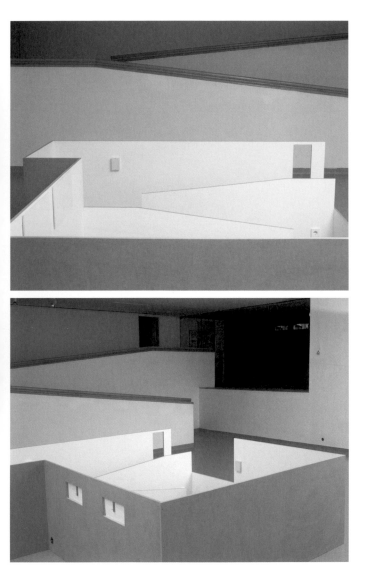

Remind me again, 1998

Steckdosen, Lüftungsklappen und Alarmsensor von der Wand abgenommen und auf einem verkleinerten Modell des Ausstellungsraums montiert.

Electric sockets, ventilation covers and alarm sensor removed from the walls and mounted onto a miniature model of the gallery.

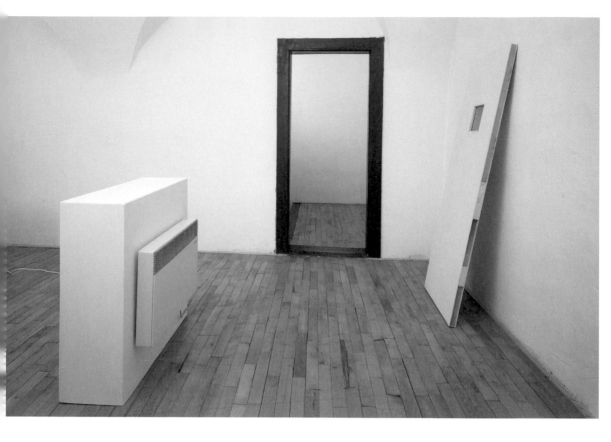

If I don't forget, 1998

Elektrisches Heizgerät von der Wand abge-
nommen und an der Seite eines Sockels fixiert,
ausgeschnittenes Element einer Tür.

Electric heater removed from the wall and fixed
to the side of a pedestal, cut-out part of a door.

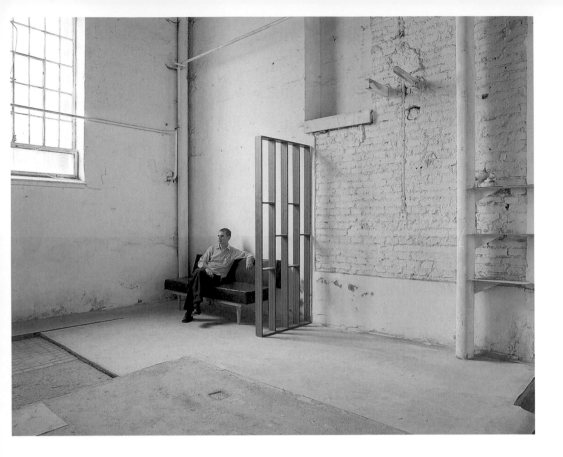

Resting Corner, 1999

Sofa und Trennwand wurden aus dem
Aufenthaltsraum der Museumsangestellten
in den Ausstellungsraum versetzt.

Sofa and shelving unit from the museum's staff room
relocated in the gallery.

This Way, Please, 1999

Aufstellung der Wächter dem Alter nach, vom jüngsten bis zum ältesten, während der Besucher durch die Ausstellung geht.

Attendants arranged in order of age from the youngest to the oldest as the visitor passes through the exhibition.

Vorentwurf für eine Performance, Tintenstift und Ölfarbe auf Papier

Preliminary drawing for performance, pen and oil paint on paper

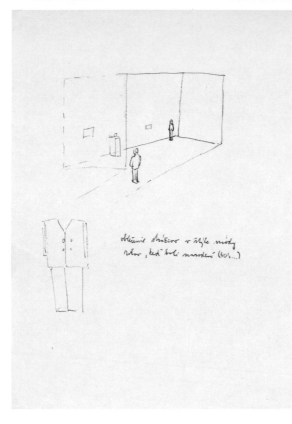

Silence, Please, 1999

Vorentwurf für eine Performance, Tintenstift
auf Papier
Preliminary drawing for performance, pen
on paper

Silence, Please, 2004

Wächter tragen Originaluniformen der Museums-
wächter aus der Zeit ihrer Geburt.
Performance im Stedelijk Museum, Amsterdam

Attendants dressed in museum attendant's uniforms
dating from the period in which they were born.
Performance at Stedelijk Museum, Amsterdam

S./pp. 51–53

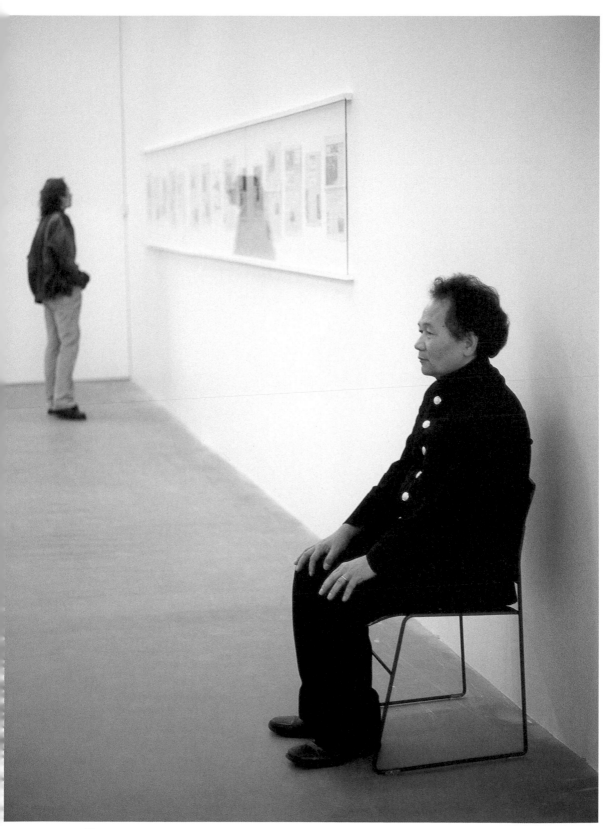

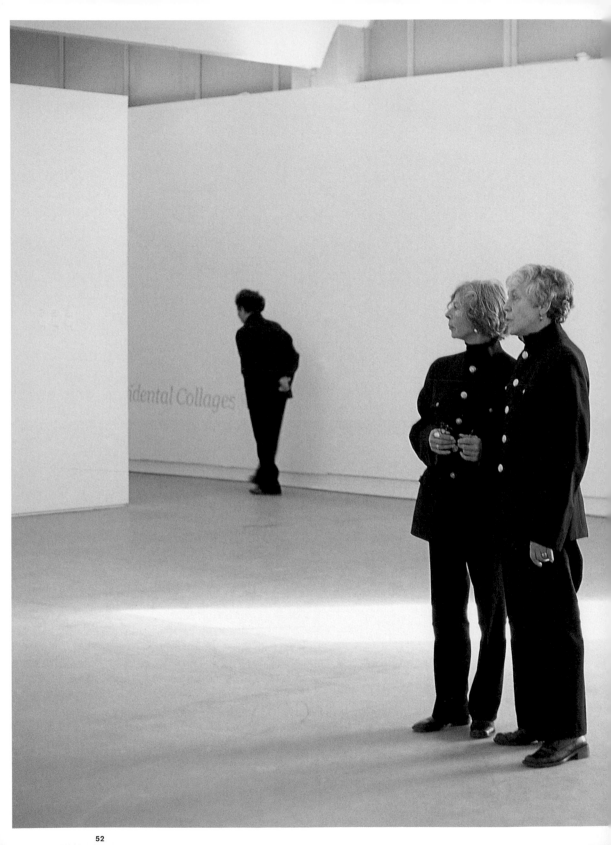

Daily News, 1998
Tintenstift und Tempera auf Papier
Pen and tempera on paper

Sharing the Room, 1998
Ein Vogelhaus wird aus einem Baum in ein naheliegendes Hotelzimmer versetzt.

Bird-box relocated to a hotel room from a nearby tree.

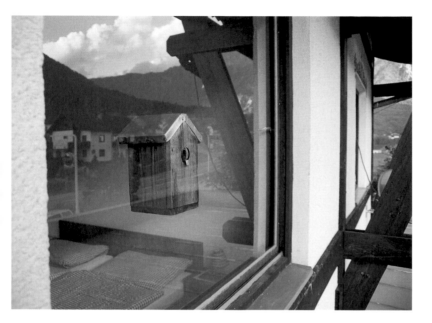

Sharing the Room, 1998

Hotelzimmer, im Fenster aufgehängtes
Vogelhaus, ausgeschnittene Öffnung in einem
Fensterglas

Installation im Hotel Unterbergnerhof in den
österreichischen Alpen

Hotel room, bird-box hung on a window,
cut-out opening in window pane

Installation in the Hotel Unterbergnerhof,
Austrian Alps

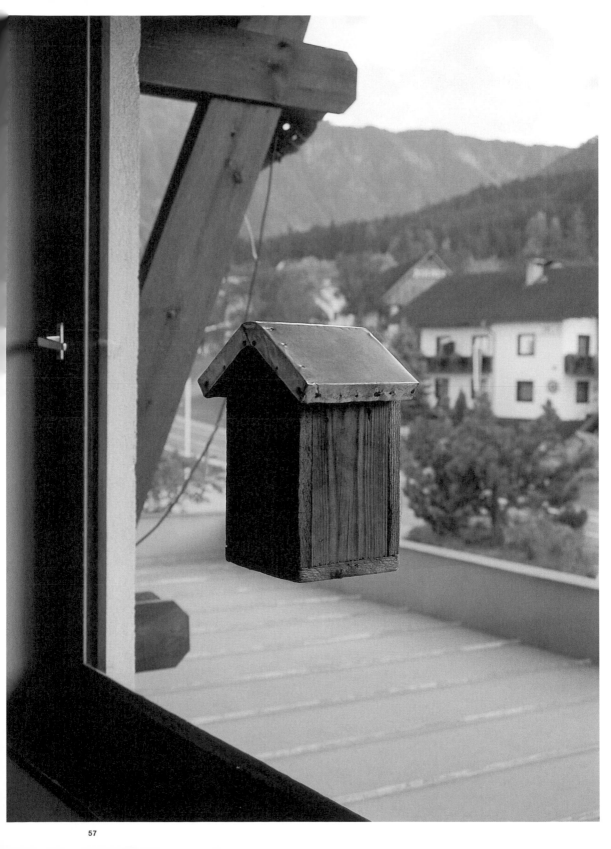

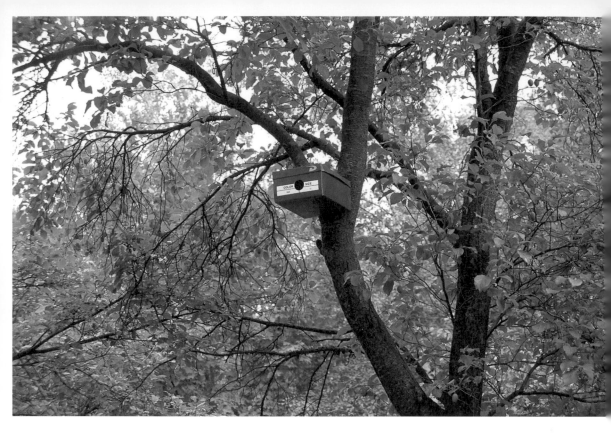

Colour and Size, 1999

Ausgeschnittene Öffnungen in Schuh-
schachteln, die mit „Farbe" und „Größe"
etikettiert wurden; die Schuhschachteln
wurden wie Vogelhäuser an verschiedenen
Stellen um eine Galerie herum montiert.

Openings made in shoe boxes bearing labels
'colour' and 'size'; shoe boxes installed like
bird-boxes in different locations around gallery.

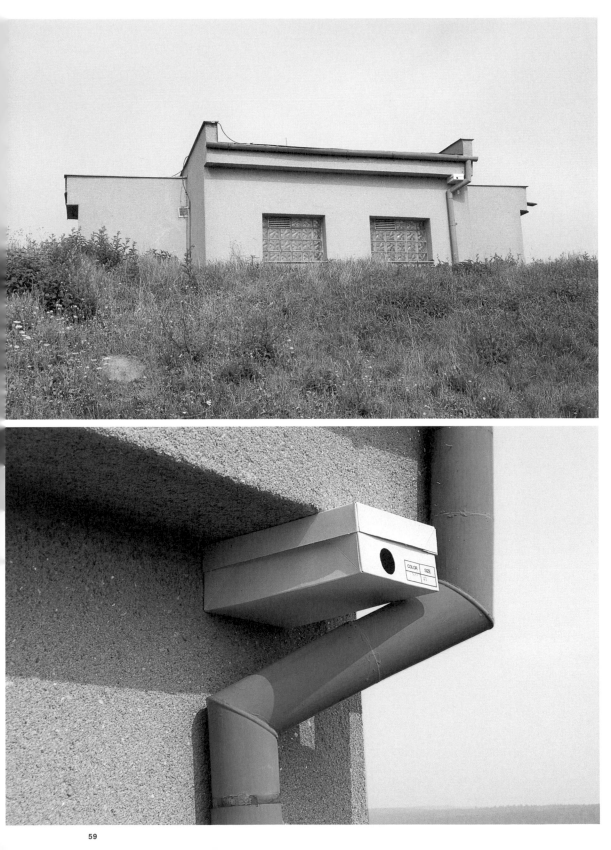

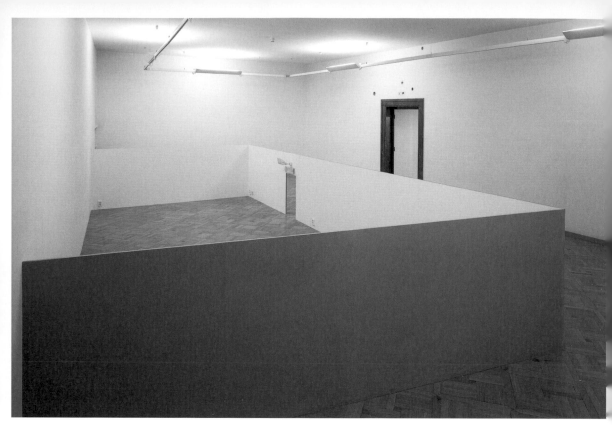

I remember this, 1998
Steckdosen, Notausgangslampe und Alarm-
sensor wurden von den Wänden abgenommen
und auf einem verkleinerten Modell des Aus-
stellungsraumes montiert.

Electric sockets, emergency exit lamp and
alarm sensor removed from the walls and
mounted on a miniature model of the gallery.

Drawn Retrospective, 2000
Zeichnung aus einer Serie von 36, Farbstift auf Papier
Drawing from a series of 36, colour pencil on paper

I can't recall this, 1998
Tintenstift auf Papier
Pen on paper

I can't recall this, 1998
Gipskartonplatte, Farbe, Heizgeräte- und Steckdosen-Attrappen
Plasterboard, paint, fake radiators and electric sockets

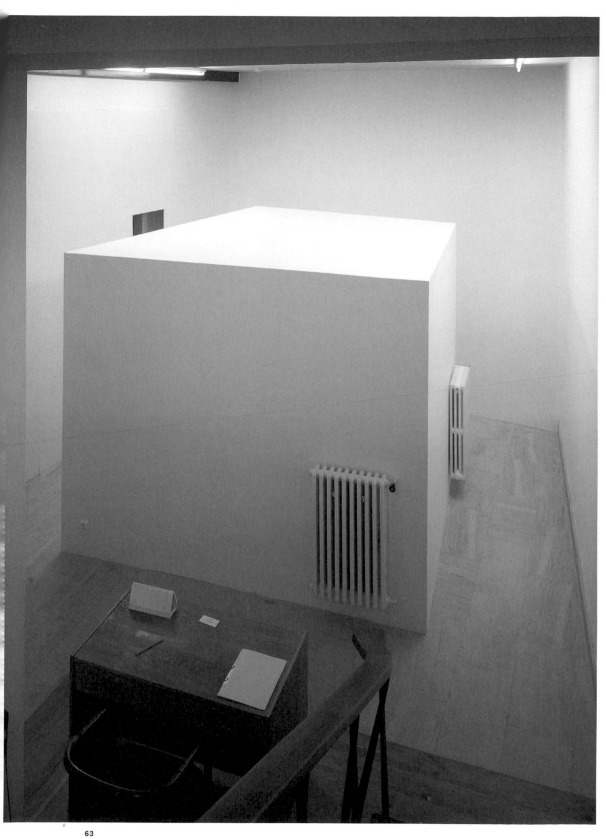

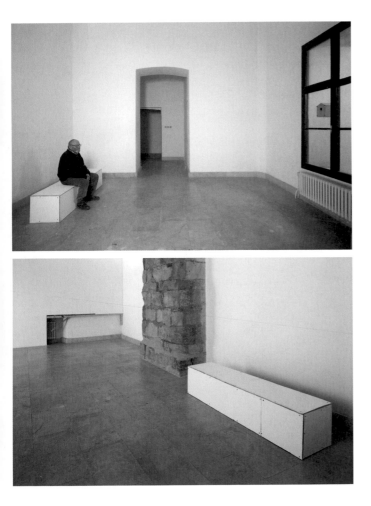

Is that the way it was?, 1998

Bank, aus einem Teil der falschen Holzwand der
Galerie angefertigt, ausgeschnittene Öffnung
in einem Fensterglas, Vogelhaus von außen an ein
Fenster montiert.

Bench made from a section of the gallery's false
wooden wall, cut-out opening in a window pane,
bird-box attached from outside onto window.

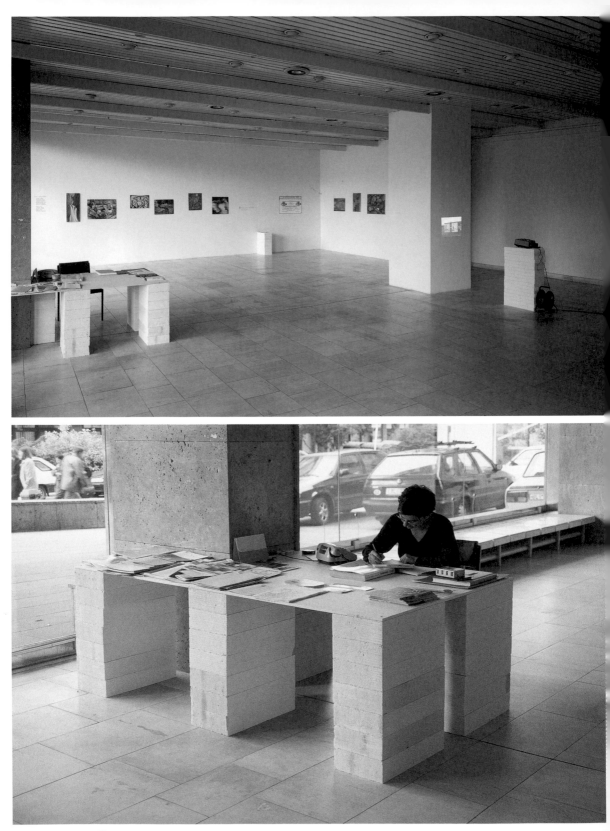

Infocentrum, 1999

Ondák besuchte einheimische Hobbymaler und lud sie ein, mit ihm und anderen professionellen Künstlern an einer Gruppenausstellung in einer Galerie teilzunehmen. Um den Nachteil des „Nicht-Professionell-Seins" auszugleichen, wurde den Hobbymalern angeboten, ihre Originale auszustellen, während von den Professionellen lediglich eine Diadokumentation gezeigt wurde. Die Galerie wurde von Ondák mit weißen Ziegeln und Gipskartonplatten adaptiert, um sie dem modernistischen Ideal eines Ausstellungsraumes anzupassen.

Veranstaltung und Installation in der Galerie Emil Filla, Ústí nad Labem

Ondák visited and invited local amateur painters to exhibit in a group exhibition in a public gallery together with professional artists, including the artist himself. To make up for the disadvantage of being 'unprofessional', the amateurs were given the opportunity to show their original paintings, while the work of the 'professionals' was only presented in slide form. Ondák refurnished the gallery by white bricks and plasterboard sheets to give it the ideal modernistic appearance thought to be suitable for the presentation of contemporary art.

Event and installation at Gallery Emil Filla, Ústí nad Labem

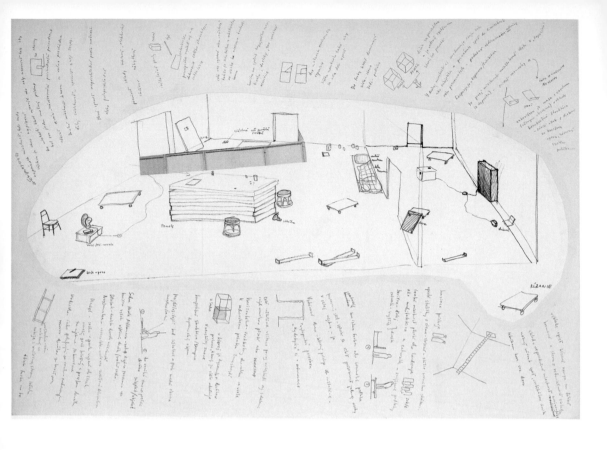

Exposure, 1998

Bleistift, Tintenstift und Klebeband auf Papier
Pencil, pen and tape on paper

Exposure, 1998

Ausgeliehene Kunstwerke aus der Sammlung des
Museums und sonstige Elemente aus dem Depot
wurden arrangiert, um eine „Ausstellung" zu simulieren.
Installation in zwei Räumen des Ujazdowski-Schlosses,
Warschau

Artworks borrowed from the museum's permanent
collection and other elements removed from the museum's
stores were arranged to simulate 'the exposition'.
Installation in two rooms of Ujazdowski Castle, Warsaw

S./pp. 69–71

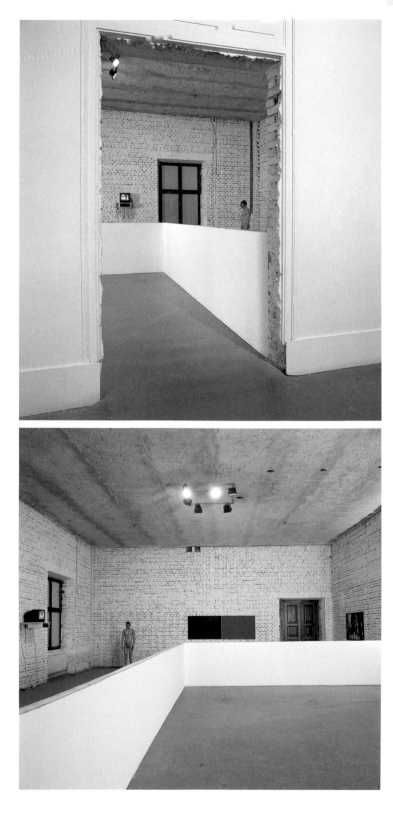

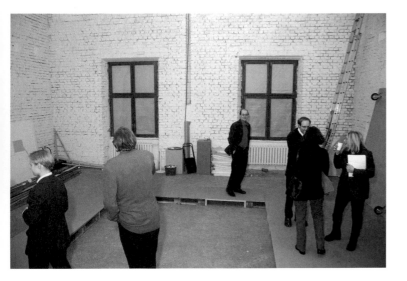

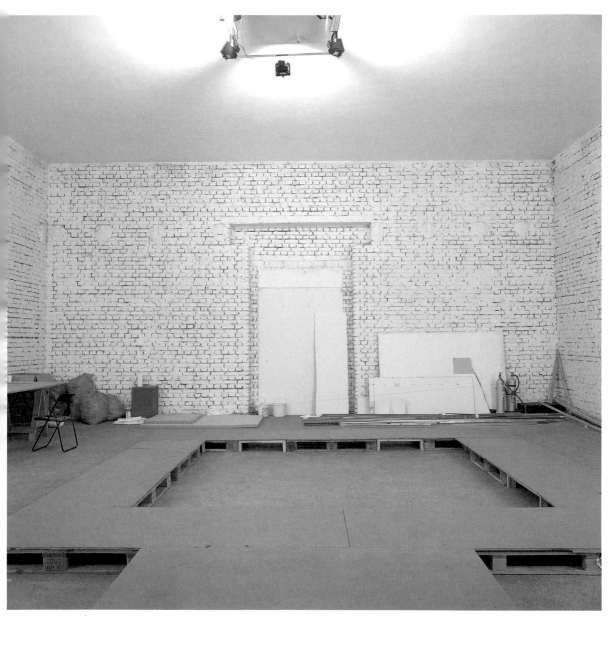

Museum/Storage, 1999

Wasserkühler, Kaffeemaschine und Stuhl
wurden von den Museumswächtern benutzt;
die Gegenstände in einer Kiste stammen aus
den Museumdepots und den Personalräumen.

Water cooler, coffee machine and chair used by
museum's attendants. Items inside box were collected
from the museum's stores and staff rooms.

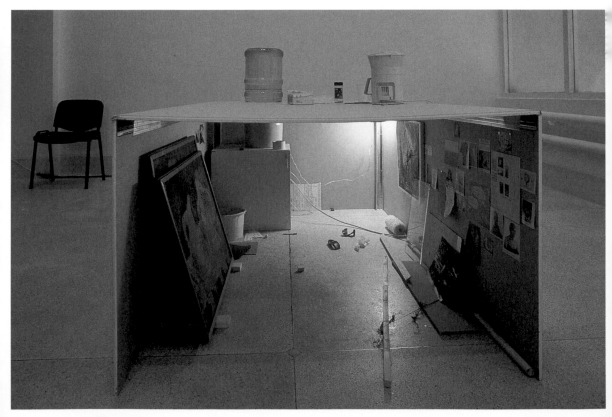

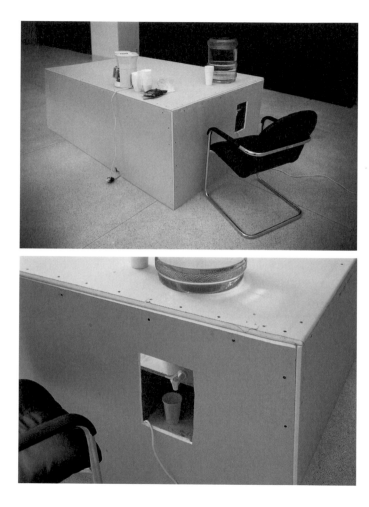

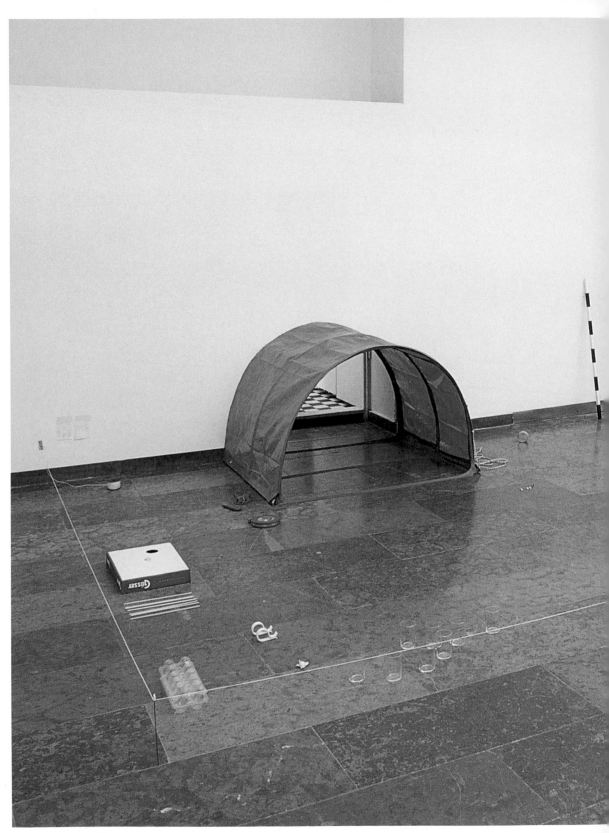

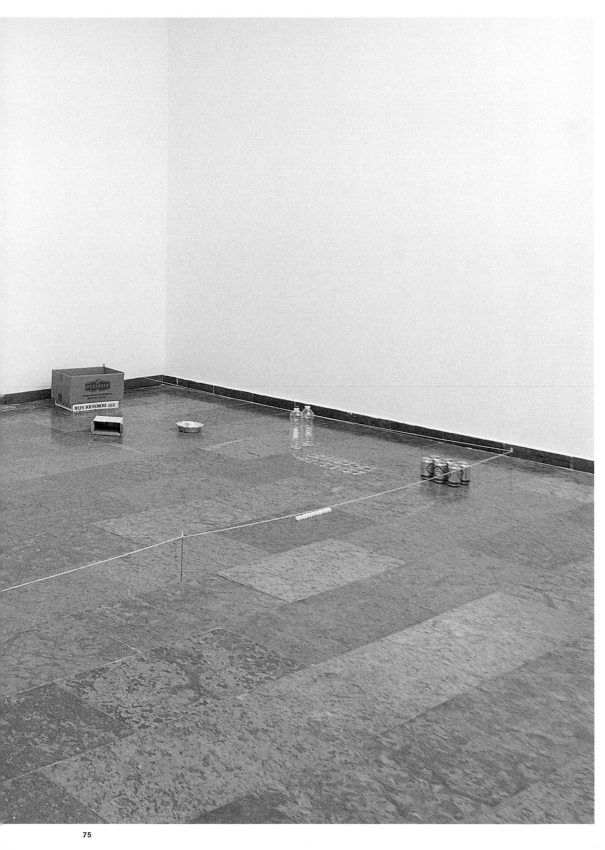

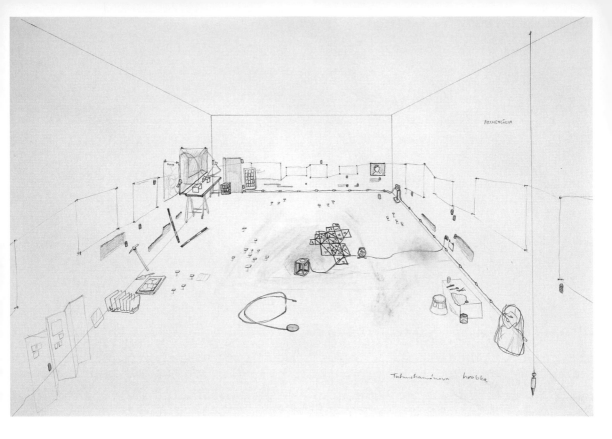

Through the Eye Lens, 1999
Bleistift und Tintenstift auf Papier
Pencil and pen on paper

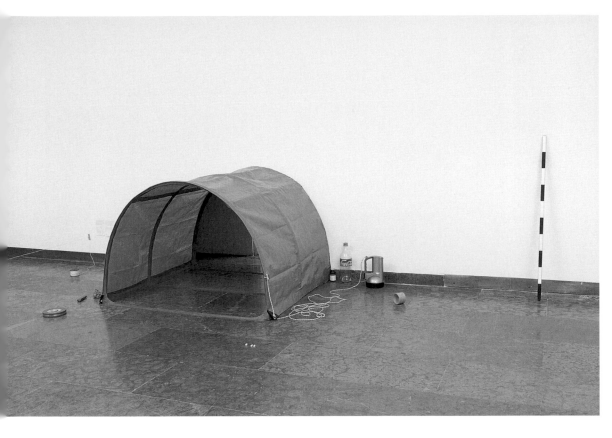

Through the Eye Lens, 1999

Vom Ausstellungsraum aus wurde eine Öffnung direkt zur Küche des Museumsrestaurants gegraben. Ondák stellte in dieser Öffnung ein kleines Zelt auf und rüstete sich mit dem Werkzeug eines Archäologen aus. Während einiger Tage vor der Ausstellung sammelte er diverse vom Kochen übrig gebliebene Gegenstände aus der Küche ein, die er durch die Öffnung in den mit Seilen markierten Bereich trug, als ob sie archäologische Funde wären. Die Ausstellungsbesucher konnten die ständigen Bewegungen der in der Küche arbeitenden Menschen hören und beobachten.

Installation Museum Ludwig, Budapest

An opening was made into the kitchen of the museum's restaurant directly from the exhibition space. Ondák inserted a small tent into the opening and equipped himself with archaeologist's tools. In the days preceding the exhibition, the artist collected several objects from the kitchen left over from cooking and brought them, as if they were archaeological finds, through the opening in the wall into an area of the gallery marked by a rope. Afterwards, visitors to the exhibition also had the chance to partially hear and observe the continuous activities of people working in the kitchen.

Installation Museum Ludwig, Budapest

S./pp. 74–75, 77

Storyboard, 2000

Ondák hat seinen Freunden und Verwandten den leeren Raum einer Galerie beschrieben. Eine Serie von 40 Zeichnungen, die sie anfertigten, war dann das einzige, das in der Ausstellung gezeigt wurde.

Ondák described the empty space of the gallery to his friends and relatives. They then made a series of 40 drawings based on his description, which were the only items in the exhibition.

Das Foto zeigt den Vater des Künstlers zeichnend, 2000
Artist's father drawing, 2000

Untitled (Empty Gallery), 2000

Ondák hat seinen Freunden und Verwandten den leeren Raum einer Galerie beschrieben. Eine Serie von 24 Zeichnungen, die sie anfertigten, war dann das einzige, das in seiner Ausstellung gezeigt wurde.

Ondák described the empty space of the gallery to his friends and relatives. They then made a series of 24 drawings based on his description, which were the only items in the exhibition.

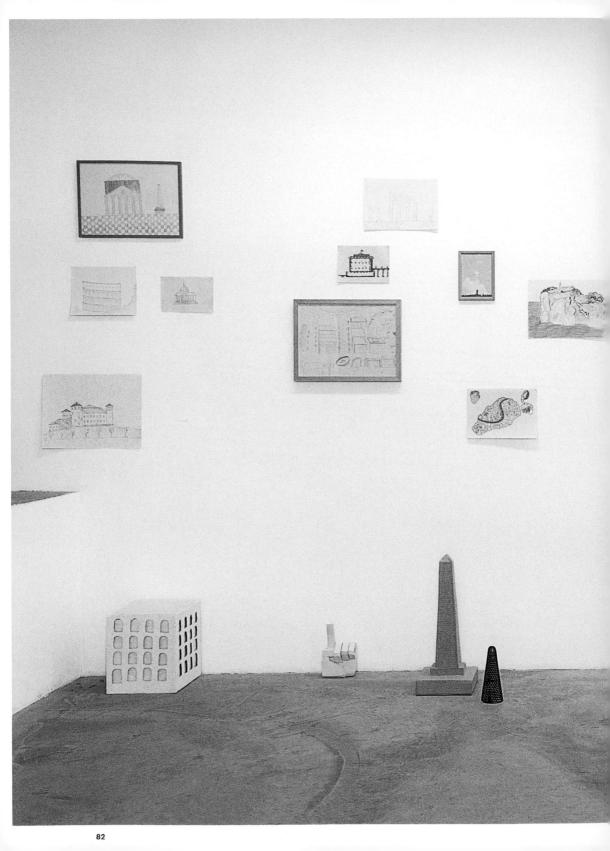

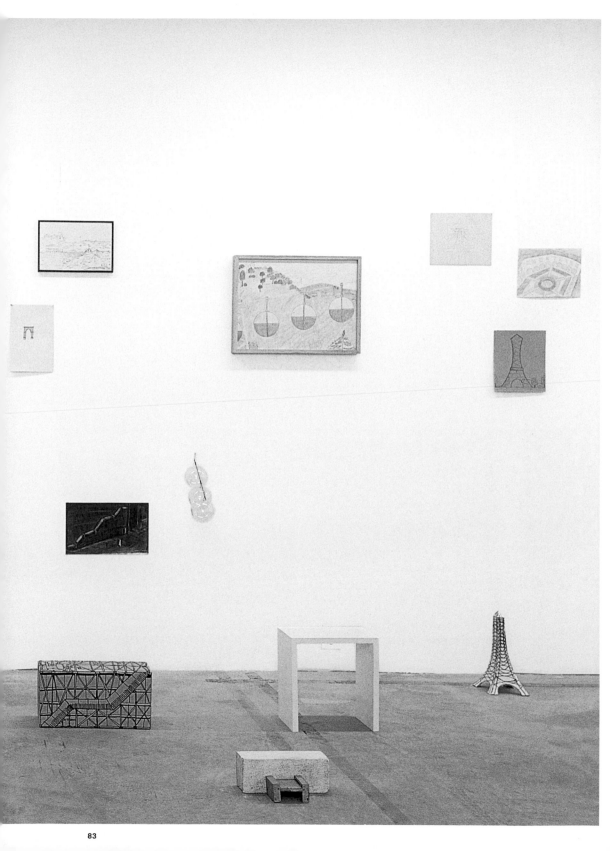

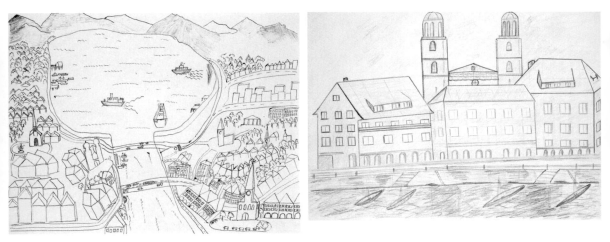

Common Trip, 2000

Zeichnungen und Gegenstände, die von
Menschen angefertigt wurden, denen Ondák
die einprägsamsten Orte, die er je besucht
hat, beschrieb.
(Detailansichten der Installation)

Drawings and objects made by people to whom
Ondák described the most memorable places he
had ever visited.
(Details of the installation)

S./pp. 82–85

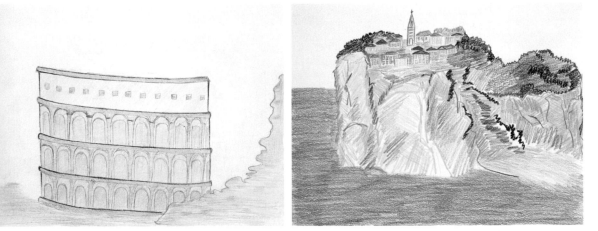

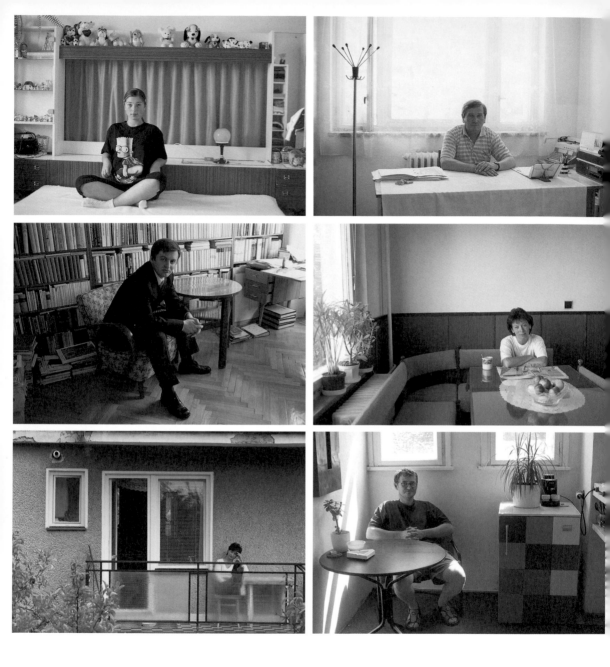

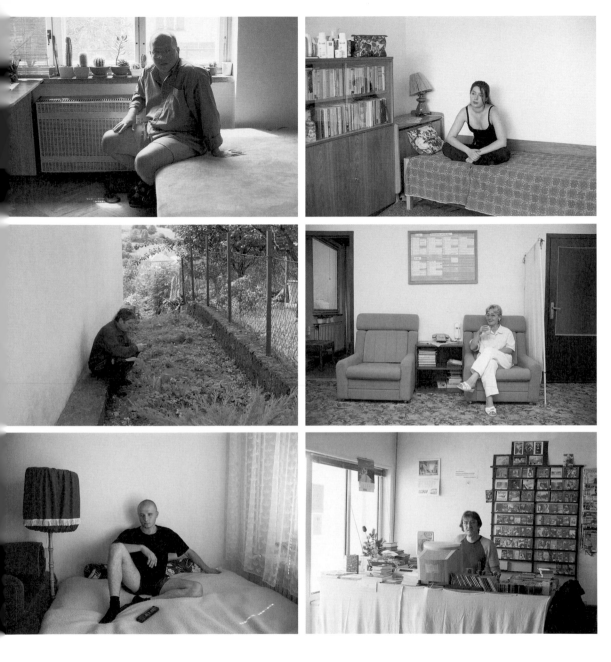

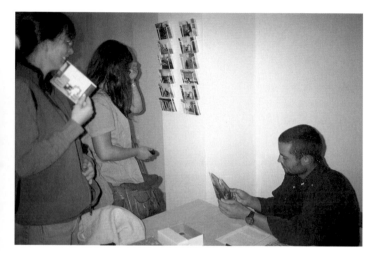

Antinomads, 2000

Freunde und Verwandte des Künstlers wurden gefragt, ob sie sich als Nomaden oder als Antinomaden verstehen. Fotografien derjenigen unter ihnen, die sich selbst als Antinomaden sahen, wurden in Serien mit jeweils 12 Postkarten gedruckt und bei Ausstellungen zur freien Entnahme aufgelegt.

Friends and relatives of the artist were interviewed as to whether they consider themselves to be either nomads or antinomads. Photographs of those who considered themselves to be 'Antinomads' were then published as a series of 12 postcards which were available to take away at exhibitions.

S./pp. 86–87

Antinomads, 2000

Installation in der Nationalgalerie, Prag und in
einem Zeitungskiosk in Bratislava

Installation National Gallery, Prague and
newsstand in Bratislava

S./pp. 88–89

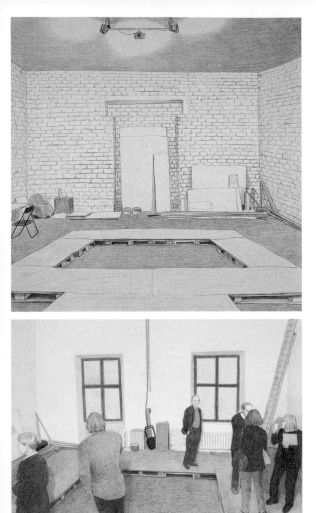

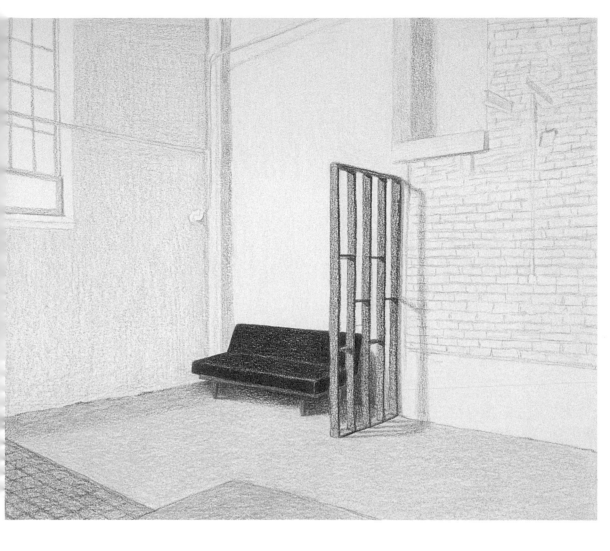

Drawn Retrospective, 2000
Serie bestehend aus 36 Zeichnungen, Farbstift auf Papier
Drawings from a series of 36, colour pencil on paper

Double, 2001

Genaue Nachbildungen der Schilder und Fahnen einer Galerie wurden an der Fassade eines gegenüberliegenden Gebäudes montiert.

Exact replicas of the gallery's signs and banners were mounted on the façade of a building across the street.

Dubbing, 2001

Serie von 30 Zeichnungen, die von den Verwandten Ondáks, basierend auf seinen Beschreibungen einer Gruppenausstellung, an der er teilnahm, angefertigt wurden.

Series of 30 drawings made by Ondák's relatives based on his description of a group exhibition in which he participated.

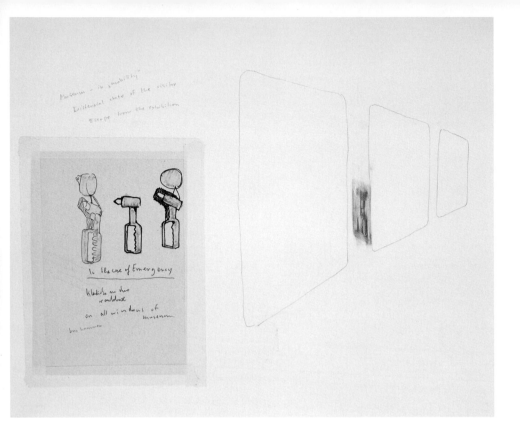

Untitled (Traffic), 2001

Tintenstift, Farbstift und Klebeband auf Papier
Pen, colour pencil and tape on paper

Untitled (Traffic), 2001

Hämmer von Notausgängen in öffentlichen Bussen
Installation in verschiedenen Einrichtungen, Slavonski
Brod, Kroatien

Bus emergency-exit hammers
Installation at various premises, Slavonski Brod,
Croatia

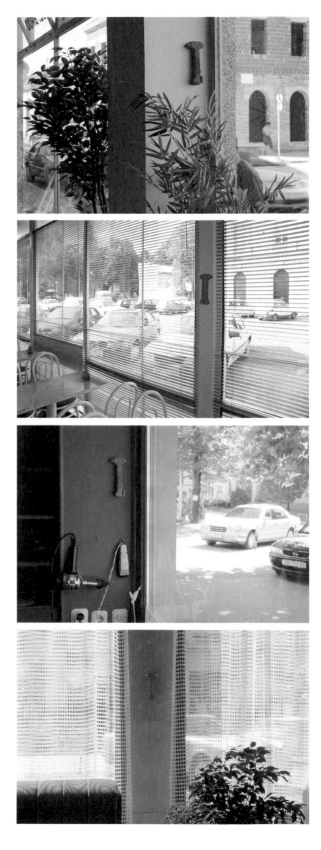

Hans Ulrich Obrist
im Gespräch mit Roman Ondák

Roman Ondák

Alle Zeichnungen, die da vor dir liegen, sind Arbeiten anderer Künstler, die mit mir in derselben Gruppenausstellung vertreten waren. Gezeichnet wurden sie von meinen slowakischen Freunden und Verwandten – basierend auf meinen Beschreibungen.

Hans Ulrich Obrist

Also eine Weiterentwicklung deiner Manifesta-Arbeit, die sich mit Monumenten beschäftigte?

Ja, so wie ich in *Common Trip* meine Erinnerungen an ferne Orte, die ich besucht hatte, neu erzählte, handelt diese Arbeit von meinen Erinnerungen an eine Ausstellung, an der ich teilgenommen habe. Eine weitere Arbeit von mir, *Double*, befand sich dort auf dem Gebäude gegenüber der Galerie. Ich hatte eine Kopie der Schilder und Transparente der Galerie machen lassen, die wir an der Fassade des gegenüberliegenden Gebäudes anbrachten. Das Haus beherbergt ein Yogazentrum, das erst am späten Nachmittag aufmachte und ansonsten tagsüber geschlossen war. Obwohl es für die Dauer der Ausstellung die gleichen Schilder trug wie die Galerie, war niemand irritiert, denn die Yogaübungen begannen immer erst kurz nach Schließung der Galerie.

Das sind Manifesta-Arbeiten?

Und dies hier sind meine Kommentare über sie. Ich notiere gern ständig alles mit.

Zeichnen ist für dich eine permanente Beschäftigung?

Ja. Und diese Zeichnungen von der Galerie waren für ein anderes Projekt gedacht, nämlich ein Projekt, das den leeren Ausstellungsraum thematisierte. Für diese Galerie sollte ich eine Einzelausstellung konzipieren. Ich beschrieb Leuten den leeren Ausstellungsraum der Galerie, die sie noch nie gesehen hatten. Daraufhin bekam ich von ihnen 24 Zeichnungen, und das waren die einzigen Arbeiten, die in der Galerieausstellung zu sehen waren.

Das heißt, du zeigst in der Tat den Raum. Wie kam es zu dieser Serie?
Du hattest ja vorher schon über das Thema Erinnerung gearbeitet – was war denn das erste Projekt dieser Art?

Das erste war *Untitled (Two Days in Stockholm)*, 1999 im Moderna Museet in Stockholm.

Da haben wir eine Fotografie.

Sie zeigt die Ausstellungsinstallation im Moderna Museet.

Das hier sind dies verschiedene Projekte?

Es sind Notizen über vielerlei Situationen, wobei ich nie weiß, ob sie einmal wichtig für mich werden oder nicht. Ich führe sie täglich. Egal, wo ich bin, wenn ich Zeitungen oder Bücher lese, mache ich Notizen oder kleine Zeichnungen und halte auf diese Weise Erfahrungen fest. Manchmal kann ich aus solchen Notizen eine Arbeit entwickeln, habe dabei aber immer etwas Immaterielles im Sinn. Zum Beispiel habe ich ein Projekt mit slowakischen Autos der Marke Skoda gemacht, das *SK Parking* hieß.

War das das Projekt für die Secession?

Ja, es war eine Zusammenarbeit mit Freunden und mit den Besitzern der Autos. Ich lieh mir Autos aus und bat meine Freunde, sie hinter das Secessionsgebäude in Wien zu fahren. Dort stellten wir die Autos ab und ließen sie zwei Monate stehen.

Die Autos gehörten, wenn ich es richtig verstehe, deinen Freunden?

Nein, die Autos wurden hauptsächlich von unbekannten Leuten zur Verfügung gestellt. Manchmal auch von Verwandten meiner Freunde. Viele der Autos waren noch in Gebrauch, auch wenn sie schon 15 oder 20 Jahre alt waren. Diese Skodas aus den späten siebziger Jahren sind in Bratislava immer noch eine prägende Erscheinung. Auf

den Wiener Straßen fehlen sie aber fast völlig. Es ist gar nicht so leicht, mit so einem Auto von der Slowakei über die Grenze nach Österreich zu fahren, und wenn man ins Zentrum von Wien kommt, werden die alten Skodas beargwöhnt, weil damit unvermittelt Armut assoziiert wird.

Das hier ist ein Druck?

Das ist einer der Offset-Drucke aus der Edition mit zwölf Postkarten, mit dem Titel *Antinomads.*

Ich meine mich zu erinnern, diese Postkarten bei Apex in New York gesehen zu haben.

Ja, sie waren dort ausgestellt. Später waren sie auch zusammen mit den Autos in der Ausstellung „Ausgeträumt…" in Wien zu sehen. Für dieses Projekt habe ich meine Freunde und Verwandten interviewt, möglicherweise sogar alle Menschen, mit denen ich in Beziehung stehe. Ich habe sie nach ihrer Einstellung zum Reisen gefragt. Alle zwölf Porträtierten haben eine negative Einstellung zum Reisen.

Alle?

Alle! Ich nannte sie „Antinomaden", und sie waren einverstanden, sich fotografieren und ihr Bild auf Postkarten drucken zu lassen. Also bat ich sie, sich einen Ort auszusuchen, an dem sie fotografiert werden wollten, und ließ von den Aufnahmen Postkarten machen, die die Ausstellungsbesucher mitnehmen konnten.

Spielt der Gedanke von Geschwindigkeit und Langsamkeit in deinem Werk eine Rolle? Die Arbeit mit den geparkten Autos lässt darauf schließen, dass Langsamkeit ein wichtiger Aspekt sein könnte.

Ja. Das Projekt beschäftigte sich eindeutig mit Bewegung, Aktion und dem Austausch von Räumen in der Zeit. Es ging um das Potenzial des Raumes überhaupt: Für mich war die Konstellation dieser Autos wie eine Momentaufnahme der „vorgefundenen Situation" in Bratislava. Da ich diese Momentaufnahme nun aber physisch nach Wien verlagerte, veränderte sich auch die Einschätzung, die die Leute von der Wirkung einer solchen Aktion hatten. Hin und wieder parkten daneben oder dahinter andere Autos; nur die Skodas fuhren nicht weg, weshalb sie zugleich jene festgefahrene, unbewegliche Situation reflektierten.

Die anderen Autos bewegten sich aber.

Ja, die anderen Autos bewegten sich, die Skodas aber nicht. Das könnte Passanten aufgefallen sein, ohne dass sie unbedingt wussten, dass es sich um ein Kunstwerk handelte.

Das erinnert ein wenig an jene Zeitkapselgeschichte, die wir heute Morgen an dem Mann beobachtet haben, der den Aufzug bedient. Vielleicht liegt hier ein ähnliches Phänomen vor.

Stimmt, der Mann im Aufzug begleitet einen in ein Café, das in einem Wahrzeichen utopischer Architektur der siebziger Jahre untergebracht ist – einer UFO-artigen Scheibe auf zwei Masten über der Donaubrücke in Bratislava, und dieser Fahrstuhl befindet sich in einem dieser Masten. Dieser Ort ist seit den siebziger Jahren absolut unverändert geblieben. Das heißt, man fährt hinauf, fährt aber zugleich auch zurück in die siebziger Jahre. Ich habe oft gedacht, dass dieser winzige Aufzug die Fähigkeit eines Zeitwandlers hat, zumal ich jahrelang immer denselben alten Mann sah, der ihn bediente. – An Autos interessierte mich, dass sie die Macht der Zeit zu spüren bekommen, wie ich selber sie ständig in Bratislava erfahre. So wie wenn man jeden Tag an einem auf dem Bordstein geparkten Auto vorbeigeht und sich, wenn das Auto zu lange da steht, fragt: „Wem gehört eigentlich dieses Auto? Warum steht es hier so lange?" So aktiviert sich das eigene Zeitbewusstsein. Die geparkten Autos bildeten für mich eine Situation, die das latente Bewusstsein der Passanten aktivieren könnte.

Interessant ist auch, dass auf den Wegstrecken der Menschen geparkte Autos als Auslöser wirken, wohingegen ein fahrender Wagen die Phantasie nicht so sehr in Gang setzt. Darin liegt etwas Paradoxes. Stimuliert wird im Grunde die Beweglichkeit dessen, was im Kopf der Menschen vorgeht. Was hat dich eigentlich bei den Arbeiten zu diesem Ansatz geführt, in denen du andere gebeten hast, anhand deiner Beschreibung einen Galerieraum zu zeichnen, also Arbeiten, in denen du Menschen, Vorstellungskraft und Erinnerung einbeziehst?

1998 habe ich eine Arbeit in Prag gemacht, in der ich mich auf verschiedene Erinnerungsmomente bezog und die Konstellation der drei Galerieräume veränderte. Dies war ein Versuch, etwas zu rekonstruieren, das vorher unsichtbar war, denn ich arbeitete ausschließlich mit Elementen, die in der Galerie bereits vorhanden waren. In einem Raum fertigte ich ein verkleinertes Modell vom Raum selbst, montierte alle Elemente von den umgebenden Wänden ab – Steckdosen, Lampen usw. – und brachte sie maßstäblich verkleinert in dem Modell an, so wie sie vorher an den Wänden

positioniert gewesen waren. Allerdings konnte man das Modell nicht betreten. Aufgrund des verkleinerten Maßstabs war die Türöffnung zu niedrig, um hindurchgehen zu können, aber die Wand immer noch zu hoch, um darüber hinwegzusteigen. In einem anderen Raum entstand ein umgestülptes Modell des Raumes, bei dem die Heizkörper an den Außenwänden angebracht waren. Im letzten Raum fertigte ich aus einem Teil der Blendwand der Galerie eine Bank. Dort konnte man sich hinsetzen und das Vogelhäuschen betrachten, das von außen an der Fensterscheibe befestigt war. In diesen Arbeiten interessierten mich die Bewegungen der Betrachter in Entsprechung zu den verschiedenen Zuständen meiner Erinnerung. Später dachte ich daran, Zeichnungen oder kleine Skizzen zu verwenden, durch die ein bestimmter Raum visualisiert oder erinnert werden kann.

Die Manifesta-Arbeit war also die erste, die aus diesem Ansatz hervorging?

Die erste Arbeit war *Untitled (Two Days in Stockholm)*, die ich nach meiner Rückkehr aus Stockholm machte; dann erweiterte ich die Idee in *Common Trip* auf die Orte, an die ich mich am deutlichsten erinnerte, und dies hier habe ich auf der Manifesta 3 gezeigt.

Was ist das?

Das ist Antimaterie. Steckdosen, die von der Wand abmontiert, in den Raum hineinbewegt und *Closer to Each Other* auf Stäben befestigt wurden. Das war etwas, das mich damals interessierte – die Vorher- und Nachhersituation; in diesem Fall waren es die Steckdosen in der Ausstellung, die entfernt wurden. Diese Art Verschiebung oder Verrückung würde ich beispielsweise mit dem Projekt mit den Autos in Wien vergleichen.

Welche Beziehung hast du zur konzeptuellen Praxis der sechziger und siebziger Jahre?

Ich mag viele Arbeiten aus dieser Zeit, aber mein Verhältnis zu ihnen und den damit verbundenen Praktiken ist für mich eher von sekundärer Bedeutung. Wenn ich arbeite, suche ich oft nach einem Potenzial, das sich aus meiner persönlichen Erfahrung oder einer Situation, in der ich mich befunden habe, entstehen kann, und schaue, ob es stark genug ist, als Quelle für meine Arbeit in Betracht gezogen zu werden.

Was ist dies für eine Arbeit?

Eine Arbeit mit Kindern. Sie heißt *Tomorrows*.

Das war doch die Ausstellung in Erlauf, in der kleinen Stadt in Niederösterreich, eine Stunde von Wien entfernt. Warst du in dieser Stadt?

Nach meinem ersten Besuch in der Stadt, als ich sah, wie winzig sie eigentlich war, fand ich, ich sollte versuchen, eine neue Situation zu schaffen, genauer gesagt, eine Veränderung der gegenwärtigen Situation der Stadt zu simulieren. Ich fragte mich, was herauskäme, wenn Kinder versuchen würden, wie künftige Repräsentanten der Stadt auszusehen. Sie würden den Altersunterschied simulieren, gleichzeitig aber könnten sie in dreißig Jahren tatsächlich solche Repräsentanten sein. Ich ging mit ihnen an mehrere Stellen, die ich auf Fotografien gesehen hatte, echten und vor Ort bekannten Fotografien aus der jüngeren Geschichte der Stadt, auf denen Lokalpolitiker vor der Kamera posierten. Ich bat die Kinder, dieselbe Situation, dieselbe Gestik zu simulieren. Von diesen Fotos machte ich Plakate, die ich überall in der Stadt aufhängte. Mir fiel wieder einmal auf, dass dies charakteristisch für die Verschiebung war, die ich vorher mit meinem skulpturalen Werk angestrebt hatte, aber es hing stärker noch mit meinem Interesse an gemeinschaftlichen Projekten zusammen, in die andere Menschen einbezogen und die offener für die verschiedensten Interpretationen sind. Wie sie am Ende aussehen, ist zu Beginn des Projekts immer sehr ungewiss.

Ob man sie nun als Kunst im öffentlichen Raum oder als Denkmäler betrachtet, jedenfalls scheinen deine Projekte auf einer Strategie der Infiltration zu beruhen. Könntest du mir sagen, wie du darüber denkst?

Weil hier Kinder einbezogen wurden, die in dieser Stadt leben, war ich mir sicher, dass diese Infiltration in ihr gesellschaftliches Umfeld und in ihren privaten Familienhintergrund auf sehr kommunikative Weise Fragen evoziert. Sie konnten sich selber auf den Plakaten sehen und das machte ihnen Spaß. Manche waren sehr stolz darauf, von Erwachsenen auf den Plakaten gesehen zu werden. Ich fand, das war das Gegenteil vieler Kunstwerke im öffentlichen Raum, die eben die Menschen nicht so stark einbeziehen.

Realisierst du zurzeit ähnliche Projekte wie *Tomorrows*? Die Postkarten haben ja offenbar auch mit dieser Strategie zu tun.

Ja, die Postkarten folgen einer ähnlichen Strategie, weil darin die Gesellschaft, aus der ich komme, miteinbezogen ist. Die Postkarten zeigen Menschen aus Bratislava bzw. der Slowakei. Sie erlangen aber erst ihre Bedeutung, wenn sie von jemandem

„aktiviert" werden, indem er sie als Postkarte verschickt. Dann entstehen Beziehungen zwischen dem auf der Postkarte Porträtierten, der Person, die sie auswählt und versendet und dem potenziellen neuen Empfänger der Karte. – Ein weiteres Projekt, von dem ich dir schon erzählte und das ich im Kölner Museum Ludwig vorgestellt habe, heißt *Announcement* und wurde mit dem Slowakischen Radio produziert. Zusätzlich zum Inlandsprogramm strahlt der Radiosender eine kurze internationale Nachrichtensendung in mehreren Weltsprachen aus. So kann man zum Beispiel in Deutschland einmal täglich Nachrichten aus der Slowakei in deutscher Sprache hören. Manche nichtmuttersprachliche Nachrichtensprecher, die dort arbeiten, haben einen starken Akzent, und meine Idee konzentrierte sich darauf. Ich dachte, wenn die Sprecher sich in einer Fremdsprache ausdrückten, könnte sich ein kleiner Fehler im Sprechtext einschleichen und den Sinn der ausgestrahlten Mitteilung verändern. Ich arbeitete mit einem der Nachrichtensprecher, und wir zeichneten eine echte Nachrichtensendung auf. Ich bat ihn, im Anschluss daran den Satz einzufügen: „Wir bitten um Ihre Aufmerksamkeit für die folgende Durchsage: Als ein Zeichen Ihrer Solidarität mit den jüngsten Ereignissen in der Welt bitten wir Sie, die Tätigkeiten, die Sie gerade ausüben, für die nächste Minute nicht zu unterbrechen." Im Museum war die Sendung eine Fiktion: Wir hatten alles auf CD aufgenommen. Die Durchsage wirkte ziemlich selbstverständlich, war aber eigentlich alles andere als klar. Und da sie den Fehler enthält, seine Tätigkeit *nicht* zu unterbrechen, bat ich eigentlich die Menschen, das, was sie in der Ausstellung gerade taten, weiter zu tun. Sie konnten sich also die Ausstellung anschauen, herumgehen oder was auch immer, wobei aber die Durchsage als eine Art Anti-Mitteilung diente, denn ich bat sie ja, *nicht* aktiv zu sein, aktivierte dabei aber eigentlich ihr Verhalten. *Announcement* war auch einer der Beiträge, die ich dir für „Do it" geschickt habe, weil sich eine solche Aufforderung ebenso gut für die Verbreitung im Netz eignet.

Vielleicht können wir sie uns einmal anhören.

Ja. Was mich hier interessierte, war meine Position als Anti-Autor, denn die Arbeit reflektierte auch, wie ich den Raum mit anderen Menschen, in diesem Fall den Ausstellungsbesuchern, teile, und nachdem der Sinn der Mitteilung verändert worden war, reflektierte diese nun deren Anwesenheit und Bewegung im Ausstellungsraum.

Was kommt jetzt?

Das ist eine Skizze, die ich von *Las Meninas* gemacht habe. Zu einem bestimmten Zeitpunkt habe ich mich sehr für dieses Gemälde interessiert – besonders für die gespiegelte Situation der tatsächlichen Position des Königs und der Königin, die sie

mit den Betrachtern, die das Bild anschauen, teilen. Die Skizze liegt noch hier, weil ich mich kürzlich wieder mit einer Arbeit beschäftigt habe, die 1999 im Ludwig Museum in Budapest entstand: Sie hängt mit einer Idee zusammen, einen anderen Raum in die Ausstellung einzubringen, und die Küche des Museumsrestaurants war Teil dieser Arbeit.

Announcement-CD: der Nachrichtensprecher spricht.

Die Mitteilung wird alle viereinhalb Minuten übertragen, sobald die Nachrichten zu Ende sind. Dann folgen erneut die Nachrichten, anschließend wieder dieselbe Mitteilung, und das geht in einer Endlosschleife so weiter.

Das heißt, eine Infiltration könnte in jedweder Radiostation stattfinden.

Theoretisch schon. Deshalb habe ich mich von einer Radiostation anregen lassen, die versuchte, mehr Einfluss zu gewinnen. Dies hier ist ein Foto des Studios des „International Radio Slovakia", wo wir die Tonaufnahmen gemacht haben.

Das ist das Gegenteil der Idee, das Verhalten der Menschen manipulativ beeinflussen zu wollen, oder nicht?

Ja, das ist das Gegenteil davon.

Es ist Anti-Manipulation. Es ist eigentlich so etwas wie ein „Tu es!" und „Tu es nicht!" zugleich.

Genau.

Weil du den Leuten nicht sagst, was sie tun sollen.

Ja. Aber das hängt eben auch mit dem Versuch zusammen, jemandes Wahrnehmung zu führen oder zu beeinflussen und dadurch seine Vorstellungskraft zu steigern. Da gibt es auch eine Ähnlichkeit zu dem Projekt, bei dem ich daran interessiert war, mit Menschen zu arbeiten, die ich bat, anhand meiner Beschreibungen Zeichnungen für mich zu machen, sodass sie gewissermaßen durch meine Beschreibungsfähigkeit angeleitet wurden. In einer anderen Arbeit, *Guided Tour*, die in Zagreb entstand, habe ich, anstatt die Ausstellungsräumlichkeiten mit Kunstwerken zu füllen, eine professionelle Führerin angestellt, die die Ausstellungsbesucher durch die leere Galerie führte und ihnen anschließend einen kleinen Platz gegenüber der Galerie zeigte.

Das war also das Projekt, das du mit WHW gemacht hast?
[WHW: What, How and for Whom?, in Zagreb ansässiges Kuratorenkollektiv. A.d.Ü.]

Ja, das war im Mai. Da auf der Einladung eine „Führung" angekündigt war, versammelte sich drei Mal täglich Publikum im Galerieraum. Zu Beginn des Rundgangs sprach eine professionelle Führerin über die Galerie. Sie stellte auch eine Frau vor, die mehrere Jahre dort gearbeitet und Eintrittskarten und Kataloge verkauft hatte. Ein paar Minuten später führte sie die gesamte Gruppe aus dem Galerieraum heraus, und es ging auf dem Platz weiter. Ihre Erläuterungen galten nun keineswegs irgendwelchen historischen Aspekten des Platzes, sondern bezogen sich auf das heutige Leben auf diesem Platz und die Menschen, die dort jeden Tag arbeiteten. So hatten wir es mit ihnen abgemacht: Wir hatten vorher mit ihnen gesprochen und das Ganze als Performance einer Führung bzw. einer Führerin und ganz normalen Menschen auf dem Platz organisiert.

Im Grunde genommen hast du also die Realität des Platzes zum Kunstwerk erklärt.

In einem gewissen Sinn schon, aber ich habe die Gruppe ja auch in den leeren Raum der Galerie gebracht, und da die beiden Räume auf eine bestimmte Weise zusammenhingen – die Führerin sprach über die leere Galerie und den Platz draußen mit der gleichen Gewichtigkeit und Ernsthaftigkeit –, nahm ich an, dass die Besucher, nachdem sie die Situation besichtigt hatten, die beiden Realitäten zu einer Erfahrung verschmelzen könnten. Die Besucher waren in der Galerie bzw. der „Ausstellung" und machten im weiteren Verlauf eine Erfahrung, die auf einer ähnlichen Beschreibung der Realität draußen beruhte, sodass sie ihre Enttäuschung über die fehlenden Werke in der Galerie mit Hilfe dieser „wirklichen Erfahrung" ausgleichen konnten. – Derzeit arbeite ich an einem weiteren Projekt, bei dem ich einen zwölfjährigen Jungen dazu einladen möchte, einen Touristenführer zu spielen. Ich werde seinen Text vorbereiten, und wir werden die gesamte Rede des Guides in die Zukunftsform setzen. Der Inhalt seiner Erläuterungen wird also ein hypothetischer sein, insofern er über Dinge spricht, die man erst in der Zukunft würde erfahren können.

Das ist für eine andere Stadt vorgesehen? Wo soll es stattfinden?

In Zadar in Kroatien, einer sehr touristischen Stadt, und wir arbeiten auch mit einem gleichsam touristischen Ansatz. Diese Rundgänge bewegen sich zwar grundsätzlich außerhalb jedweder Tourismusstrukturen, sind aber in ihren Methoden touristisch angelegt. In Zagreb wollte ich gründlich vorgehen: Anstatt allen, die im Verteiler der Galerie stehen, Einladungskarten für die Ausstellung zu schicken, sandten wir ihnen Ankündigungskarten für unsere Führungen, gleichzeitig haben wir aber auch eine

Menge davon in Bahnhöfen und Busbahnhöfen, Tourismusbüros usw. ausgelegt, weshalb ich davon ausgehen konnte, dass sich unter die Gruppe der Ausstellungsbesucher auch andere Gruppen mischten.

Eine Verquickung verschiedener Arten von Publikum also.

Aber nur bis zu dem Zeitpunkt, an dem die Leute von der Touristenseite merkten, dass sie Teil eines Kunstereignisses waren.

Ich möchte gern noch etwas mehr über deine Zeichnungen erfahren, die ich immer blockweise in Ausstellungen kennen gelernt habe – wie zum Beispiel im Konzept der Erinnerung des Ausstellungsraums –, aber ich wusste nicht, dass du selbst so viele andere Zeichnungen anfertigst. Ich habe mich gefragt, ob dies eine Tätigkeit ähnlich dem Aufschreiben in Notizbüchern ist. Du hast da lauter verschiedene Zeichnungen, sind das nun Projekte, Ideenskizzen? Du sagtest vorhin, dass du ständig damit beschäftigt bist.

Ja, eine permanente Tätigkeit. Sie fungieren als meine Notizen. Sie berühren sich beispielsweise nicht mit den anderen Arbeiten, bei denen ich nicht eingreife. Diese Zeichnungen, diese Notizen habe ich noch nicht gezeigt.

Warum nicht?

Ich weiß es nicht. Vielleicht kann ich sie hier als meine eigene permanente Privatausstellung betrachten, anders als diejenigen, die für eine Öffentlichkeit gedacht sind.

Das alles ist reine Privatbeschäftigung?

Ja, und dies hier ist eine weitere Privatbeschäftigung. Da sammle ich Ausschnitte.

Ein weiteres Archiv.

Das ist ein Archiv für Notizen und Ausschnitte. Da vermischt sich alles, das ist ein Strom von Bildern. Ich sammle sie und versuche dann, Verbindungen zu finden, aus denen ich eine Quelle für meine Arbeit gewinnen kann. Hier habe ich etwa „Film", „Beziehungen", „Flug" …

Es handelt sich um so etwas wie deinen Atlas?

Ja, und er steht in enger Verbindung mit den Zeichnungen und ist wie sie vorwiegend zum Privatgebrauch gedacht.

Das erinnert mich an Aby Warburg: Er griff lauter verschiedene Elemente aus Geschichte und Gegenwart heraus und stellte sie simultan in einen Raum. Er sagte, die Kunstgeschichte solle keine Geschichte von Bildern sein oder jedenfalls nichts Lineares, sondern ein Raum der Simultaneität. Diese Bücher gleichen solchen simultanen Räumen.

Meine Archivverknüpfungen dienen mir als eine Art Generator einer Parallelwelt. Schau, diese Zusammenstellung ist über Erlauf. Ich habe Informationsmaterial mit den ganzen Fotos gefunden, auf denen die wichtigsten Ereignisse im Leben der Stadt dokumentiert waren. Zu diesem Zeitpunkt interessierte ich mich für Denkmäler und beschloss, dieser Quelle nachzugehen.

Und wie ging es weiter?

Das sieht man auf dieser Fotografie: ein Treffen von Generälen des Zweiten Weltkriegs fünfzig Jahre danach vor diesem russischen Denkmal. Auf der anderen Straßenseite befindet sich ein weiteres, von Jenny Holzer gestaltetes Denkmal, also kehrte ich die frühere Situation um, ließ kleine Mädchen vor diesem Denkmal stehen und machte davon eine Aufnahme.

Das heißt, es gibt die Karteien mit deinen Projekten, und dann die Karteien sozusagen der verschiedenen Typologien, Gruppen, Beziehungen, viele Archive, ein Archiv.

Jeder Tag ist ein kontinuierlicher Strom von Situationen, die aber häufig unsichtbar sind. Deshalb zeige ich auch nichts von diesen Notizen oder aus diesem Archiv oder anderes aus diesen Zusammenstellungen, weil sie ganz einfach so etwas wie der gewöhnliche Strom der täglichen Zufälligkeit sind. Mir kommt es im Moment mehr darauf an, herauszufinden, ob in diesen Beziehungen ein unsichtbares Potenzial steckt.

Welche Beziehung hast du zur Utopie?

In Bratislava zu leben, ist für mich sehr wichtig, denn hier spürt man sozusagen immer eine vakante Situation. Es gibt etwas, an das viele hier glauben: Dass in der Zukunft etwas eintreten oder sich verändern wird. Andererseits sind die Menschen aufgrund der jüngeren geschichtlichen Entwicklungen vielfach desillusioniert, und obwohl Utopie ein Wort ist, das in Diskussionen nicht oft ausgesprochen wird, hat doch fast jeder sie im Hinterkopf.

Als ein „Prinzip Hoffnung"?

Als ein Prinzip Hoffnung, und ich glaube, meine Arbeit mit Autos hatte in gewisser Weise auch mit diesem Thema zu tun, weil sie ein Zeichen für die Hoffnung auf Veränderung war, oder ein Zeichen, dass man wenigstens etwas demonstrieren kann, dass man die Chance hat, etwas zu visualisieren. Ich möchte dir gern die kleine Zeichnung hier zeigen. Über den Köpfen der Menschen steht in großen Lettern „Utopia". Das ist nur eine fiktionale Vision. Diese Utopie wäre eine Bedrohung. Sie schwebt an Fäden aufgehängt im Raum. Und in dieser Zeichnung hier können wir versuchen, wenn wir etwas verändern wollen, ein Anagramm daraus zu machen: „Enttäuschung über die Gegenwart". Den Menschen zuzuhören, die Zeitung zu lesen und immer wieder Äußerungen von Enttäuschung und dergleichen mitzubekommen, veranlasst mich dazu, sie als eine potenzielle Energie wahrzunehmen.

Das bringt mich zu einer abschließenden Frage, die ich dir gerne stellen möchte. Es ist die einzige Frage, die ich immer in allen Interviews stelle: die Frage nach dem unverwirklichten Projekt. Welches ist dein utopisches Projekt? Hast du Projekte, die zu groß sind, als dass sie zu realisieren wären, oder zu klein, oder die vielleicht sogar zensiert worden sind? Was sind deine nicht-realisierten Projekte?

Ich hatte einmal eine Idee für Brno. Ich war zu einer Ausstellung in dem Kloster eingeladen, in dem Mendel war. Kennst du das?

In diesem Kloster wurde während des Kommunismus die einzige religiöse Zeremonie abgehalten.

Richtig, da war also dieses Kloster und Mendels ganze Geschichte, und ich war zu der Ausstellung eingeladen, die ihm gewidmet sein sollte. Mein Vorschlag war sehr einfach, wurde aber nie verwirklicht. Genauer gesagt, er wurde abgelehnt, weil ich ein Objekt aus einem Hof in Bratislava in die Hofsituation von Mendels Kloster bringen wollte. Ich kann dir ein Foto zeigen, auf dem man einen Eindruck davon bekommt. In vielen Wohnvierteln von Bratislava standen seit den sechziger und siebziger Jahren in den Höfen Kugelgerüste aus Eisen. Man findet sie auf Spielplätzen, und die Kinder klettern auf ihnen.

Und du wolltest es als Ready-made zeigen?

Ja, so wie es war. Es sollte dasselbe Ding bleiben, immer noch für denselben Zweck, wieder in einem Hof … Nur eben verlassen, weil es in dem Männerkloster keine Kinder gibt. Obwohl wir nie über die Abwesenheit von Kindern an solchen Orten nachdenken, würde die Anwesenheit eines solchen Objekts mitten auf dem Klosterhof Fragen über

die Regeln der Kirche aufwerfen, der diese Gemeinschaft angehört. Also dachte ich, das verlassene Objekt, das die ganze Zeit über verlassen dagestanden hätte, wenn das Projekt verwirklicht worden wäre, könnte eine Grundstruktur für diese unmögliche Aktivität bilden – oder so etwas wie eine potenzielle Aktivität, die nicht in Erfüllung gehen kann, nur weil das System sie nicht erlaubt.

Ein abgelehntes Projekt also.

Ja.

Das führt eigentlich zu einer Frage, die ich schon früher stellen wollte, nämlich zur Wissenschaft bzw. deinem Verhältnis zur Wissenschaft. Denn du warst ja in Zürich am Helga-Novotny-Institut, und als wir uns zum allerersten Mal trafen, bei der Manifesta 1, war deine Arbeit im Naturhistorischen Museum zu sehen. Wie sieht also dein Verhältnis zur Wissenschaft aus?

Seit meiner Zeit als Student an der Akademie war ich an täglicher Forschungsarbeit interessiert, so als stünde sie mit der Wissenschaft in Verbindung, ohne mich aber allzu sehr darauf einzulassen. Es gibt bei der Aufnahme von Wissen Grenzen, wo es besser für mich ist, nicht mehr über etwas zu wissen, als ich unbedingt brauche, und genügend Raum für die Intuition zu lassen.

Es diente dir als Inspiration?

Ich stelle diese Forschungen an, aber nur bis zu dem Grad, an dem ich noch das Gefühl habe, dass es interessant ist, sie als die Tätigkeit eines Amateurs aufzufassen. Deshalb beziehe ich auch so gerne Zeichnungen von Amateuren in meine gemeinschaftlichen Projekte ein. Ich mag einfach den Freiraum, der den anderen dabei gelassen wird. Ich zeige dir jetzt ein Beispiel von meinen Pseudo-Forschungen. Die Arbeit, die ich in Budapest anhand einer Küche gemacht habe – hier ist das Foto –, hieß *Through the Eye Lens*. Dieser Teil der Wand dort wurde herausgesägt, um einen Durchbruch zur Küche des Museumsrestaurants zu schaffen.

Ein Teil der Wand?

Es war nur eine Rigipswand, die diese beiden Räume voneinander trennte. Ich schützte das Loch mit einer Art Zelt und stellte einige Tage lang vor der Öffnung der Ausstellung archäologische Ausgrabungen in der Küche an. Ich ging durch die Zelt-Öffnung hinein und brachte Objekte in die Ausstellung, die nach dem Kochen in der

Küche liegen geblieben waren, etwa leere Bierdosen, Plastikflaschen oder Zucker-
würfel. Von der Seite des Ausstellungsraumes aus wussten die Besucher vorher nicht,
dass dort eine Küche war, denn der Eingang zum Restaurant lag weit weg, auf der
anderen Seite desselben Stockwerks. Doch als ich die Öffnung in die Wand machte,
konnte man sich dieser Verbindung bewusst werden, nicht nur über die gewöhnlichen
Objekte, die ich hereinbrachte und auf dem Boden liegen ließ, sondern ebenso durch
den Essensgeruch oder die Geräusche beim Geschirrspülen, die durch die Öffnung
eindrangen, aber auch, indem man die eine oder andere Bewegung der hinter der
Wand arbeitenden Menschen sah. Diese beiden Realitäten – die bewegungslose der
wie auf einer Fotografie eingefangenen Fundobjekte und die fortlaufende, die sich
durch die Öffnung beobachten ließ, verliefen parallel, aber in einem gewissen Sinn
zueinander diskontinuierlich.

Das fällt vielleicht unter die Kategorie Alltagswissenschaft.

In gewissem Sinn liegt es auf der gleichen Ebene wie meine Notizen oder Ausschnitt-
Sammlungen. Diese beiden Bilder hier sind von einer Performance, die ich vor kurzem
in einem anderen Raum gemacht habe.

In Prag?

In der Spala-Galerie in Prag. Eine der beiden Arbeiten, *Tickets, Please*, entstand in
Zusammenarbeit mit einem alten Eintrittskartenverkäufer, den ich seit vielen Jahren
gut kenne. Er hat einen Enkel, der jetzt elf Jahre alt ist. Ihn habe ich eingeladen, in
der Galerie gemeinsam mit seinem Großvater Karten zu verkaufen, wobei aber jeder
seine Kasse auf einem anderen Stockwerk haben würde. Im Obergeschoss fertigte ich
eine exakte Kopie der Arbeitsumgebung des Großvaters – einer festen Installation im
Erdgeschoss – an und bat ihn, in diese Replik im ersten Stock umzuziehen. Sein frühe-
rer Arbeitsplatz im Erdgeschoss wurde dann mit seinem Enkel besetzt, der dort Karten
und Kataloge verkaufte. Die Besucher zahlten erst einmal die Hälfte des normalen
Eintrittsgeldes an den Enkel, wenn sie dann ins Obergeschoss kamen, den Rest an
den Großvater. Die zweite Arbeit, *Teaching to Walk*, war eine Zusammenarbeit mit
einer Freundin, deren Sohn damals gerade ein Jahr alt war und die in der Nähe der
Galerie wohnte. Ich bat sie, täglich um zwei Uhr nachmittags in die Galerie zu kommen
und ihrem Sohn dort eine halbe Stunde lang das Laufen zu lehren. Sie war in der Rolle
einer Besucherin, wurde aber wegen dieser Beschäftigung zu einem weiteren Blick-
punkt, ganz wie die anderen Kunstwerke in der Galerie. Die Beziehung der beiden
Performer – Mutter und Sohn – zum Raum, den sie jeden Tag bespielten, unterlag
einem ständigen Wandel. Im Fortgang der Ausstellung lernte das Kind immer besser
laufen.

Hans Ulrich Obrist in Conversation with Roman Ondák

Roman Ondák

These drawings are all about works by other artists which appeared together with me in the same group show. My friends and relatives in Slovakia drew them based entirely on my descriptions.

Hans Ulrich Obrist

So it's a development of what you did in Manifesta about the monuments?

Yes, in the same way that in *Common Trip* I retold my own recollections of faraway places I'd visited in the past, this work was about my own recollections for a show I'd participated in. Another piece of mine there, *Double*, was on the building opposite the gallery. I had a replica made of the gallery's signs and banners and we installed it on the façade of the building across the street. That building housed a yoga centre which opened late in the afternoon and was otherwise closed during the day. Although it had the same signs as the gallery for the duration of the show, nobody was disturbed because the evening yoga exercises began just after the gallery closed.

These are Manifesta pieces?

Yes. And these are my comments on them. I like to be continuously making notes.

So drawing is a permanent activity?

Exactly. And these drawings of the gallery were for another project, which was the one with the empty gallery space. I described to people who had never seen the gallery –

where I was invited to conceive my solo exhibition – what the empty space inside looked like. I then got from them twenty-four drawings and these were the only works in the space of the gallery during the exhibition.

So you showed the space, in effect. How did this series start? You'd worked with the topic of memory before that – what was the first project of this type?

The first one I did was *Untitled (Two Days in Stockholm)* in 1999 at the Moderna Museet in Stockholm.

That's another one of the photographs.

This is a picture of the way it was installed.

These are all different projects.

They're notes of lots of situations – I don't know whether they'll be important for me or not. I do them every day. As I'm reading newspapers or books, I'm making notes or doing small drawings absolutely anywhere and recording experiences in this way. Sometimes I can generate a piece of work from such notes, but I always try to make it something immaterial. For example, I did a project with Slovak Skoda cars, called *SK parking*.

That was the project for the Secession?

Yes, it was a collaboration with some of my friends and the owners of the cars. I borrowed a number of them and asked my friends to drive them to the car park behind the Secession in Vienna. We parked the cars and left them there for two months.

So the cars belonged to your friends, in fact?

No, the cars were mainly from other people, sometimes from relatives of my friends and so on. The people I borrowed them from were still using them quite often, although they bought them 15 or 20 years ago. These Skodas from the late seventies are still visually very present in Bratislava, but almost completely absent from Viennese streets. It's not easy to cross the border between Slovakia and Austria with this kind of car, and if it reaches the centre of Vienna, it immediately becomes the object of suspicion because everyone associates it with poverty.

This is a print?

That's one of the offset prints from an edition I made: twelve postcards called *Antinomads*.

I remember seeing these cards at Apex in New York.

Yes, that's right, they were on show there. They also appeared later, along with the cars, in the show (Ausgeträumt…) at the Secession. For this project I interviewed all my friends and relatives, perhaps all the people I have some relationship with, asking them questions about their attitudes to travelling in general. All these twelve people had a negative attitude toward travel.

All of them?

All of them! I called them 'antinomads' and they agreed to have their photos taken and put on postcards. So I asked them to select a place where they wanted to be photographed, and then I had the shots made into postcards that were given away free to visitors during the exhibition.

And would you say that notions of speed and slowness play a role in your work? The work with the parked cars certainly suggests that slowness might be a factor.

Yes, that's true. The project was definitely concerned with motion, action and exchange of spaces over time. It was about the potential of space in general: for me the constellation of these cars was like a snapshot of the 'found situation' in Bratislava. Since I physically displaced this snapshot to Vienna, it then led people to think differently about the effects of the action. From time to time other cars would park next to them or behind them, and it was only the Skodas that didn't move, so they also reflected this fixed, motionless situation.

The other cars moved.

The cars moved but these didn't, and this was something that passers-by might notice without them necessarily knowing that this was a work of art.

That's a bit like the time capsule thing, I mean the thing we observed this morning with the guy who operates the lift. It's a similar phenomenon, perhaps.

Right, this guy in the lift takes you up to the café that's in one of the symbols of our Utopian architecture of the seventies, a UFO-shaped disc built on two pylons over the Danube bridge, and this elevator is inside one of these pylons. Absolutely nothing about this place has changed since the seventies. So you go up, but at the same time you're going back to the seventies as well. I've often thought about this tiny elevator having the ability to transform time, and especially when I always saw the same old man operating it for years. With cars I was interested in the fact that they sense the potency of time that I experience myself all the time in Bratislava. Like when everyday you go past a car that is parked on the pavement, and if the car's been there too long you ask yourself: 'Who's the owner of this car? Why has it been here for so long?' So you activate your own awareness of time. This situation of stationary cars was for me something that might activate the potential awareness of passers-by.

And it's interesting that parked cars act as triggers during people's journeys, as opposed to a moving car that doesn't trigger the imagination in this way. There's something paradoxical about this. It actually encourages a mobility in terms of what's happening in people's minds. With works such as the one in which you asked people to draw the gallery space based on your description of it – works in which you involve people, imagination and memory – what was it that led you to this approach?

I did a piece in Prague in 1998 in which, referring to different states of my memory, I changed the constellation of the three gallery rooms. It was an attempt to reconstruct something that had previously been invisible because I was working only with elements that already existed formally in the gallery. In one room I made a reduced model of the room itself, dismounted all the elements from the surrounding walls – such as electric sockets, lamp etc. – and reinstalled them on this model in the same proportions, scaled down, as they had had on the walls before, but people couldn't enter the model. Because of its reduced scale, the door opening was too low to walk through, but the height of the wall still too high to be able to step over. In another room an inside out model of the room was made, with radiators mounted on its outside walls. In the last one I made a bench from part of the gallery's false wall. People could sit on the bench and look at the birdhouse which was attached from outside to the window pane. In these pieces I was interested in the movement of spectators according to different states of my memory. Later on I thought of using drawings or small sketches by which a certain space could be somehow visualised or memorised.

Was the Manifesta piece the first work that resulted from this?

The first piece was *Untitled (Two Days in Stockholm)*, I did it after my return from that city, then I did an extension of the idea in *Common Trip* about the places I remember-ed most, and this I showed at Manifesta 3.

What's this?

This is anti-matter. Electric sockets dismounted from the wall, moved into the space and fixed on sticks *Closer to Each Other*. This is something I was interested in at the time – the before and after situation; in this case it was the sockets in the exhibition that were removed. This type of shift or displacement is something I would compare to the car project, for example.

What's your relationship to the conceptual practice of the '60s and '70s?

I like many of the works of the period to which you're referring, but my relationship to them and to the practices which accompanied them is rather something that I keep in my mind as background information. When I'm working, I'm often searching for the potency that can result from my personal experience or a situation I found myself in, whether in such a case it's intense enough to provoke me to think about it as a source for my work.

Which piece is this?

It's one with a group of children. It's called *Tomorrows*.

That was in Erlauf, the show I saw in a small town in Niederösterreich, an hour from Vienna. Did you visit that small town?

After my first visit of the town, when I saw how very small it was, I realised that my intention should be to try to make a new situation, or more precisely, to simulate a change of the present situation of the town. I wondered what it would be like if chil-dren were to try to appear like future representatives of the town. They would be simu-lating the age difference, but at the same time they could actually go on to be those representatives in reality in thirty years' time. I went with them to several places which I saw on photographs, on real and locally well-known photographs of the town's recent history, on which local representatives were posing in front of cameras. I asked the children to simulate the same situation, the same gestures. From those photos I made posters which I put up throughout the town. That again struck me as being character-istic of this shift that I'd been addressing through my sculptural works earlier, but it

was more connected with my interest in collaborative projects in which other people are involved and which are more open to all kinds of interpretation. How it ends up looking is very much open at the start of the project.

Whether considered in terms of public art or monuments, your projects appear to rely on a strategy of infiltration. Could you tell me about your thoughts on this?

I was sure that by involving real children from the city this infiltration into their social lives and private family backgrounds would open up some very communicative ways of asking questions. They were able to see themselves on the posters and they enjoyed that. Some of them were very proud to be seen by adults on the posters. This was something I thought was the opposite of many public art pieces that don't involve people in such a way.

And do you have other projects going on at the moment similar to *Tomorrows*? The postcards also seem to be connected to this strategy.

Yes, the postcards are a similar strategy because my own community was involved. They show people from Bratislava or Slovakia, but primarily these postcards acquire meaning after they've been 'activated' by somebody who takes them from a gallery and eventually sends them to somebody else. Then you begin to find relationships between someone who's on the postcard, the person who chose and sent it, and the possible new receiver of the card. Another project I was telling you about and which I did at the Museum Ludwig Cologne is called *Announcement*, and was realised at Slovak Radio. In addition to its main domestic service, the station provides a short daily international broadcast in several world languages. So it's possible to tune to it in Germany, for example, and listen once a day to news from Slovakia in German. Some of the non-native newsreaders working there have an obvious accent and my idea was focused on this aspect. I thought that because they're expressing themselves in a foreign language, a little error might appear in the spoken text and could change the sense of the message broadcasted. I was working with one of the newsreaders and we recorded a real news broadcast. I asked him to add this sentence after he'd read his news report: 'Your attention please for the following announcement: As a sign of solidarity with recent world events, for the next minute do not interrupt the activity you are doing at this moment'. In the museum, the broadcast was fictional: we had recorded everything on CD. The announcement seemed to be quite self-evident, but actually it wasn't clear at all. And since there's this mistake about not interrupting activity, I was actually asking people to continue in what they were doing at the exhibition. So they can look at the exhibition, they can walk or whatever, but somehow it serves as an anti-mes-

sage, because I asked them *not* to be active and actually I'm activating their behaviour. And *Announcement* was also one of the contributions I sent you for 'Do it', because it's also a kind of request that can be distributed on the Web.

Perhaps we can listen to it.

Yes. What I was interested in here was the position of myself as an anti-author, I would say, because that was also reflecting my sharing of the space with other people, in this case visitors to the exhibition; since the sense of the message was changed, it reflected their presence and movement in the space of exhibition.

What's next?

This is a sketch I made of *Las Meninas*. At one time I was very interested in this paint-ing – particularly in this mirrored situation of the real position of the king and queen which they share with spectators looking at the painting. I still have this sketch here because I recently returned to a piece I did in 1999 for the Ludwig Museum in Buda-pest, and this sketch was connected with my idea about the inclusion in the exhibition of another space by observing it, and the kitchen of the museum's restaurant was part of that in this piece.

Taped news, newsreader speaking.

The announcement is played every 4 1/2 minutes, when the news ends. And then we have the news again and the same announcement again, and it continues endlessly in a loop.

So that means an infiltration could happen in any existing radio station.

Yes, theoretically. So I was inspired by a radio station which was trying to have some broader influence. This is a photo of the studio of International Radio Slovakia, where we recorded it.

This is the opposite of the idea of trying to influence people's behaviour in terms of manipulation, or is it the opposite?

Yes, this is the opposite.

It's anti-manipulation. It's actually a kind of 'don't do it!' as well as 'do it!'.

Exactly.

Because you don't tell people what to do.

Yes. But it's also connected with this attempt to lead or influence somebody's perception and thus increase his imagination. That's also in some way like the project where I was interested in working with people whom I asked to make drawings for me based on what I described to them, so somehow they were led by my potential to describe something. In another work, *Guided Tour*, which I did in Zagreb, instead of filling the exhibition premises with any artworks, I employed a professional guide who guided visitors to the exhibition through the empty gallery and a small square in front of it.

So that's the project that you did with WHW?

Yes, that was in May. Three times a day, as was announced on the invitation for a 'Guided Tour', some people gathered in the gallery space. At the beginning of the tour a professional guide talked about the gallery. She also introduced a woman who had worked there for several years and was selling tickets and catalogues. After a few minutes she took the whole group outside the gallery space and they continued in the square. Her commentary, instead of talking about any historical aspects of the square, focused on life in the square today and the people who worked there every day. That was our deal with them: we spoke with them in advance and organized it as a the performance of a guided tour, or of a guide and real people in the square.

So basically, you declared the reality of the square to be the piece of art.

In a certain way, yes, but I also put the group into the empty space of a gallery and since those two spaces were somehow interlinked — because the guide was talking about the empty gallery and the square outside with equal importance and seriousness — I supposed people, after they'd visited this situation, could later fuse these two realities into one experience. People were in the gallery or 'the exhibition' and then they had a continuous experience based on a similar description of the reality outside, and they could compensate their disillusionment at the missing works in the gallery with this 'real experience'. Now I'm working on another piece, in which I would like to invite a small, 12-year-old boy to act as a tourist guide. I'll prepare the script with him and we'll put everything in the guide's talk into the future tense. The content of his commentary will thus be hypothetical, since he would be talking about things which one might experience in the future.

That is for another city? Where will it happen?

This will be in Zadar in Croatia, which is a very touristy city, and we are working with a tourism kind of approach. These tours are basically outside of any structure of tourism, but are meant to be touristic in their methods. In Zagreb I wanted to be thorough, so instead of sending invitation cards for the exhibition to all the people who were on the gallery's mailing list, we sent them cards announcing our guided tours; but also we distributed lots of them to the railway and bus stations, tourist offices, etc., so I supposed that different groups of people may also have got in amongst that group of exhibition-goers.

So it's a crossing of audiences.

But only up to the point when the people from the tourist side realised that they were part of an art event.

I was curious to know more of your drawings because I'd always known them as blocks in exhibitions – as, for example, the idea of the memory of this gallery room – but I hadn't known that you yourself do all these other drawings. I was wondering if this was an activity like jotting things in notebooks. You have a lot of different drawings; are they projects, sketches of ideas? You said before that it's something you do constantly.

Yes, it's a permanent activity. They function as my notes. They're not connected with, for example, these other pieces, in which I don't intervene. I haven't shown these drawings, these notes yet.

Why?

I don't know. I can perhaps see them here as my own private permanent exhibition, which is different from the ones meant to be for a public.

So this is all private activity.

Yes, and this is another private activity. I'm collecting clippings here.

That's another archive.

That's an archive of notes and clippings. It has all kinds of things mixed up in it, it's a flow of images. I'm collecting them and then I try to find some connections from which I could pull out a source for my work. Here, for instance, I've got 'Film', 'Relationships' or 'Flying'.

This is like your atlas?

Yes, and it's very much connected with those drawings and it's also, like them, basically for my private use.

It reminds me of Aby Warburg: he took all these different elements from history and from the present and put them in this mental space. He said that art history shouldn't be a history of images, shouldn't be conceived in linear terms, but instead as a 'Denkraum'.

My archive connections serve for me as a kind of generator of a parallel world. Look, this set is about Erlauf. I found documentation which had all these photos showing the most important events in the town's local life. At that time I was interested in the notion of monuments and decided to follow this source.

And what was the follow-up?

That was on this photograph: a meeting of World War II generals fifty years on in front of this Russian monument. There's another monument across the street conceived by Jenny Holzer, so I made a reversal of that earlier situation with small girls in front of this one and captured it in photograph.

So they are the files of your projects, then there are the files of these different typologies, so to speak, the groups, the relations, many archives, one archive. In an archive always another archive is hidden.

Each day is a continuous flow of situations, but they're quite often invisible. That's why I'm not showing these notes or this archive, or anything else from these sets, because they're like this routine flow of daily randomness. For me it's more important at the moment just to find out if there's some invisible potential in these relations.

What's your relation to utopia?

Living in Bratislava is crucial for me because here one always senses, as it were, a vacant situation. There's something that many people believe in here: that something will come or will be changed in the future. And on the other hand there's also a disillusionment that people feel here which is connected to some recent historical developments, and although utopia is a word which is not very often used in discussions, it's something that's in almost everybody's mind.

As a 'principle of hope' (Ernst Bloch).

As a principle of hope, and I think my work with cars was also that topic in a way because it was a sign of hope for change or a sign that one can at least demonstrate something, one can have the chance to visualize something. I'd like to show you this little drawing here. It's got 'Utopia' written in huge letters far above people's heads. It's just a fictional vision. This utopia would be a threat. You know this utopia is just flying in space, suspended on threads. And in this drawing here we can try to make an anagram of this if we wanted to change it: 'Disillusionment at the present'. Listening to people, reading newspapers and having all that repetition of these words of disillusionment and whatever about it makes me to feel it like a potential energy.

This utopia brings me to the last question I wanted to ask you. It's the only question I always ask in all interviews: the question of the unrealised project. Do you have any projects which are too big to be realised, too small, or have been censored? What are your unbuilt projects?

There was an idea for Brno. I was invited to a show for Mendel's monastery. Do you know it?

In Mendel's monastery was the only time there was a religious ceremony during communism.

Right, so there was this monastery and the whole story of Mendel, and I was invited for the show, which was supposed to be dedicated to him. My proposal was very simple, but it was never realised; it was actually refused, because I wanted to bring an object from a courtyard in Bratislava to the courtyard situation at Mendel's monastery. I can show you the photo of what it looks like. We've had these iron skeleton globes in many courtyards in residential districts of Bratislava since the sixties and seventies. You'll find them in playgrounds and children can climb on them.

You wanted to bring it as ready-made?

Yes, as what it was. It would remain the same thing, still be for the same purpose, again in a courtyard, etc. Just abandoned, because there are no children in this male monastery. Although we never think of the absence of children in such places, the presence of such an object in the middle of the monastery courtyard would provoke questions about the rules of the church this community is part of. So I thought this abandoned object, which would have stayed abandoned there for the whole time if the project had been realised, could create a set-up for this impossible activity or something like a potential activity which can't be fulfilled just because of the system which doesn't allow it.

So it was a refused project.

Yes, it was.

That actually leads to a question I meant to ask earlier, which is about science, your whole relationship to science, because you were in Zurich at Helga Novotny's Institute, and the very first time we met, at Manifesta 1, your work was in the Natural History Museum. So I wanted to ask you about your relationship with science.

Since I was a student at the Academy I've been interested in working constantly on daily research as if it were something related to science, but without getting too involved in it. There are some limits in the absorption of knowledge when it's better for me not to know more about something than is necessarily needed and to leave enough space for my intuition.

You used it as an inspiration?

I am doing this research but only up to the point where I feel it's still interesting to understand it as an amateur. That's why I also like a lot of drawings which are done by amateurs involved in my collaborative projects. I like the openness that's left to these people, you know. I'll show you an example of my pseudo-research. This piece I did in Budapest with the kitchen – this is the picture – was called *Through the Eye Lens*. This part of the wall here was cut out to make an opening into the kitchen of the museum's restaurant.

Part of the wall?

It was a false plasterboard wall dividing these two spaces. I protected this hole with a kind of tent and then over several days before the opening of the show I made archae-

ological excavations in that kitchen. So I went there through this tent/opening and brought to the exhibition some objects which were left in the kitchen after cooking, such as empty beer cans, plastic bottles or sugar cubes. From the side of the exhibition space, people didn't previously know there was a kitchen there, since the entrance to the restaurant was far away on the other side of the same floor. But when I made this opening into the wall, you were able to be aware of this connection not only via ordinary objects which I brought and left lying on the floor, but also from the smell of meals or the noise dishes being washed coming through the opening, and partially by seeing some movement of people working behind the wall. These two realities – the motionless one of those found objects, as if were caught on a photograph, and the continuous one, observed through the opening – were parallel, but discontinuous in a sense.

It perhaps falls into the daily science category.

Somehow it's on the same level as my notes or collections of clippings. These two images here are from performances I recently realized in another space.

That was in Prague?

That was in the Spala gallery in Prague. One of the works there, *Tickets, Please*, was made in cooperation with an old ticket seller I've known very well for many years. He has a grandson who's now eleven years old. I invited him to the gallery to sell tickets together with his grandfather, but each of them would have his counter on a different floor. On the first floor I created an exact copy of the grandfather's environment – which was a permanent fixture on the ground floor – and asked the grandfather to move up to this replica on the first floor. His former ground floor environment was then inhabited by his grandson, and he was selling tickets and catalogues on that floor. So, firstly you payed half the price of the usual entrance fee to the grandson, and then when got up to the first floor, payed remainder to his grandfather. And the second work, *Teaching to Walk*, was a collaboration with a friend of mine whose son just happened to be a year old at the time and they lived near the gallery. I asked her to come every day at 2 p.m. to the gallery and to teach her boy to walk there for about half an hour. She was in the role of one of the visitors, but because of this activity she became another point of observation, like other artworks in that space. The relationship of these two performers – mother and child – to the space they every day occupied was subject to continuous change. As the exhibition went on, the child's skill in walking improved.

Slovakoczechia, 2001
Sticker, Edition
Edition of stickers

Skodas unterwegs von Bratislava nach Wien, November 2001
Transit of Skodas from Bratislava to Vienna, November 2001

SK Parking, 2001

Slowakische Skodas parkten zwei Monate hinter dem Gebäude der Secession in Wien.

Slovakian Skodas were parked behind the Secession building in Vienna for two months.

S./pp. 129–131

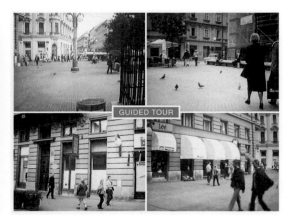

Einladungskarte für „Guided Tour", Zagreb, 2002
Invitation card for 'Guided Tour', Zagreb, 2002

Guided Tour, 2002

Von einem eigens angeheuerten professionellen Touristen-
führer wurden Führungen angeboten, welche den leeren
Galerieraum sowie den Alltag auf dem Platz davor kommen-
tierten.

Tours commenting on the empty gallery space and on
contemporary reality on the square in front of the gallery
were given by a professional guide hired for this occasion.

S./pp. 133–137

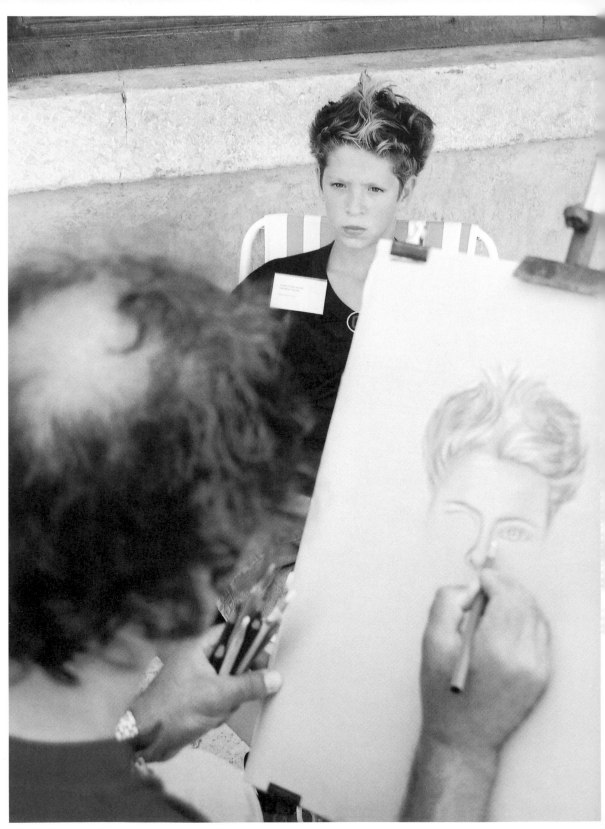

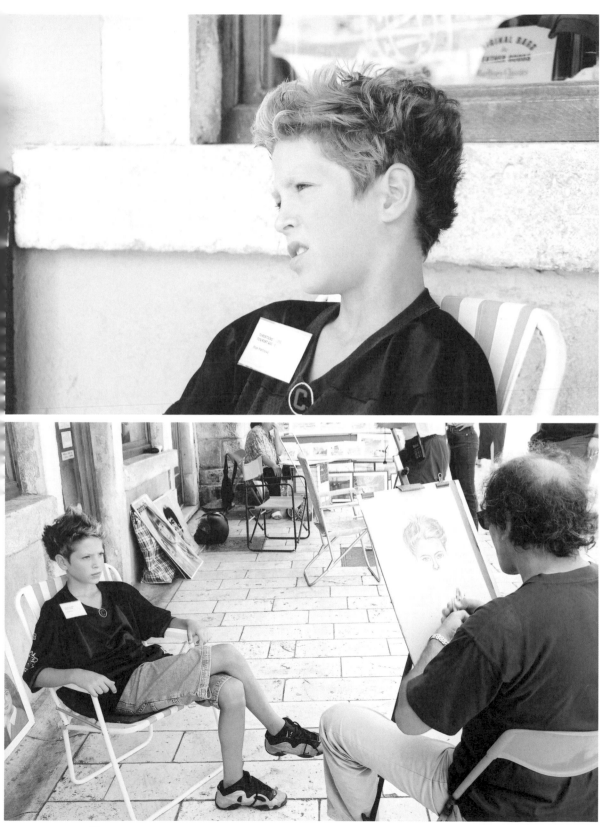

Guided Tour (Follow Me), 2002

Ein Porträt des jungen Touristenführers
wurde in Auftrag gegeben, um seine
„Guided Tour" zu bewerben, 2002.

Führungen wurden von einem 12-jährigen Jungen
angeboten, dessen Kommentare ausschließlich in
der Zukunftsform gehalten waren.

A portrait of the young tourist guide was
commissioned for the advertisement of his
'Guided Tour', 2002.

Tours were provided by a 12-year-old boy whose
commentary was given entirely in the future
tense.

S./pp. 138–139

S./pp. 141–143

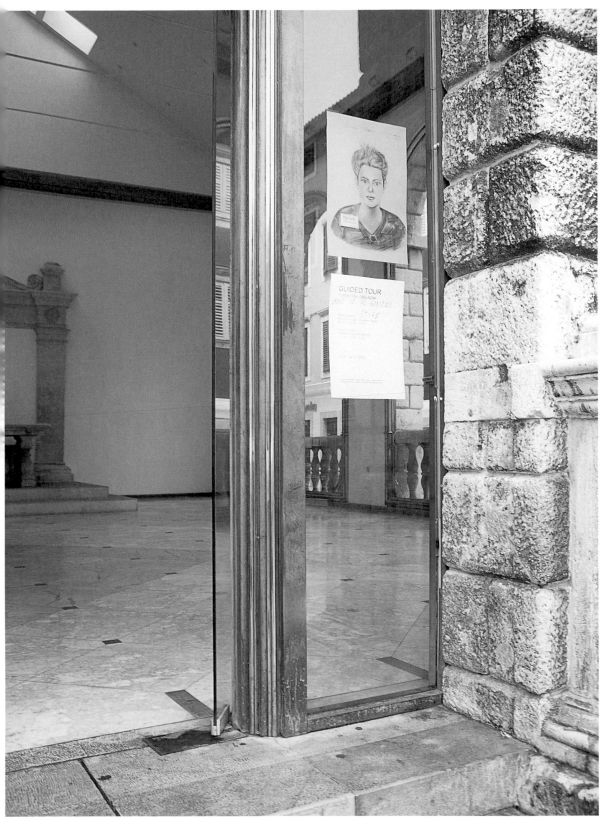

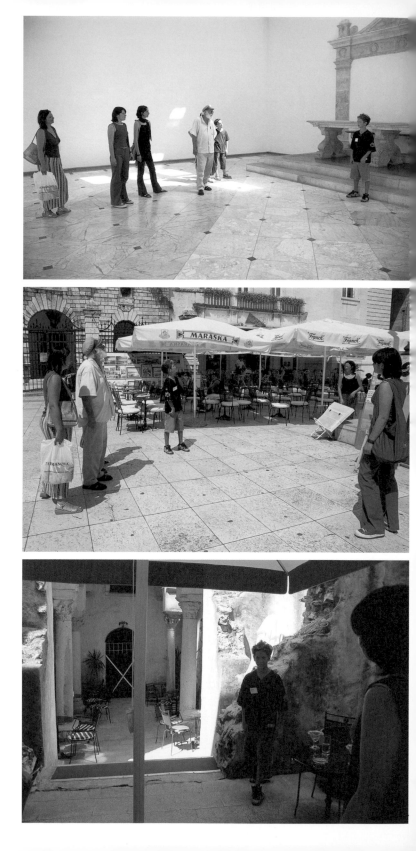

Das Dritte Denkmal, 2002
Auf einen Gehsteig gesprühte Inschrift
Installation in Erlauf, Österreich

Sprayed inscription on a pavement
Installation in Erlauf, Austria

Tomorrows, 2002

Serie von 6 Plakaten und 6 Farbfotografien
Installation mit Plakaten in Erlauf, Österreich
(Detailansichten der Installation)

Series of 6 posters and 6 colour photographs
Installation with posters in Erlauf, Austria
(Details of the installation)

S./pp. 146–149

Aufnahme von „Announcement" im Studio des slowakischen Rundfunks, Bratislava, 2002
Recording of 'Announcement' in the studio of the Slovakian Radio, Bratislava, 2002

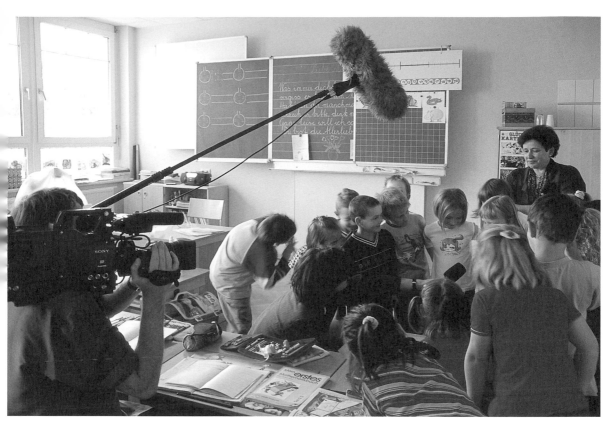

Tomorrows (Interview), 2002

Nachdem die Kinder für „Tomorrows" foto-
grafiert wurden, interviewte sie ein lokales
Fernsehteam.
C-Print

Children interviewed by local television after
they had been photographed for 'Tomorrows'.
C-print

Simultaneous emphasis on past,
present, and future events

Aus einem Buch ausgeschnittenes Bild,
Pittsburgh, 1995
Cutting from a book, Pittsburgh, 1995

Tickets, Please, 1999
Projekt für eine Performance, Text auf Papier gedruckt
Project for performance, text printed on paper

Ak má predavač lístkov vnuka, bude pozvaný, aby predával lístky na výstavu
so svojim starým otcom. Zaujme pôvodné miesto starého otca na prízemí,
ktorý sa presťahuje o poschodie vyššie do presnej repliky prostredia z
prízemia. Divák si najprv kúpi lístok u vnuka na prízemí a už o niekoľko
minút znovu, keď sa dostane k starému otcovi na prvé poschodie.
Vstupné bude v oboch prípadoch zľavnené na polovicu.
Otváracie hodiny galérie sa prispôsobia možnostiam chlapcovho voľného času.

If the ticket seller has a grandson, he'll be invited to sell tickets at
the exhibition with his grandfather. He'll take his grandfather's original
place on the ground floor and the grandfather will move up a floor to a
precise replica of the ground floor environment. The visitor will first buy
a ticket from the grandson on the ground floor and again just a few minutes
later when he gets to the grandfather on the first floor.
In both cases the ticket price will be reduced by half.
The gallery's opening hours will be accommodated to when the boy is free.

Tickets, Please, 1999

Vorentwurf für eine Performance, Tintenstift und Bleistift auf Papier

Preliminary drawing for performance, pen and pencil on paper

Teaching to Walk, 2004

Eine junge Frau wurde eingeladen, mit ihrem einjährigen Sohn in die Galerie zu kommen, um ihm dort das Gehen beizubringen. Die Performance fand täglich statt und dauerte jeweils eine halbe Stunde.

A young woman was invited to come to the gallery with her one-year-old boy to teach him to walk there. The performance was repeated every day for half an hour.

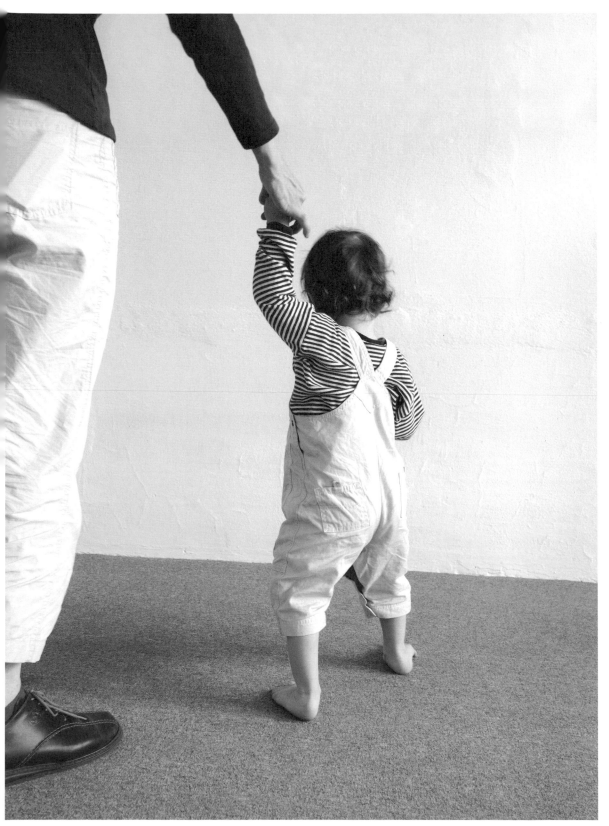

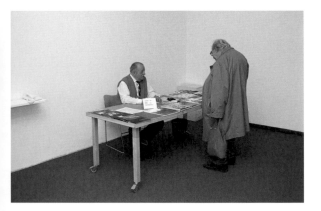

Tickets, Please, 2002

Der Kartenverkäufer verkaufte gemeinsam mit seinem Enkelsohn Eintrittskarten für die Ausstellung. Der Enkelsohn verlangte im Erdgeschoss des Ausstellungsgebäudes die Hälfte des üblichen Eintrittspreises, der Großvater kassierte im ersten Stock die ausstehende zweite Hälfte. Performance und Fotodokumentation

The ticket-seller was selling tickets for the exhibition with his grandson. The grandson was requesting half the usual entrance fee on the ground floor and his grandfather was collecting the remaining half of the entrance fee on the first floor. Performance and photo document

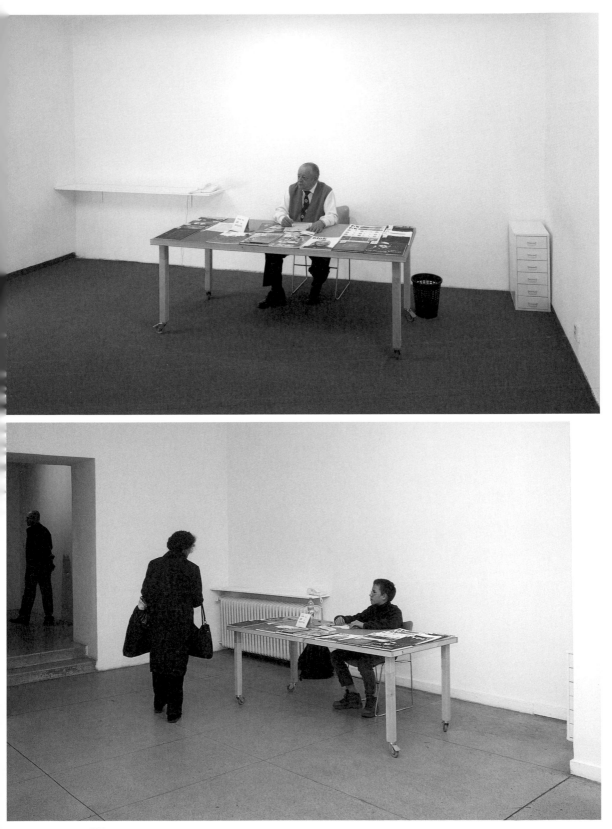

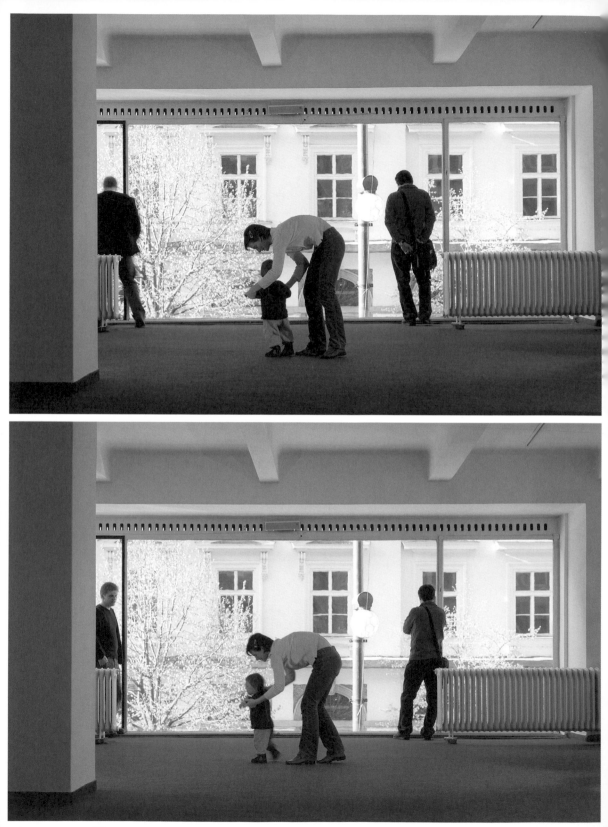

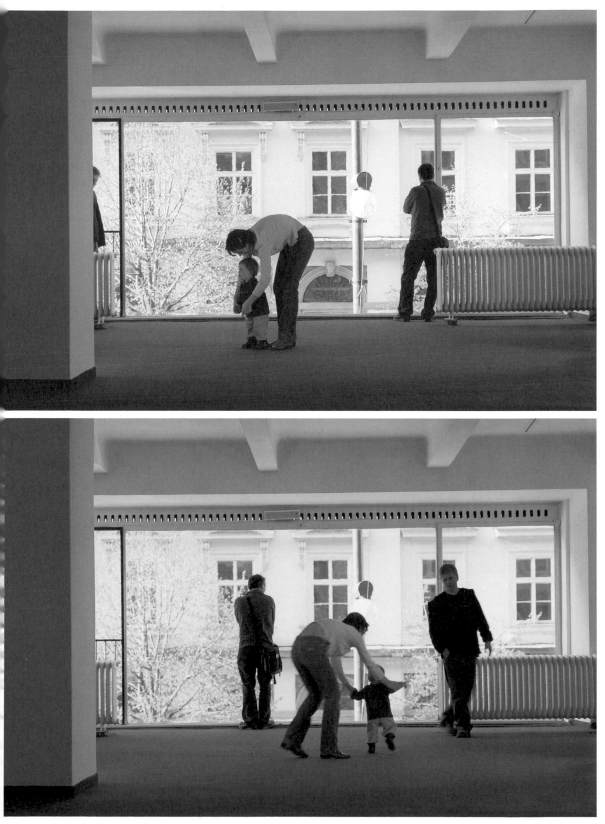

Teaching to Walk, 2002

Eine junge Frau wurde eingeladen, mit ihrem
einjährigen Sohn in die Galerie zu kommen,
um ihm dort das Gehen beizubringen. Die
Performance fand täglich statt und dauerte
jeweils eine halbe Stunde.

A young woman was invited to come to the gallery
with her one-year-old boy to teach him to walk there.
The performance was repeated every day for half an
hour.

S./pp. 158–159

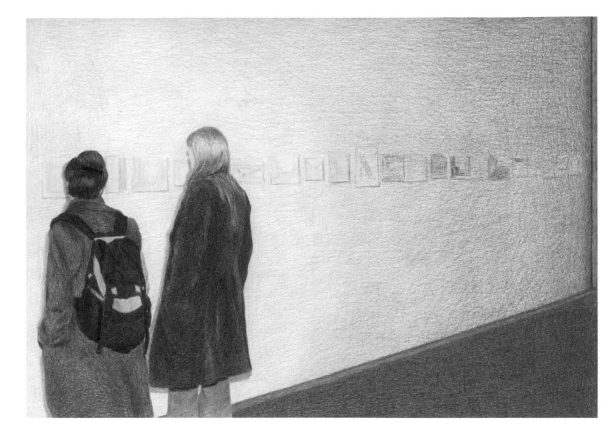

Short Drawn Retrospective, 2002

Serie bestehend aus 12 Zeichnungen, Farbstift auf Papier
Drawing from a series of 12, colour pencil on paper

Bad News Is a Thing of the Past Now, 2003
Diptychon, s/w Fotografien
Diptych, b/w photographs

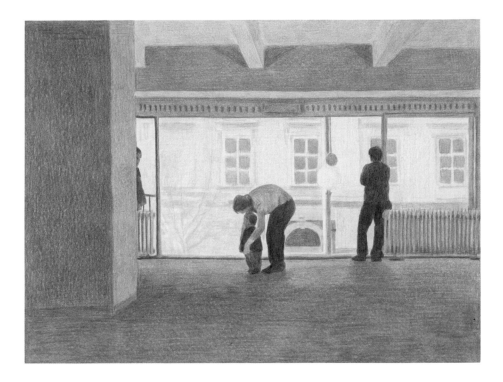

Drawn B & W Retrospective, 2003
Serie bestehend aus 18 Zeichnungen, Farbstift auf Papier
Drawing from a series of 18, colour pencil on paper

I'm just acting in it, 2004

Auf der Basis einer Beschreibung des Kurators zeichneten Ondák zehn Menschen, wie er im leeren Ausstellungsraum herumgeht. Serie bestehend aus 10 Zeichnungen

Based on the curator's description, ten people drew Ondák wandering in the empty exhibition space.
Drawing from a series of 10

Announcement, 2002

Folgende Ankündigung wird alle viereinhalb Minuten wiederholt: „Als ein Zeichen Ihrer Solidarität mit den jüngsten Ereignissen in der Welt bitten wir Sie, die Tätigkeiten, die Sie gerade ausüben, für die nächste Minute nicht zu unterbrechen."
Klanginstallation, Radioempfänger, Radiosendung auf CD

The following announcement is repeated every 4.30 min.: 'As a sign of solidarity with recent world events, for the next minute do not interrupt the activity you are doing at this moment.'
Sound installation, radio set, radio broadcast on CD

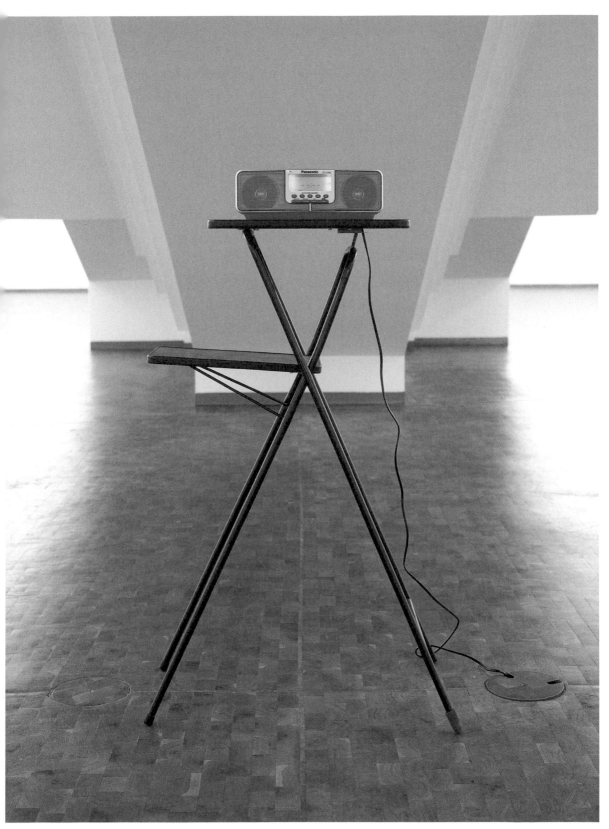

**Self-portraits of Two Artists as
Young Men**, 2003

Selbstporträt und Fotografie eines Freundes des
Künstlers aus den 50er Jahren; Selbstporträt und
Fotografie des Künstlers aus den 80er Jahren

Self-portrait and photograph of the artist's
friend from the 50s; self-portrait and photograph
of the artist himself from the 80s

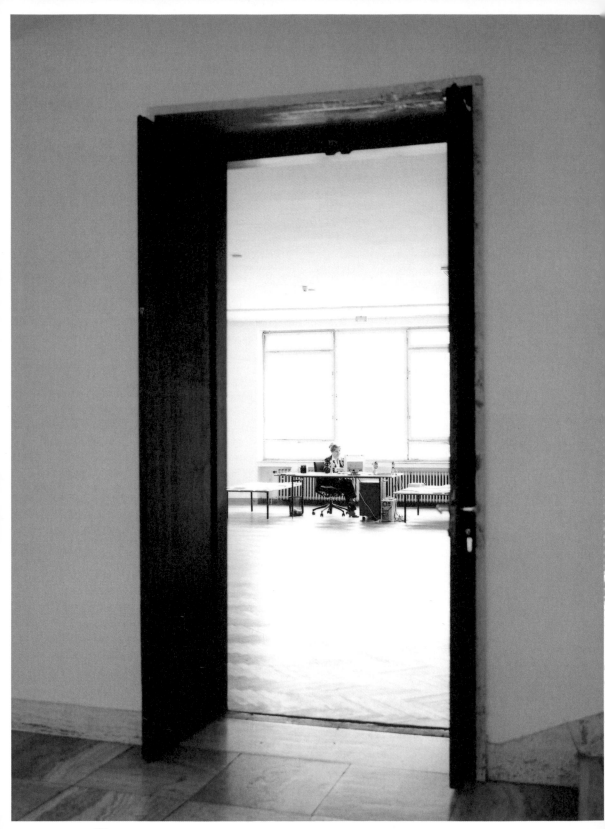

Another Day, 2003

Die Kartenverkäuferin wurde gemeinsam mit ihrem Ladentisch und den Katalogen vom Foyer in den Ausstellungsraum übersiedelt, wo sie den Kartenverkauf fortsetzte.

The ticket-seller and her counter with catalogues were removed from the foyer to the exhibition space where she continued to sell tickets.

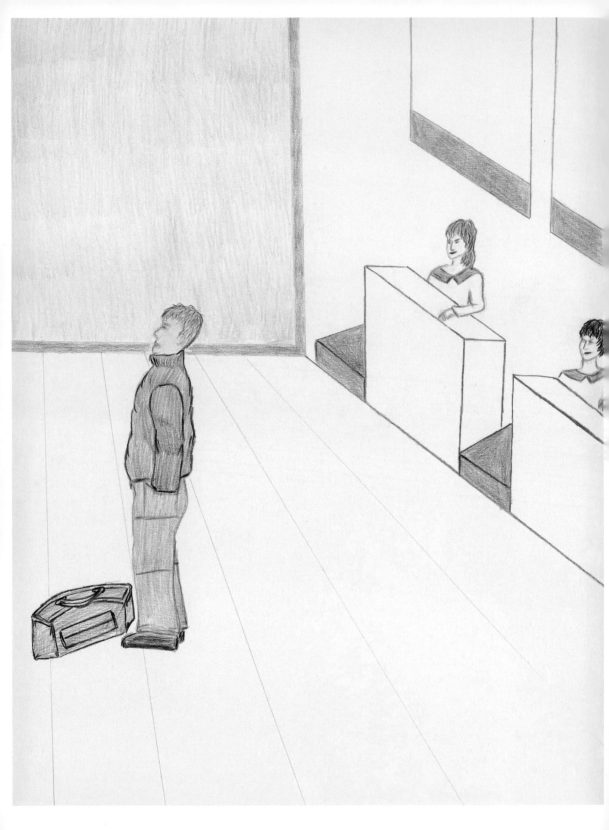

Slowed-down Journey, 2003

Acht Menschen wurden gebeten, sich Ondák
unterwegs beim Gehen durch verschiedene
Städte vorzustellen und ihn dabei zu zeichnen.
Serie bestehend aus 8 Zeichnungen

Eight people were asked by Ondák to imagine
and draw him walking in different cities while on
his travels.
Drawings from a series of 8

S./pp. 170–173

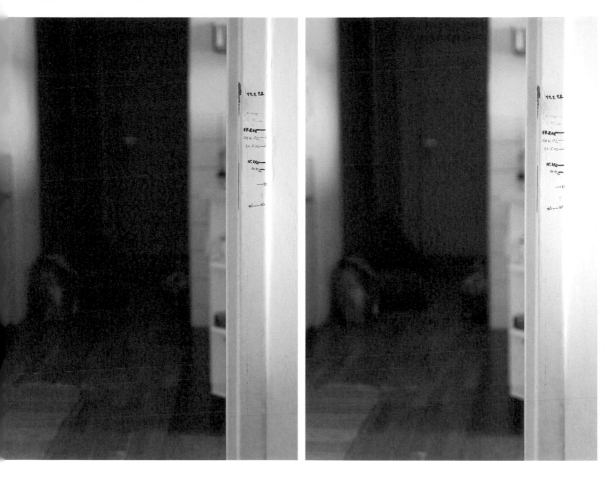

His Affair with Time, 2003

Diptychon, C-Prints
Diptych, C-prints

Occupied Balcony, 2002
Installation
Rathaus, Graz
Installation
Town Hall, Graz

Awaiting Enacted, 2003

16-seitige Zeitung, die ausschließlich mit
Bildern von Menschen illustriert ist, die in
einer Warteschlange stehen.

A 16 page newspaper filled entirely with
pictures of people waiting in queues.

Letter, 2003

Text, Stempel und Unterschrift auf Papier
Text, stamp and signature on paper

Roman Ondák
Páričkova 9
821 08 Bratislava
Slovakia

MINISTERSTVO KULTÚRY SR		
Org. útvar:		Došlo: 12. 3. 2003
Číslo: 373/ 2003-1	Prfl:	Skart. zn.:

Ministry of Culture
Nám. SNP 33
813 31 Bratislava
Slovakia

Dear Minister,

could you support my intention to establish a Virtual Museum of Contemporary Art?

Yours sincerely,

Roman Ondák

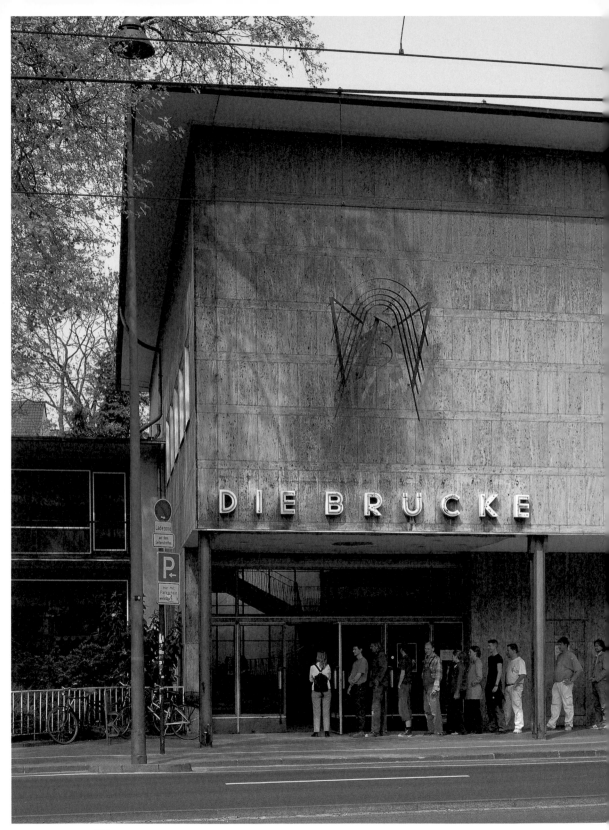

Announcement, 2003

Offsetdruck auf der Rückseite einer Mitgliedskarte
Kölnischer Kunstverein

Offset print on the back of a membership card
Courtesy Kölnischer Kunstverein

Als ein Zeichen ihrer Solidarität mit den jüngsten Ereignissen in der Welt bitten wir Sie, die Tätigkeiten, die sie gerade ausüben, für die nächste Minute nicht zu unterbrechen

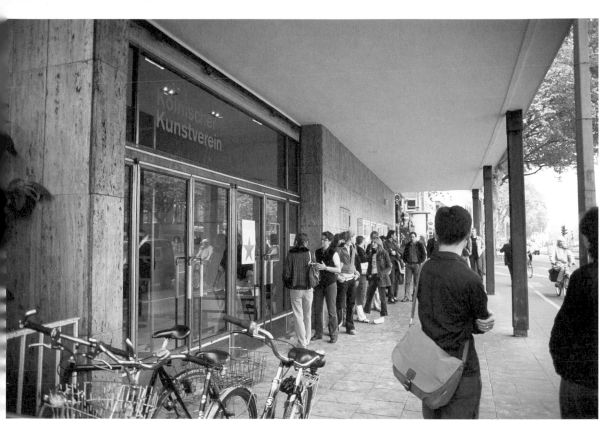

Good Feelings in Good Times, 2003

Künstlich inszenierte Warteschlange, die sich
täglich vor dem Haupteingang zum Kölnischen
Kunstverein bildete.

Queue formed artificially every day in front
of the main entrance to Kölnischer Kunstverein.

S./pp. 180–181, 183

Awaiting Enacted, 2003
Work in progress

Awaiting Enacted, 2003
Serie bestehend aus 16 Zeitungscollagen
Newspaper collages from a series of 16

S./pp. 185–187

Nebojte sa cestovať lietadlom

Vážení cestujúci, pripútajte sa, prosím. Kapitán lietadla a celá jeho posádka vám želajú príjemný let. Popri otázke kam cestovať na dovolenku sa dostávame aj k ďalšej - ako cestovať.

Elena Guštafíková

Lietanie patrí k najbezpečnejším možnostiam dopravy na dovolenku. Určite je aj najatraktívnejšou možnosťou.• Letecká doprava je rýchla a pohodlná. Za niekoľko hodín príjemného letu spestreného vtáčou perspektívou pohorí, riek, veľkomiest sa ocitnete na mieste svojej dovolenky

Charter

Cestovné kancelárie v snahe znížiť cestovné náklady na prepravu svojich klientov na vzdialenejšie dovolenkové destinácie si na letnú sezónu objednávajú celé lietadlo. Takto prenajaté lietadlo sa volá charter. Ceny charterových leteniek sa pohybujú v nákladových rovinách a sú preto najvýhodnejšie.

Všeobecne však platí, že k charterovej letenke musí byť vystavený aj voucher, čiže poukaz na pobyt. Inak sa môže stať, že letecký prepravca odmietne cestujúceho.

Charterové linky patria k nepravidelným spojeniam. Preto sú vždy v prípade meškania pravidelné linky. Nie je teda výnimkou, že na veľkých medzinárodných letiskách môžu charterové linky meškať aj viac ako dve hodiny.

Letisko

Na každý medzinárodný let sa musíte zaregistrovať dve hodiny pred plánovaným odletom. Registrácia alebo odbavenie sa nazýva check-in. Cestujúci sa prezentuje platným cestovným dokladom, letenkou a uzamknutou batožinou označenou menom, adresou a telefónnym číslom.

Pracovníci pri odbavovacom pulte pridelujú miesta v lietadle. Ak máte oprávnenú požiadavku na sedenie v lietadle (býva vám v lietadle zle, trpíte klaustrofóbiou a chcete sedieť pri núdzovom východe alebo letíte prvý raz a chcete sedieť pri okne), poinformujte pracovníkov letiska ešte skôr, ako odovzdáte svoju batožinu. Check-in býva spravidla otvorený hodinu.

Po podaní batožiny a registrácii na stanovisku check-in dostanete do rúk palubnú kartu (boarding card). Na nej je vyznačený boarding time (čas nástupu do lietadla) a boarding gate (brána na nástup do lietadla) a číslo sedadla v lietadle. S touto kartou a platným cestovným pasom prejdete colnou, pasovou a bezpečnostnou kontrolou.

V stanovenom čase vás k lietadlu odvedie letiskový personál a zverí do opatery leteckému personálu.

Pripútajte sa, prosím

Pri vzlietnutí a pristávaní sú cestujúci povinní pripútať sa. Odporúča sa zostať pripútaný počas celého letu. Mobilné telefóny a iné elektronické prístroje môžu narušiť komunikáciu, a preto vás posádka požiada o ich úplné vypnutie.

. Väčšina charterových letov, ako aj pravidelných liniek, je nefajčiarska. Porušenie zákazu fajčenia môže byť pokutované až do výšky tisíc dolárov.

Ak cestujete s dieťatkom do dvoch rokov, automaticky sa mu priznáva štatút INF (infant) a cestuje zadarmo. Dieťa však nemá nárok na vlastné sedadlo. Rodiny s deťmi do dvoch rokov bývajú spravidla usádzané v prednej časti lietadla. Pri odlete a prílete sa odporúča cmúľanie cukríka alebo žuvačky na vyrovnanie vnútorného tlaku v ušiach, zabráni to tzv. zaľahnutiu. Pri dlhšom lete sa poprechádzajte po lietadle - zabránite tak prípadným opuchom nôh.

Počas letu sa podáva catering, čiže studené alebo teplé občerstvenie spolu s nealko nápojmi, čajom, kávou a prípadne pivom. Catering je zahrnutý v cene letenky.

Počas letu sú cestujúci povinní zachovávať primeranú opatrnosť a zdržať sa konania, ktoré by mohlo ohroziť bezpečnosť cestujúcich alebo plynulosť letu – hovorí všeobecné pravidlo. Vyhnite sa radšej nadmernej konzumácii alkoholu. Opitosť je totiž dôvodom na vysadenie z lietadla. Ďalším dôvodom môže byť odmietnutie bezpečnostnej prehliadky, postihnutie prenosnou chorobou, ktorá môže ohroziť ostatných účastníkov letu. Dávajte si pozor aj na predpisy krajiny a krajine príletu a odletu (napríklad neplatný cestovný pas alebo zákaz vstupu do krajiny - dodržujte sa to najmä v krajinách Schengenu).

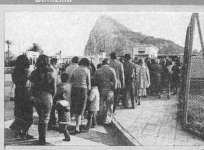

Batožina

Batožina, ktorá sa prepravuje v batožinovom priestore lietadla, je zapísaná v letenke a nesmie presahovať hmotnosť:
- v turistickej triede 20 kilogramov,
- v business triede 30 kilogramov.

Za každý kilogram batožiny navyše si prepravca môže účtovať poplatok za nadváhu. Hmotnosť batožiny sa môže v rámci jednej rodiny alebo spolucestujúcich zlučovať.

Za nadváhu sa nepovažuje preprava detského kočíka a zložiteľného invalidného vozíka – tie sa prepravujú bezplatne.

Batožina, ktorá cestuje s vami v kabíne, je príručná. Nesmie vážiť viac ako päť kilogramov. Za príručnú batožinu sa považuje aj dámska kabelka, kabát, dáždnik alebo palica, fotoaparát, videokamera, ďalekohľad, osobný počítač, mobilný telefón, košík a jedlo pre dieťa na čas letu, barle a ortopedické protézy.

Prezrite si svoju príručnú batožinu – nemáte v nej byť ostré predmety (za ktoré sa považuje aj pilník a manikúrové nožničky!), strelné zbrane, strelivo, ale aj hračky, ktoré sa podobajú na skutočné zbrane.

Ak po prílete zistíte, že je vaša batožina poškodená alebo nedostane všetku batožinu, ktorá je zapísaná na letenke, vyhľadajte kanceláriu Baggage claim a batožinu reklamujte.

Ak je batožina poškodená, žiadajte spísanie Zápisu o škode tzv. PIR protokol, na základe ktorého môžete žiadať náhradu škody od leteckej spoločnosti alebo poisťovne. Ak nemáte možnosť získať PIR protokol a batožina je v stave, že ju musíte akurát vyhodiť, odporúča sa urobiť si fotografie.

Ak si chcete na dovolenku zobrať bicykel, lyže, golfové palice, potápačský výstroj alebo surf, kontaktujte týždeň pred odletom cestovnú kanceláriu alebo leteckú spoločnosť a žiadajte vystavenie tzv. EBT (Excess Baggage Ticket), čiže letenky na nadrozmernú batožinu. Táto preprava je spoplatnená spravidla sumou tisíc až dvetisíc korún.

Výhodné nákupy

Ak máte po odbavení na stanovisku check-in trocha času, môžete využiť obchody s Duty free (v krajinách mimo Európskej únie) alebo Best Buy (v krajinách Európskej únie) a výhodne nakúpiť. Nezabudnite však na vyhlášku SR a NBS č. 335/1996 Zb. z., zákona 202/1995 Zb. z., podľa ktorej môžete na Slovensko doviezť maximálne: 200 kusov cigariet alebo 50 kusov cigár alebo 0,25 kg tabaku, ďalej liter destilátov alebo liehovín, dva litre vína, 50 ml parfumu.

Let so živým zvieraťom

V kabíne pre cestujúcich sa nesmú prepravovať živé zvieratá. Výnimkou je iba slepecký pes, ktorý sa prepravuje bezplatne. Domáce zvieratá sa prepravujú v pevne uzatvorených klietkach, ktoré si musíte zabezpečiť sami. Počas letu sa tiež musíte postarať o ich kŕmenie. Pri lete dlhšom ako hodinu sa odporúča podať utišujúce prostriedky. Nezabudnite na predpisy o tranzite a dovoze zvierat, ako aj na veterinárny a očkovací preukaz – očkovania nesmú byť staršie ako mesiac.

ic INTERCONTACT
BRATISLAVA

Už 10. rok
Váš spoľahlivý partner pre lodné lístky
na všetky trajektové linky v Európe

Rezervácie pre jednotlivcov aj skupiny:
INTERCONTACT BRATISLAVA,
Šancová 80, 811 05 Bratislava 1
Tel.: 02/5262 6497, Tel.+ Fax: 02/5262 4351, 5245 3034
e-mail: intercontact@zutom.sk

XD-0698/A

100+1
zahraniční zajímavost

Zvláštní zimní číslo • Ročník XXI • 1984

26

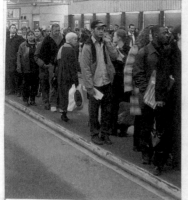

Úvahu nad událostmi letošního roku napsal pro 100+1 ZZ komentátor TASS Jurij Kornilov. (Viz str. 59)

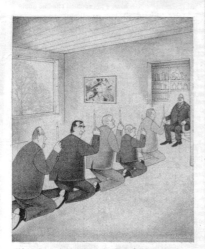

Afghánistán - Jan Stejskal • Belgie - Igor Pírek • Bulharsko - Miroslav Soukup • Čína - Jaroslav Höfer • Francie - Karel Barták • Indie - Pavel Jandourek • Itálie - Ivan Mráz • Jugoslávie - Miroslav Jílek • Kuba - Ilona Kovaříková • Libanon - Václav Bervida • Maďarsko - Štefan Németh • NDR - Jan Hamršmíd • NSR - Jan Rezek • Polsko - Jiří Vaško • Rakousko - Cestmír Sládek • Rumunsko - Jaroslava Kohoutová • SSSR - Jindřich Krob, Dušan Špak • USA - Richard Hajský • Velká Británie - Michael Janata • Vietnam-Jaroslav Nedbal

- Vychází čtrnáctidenně (26x ročně)
- Cena výtisku 7 Kčs
- Tiskne Polygrafia, n. p., závod 01, 128 17 Praha 2, Svobodova 1
- Rozšiřuje PNS. Informace o předplatném podá a objednávky přijímá každá administrace PNS, pošta a doručovatel
- Objednávky do zahraničí vyřizuje PNS - ústřední expedice a dovoz tisku Praha, závod 01, administrace vývozu tisku, Kafkova 19, 160 00 Praha 6
- Inzerci přijímá a za inzerci odpovídá ČTK - REPRO, odbyt. odd. 111 44 Praha 1, Opletalova 5, telefon 37 37 88 nebo 22 68 53
- Redakci nevyžádané příspěvky se nevracejí

Dáno do výroby 17. 11. 1984 a vyšlo 20. 12. 1984 • 47358

V PŘÍŠTÍM ČÍSLE

ZNOVU U JEDNACÍHO STOLU / Na okraj jednání SSSR-USA • STÁLÝ NEKLID / Napjatá situace v Chile • G. K. ŽUKOV, MARŠÁL SOVĚTSKÉHO SVAZU / O životě sovětského vojevůdce, který má značný podíl na porážce fašismu • ROZPŮLENÝ ŽIVOT / Italové pracující v zahraničí jsou dlouhodobě odděleni od svých rodin • VYTOUŽENÉ DĚTI / Neplodnost je jedním z velkých problémů • ZEMĚKOULE V REKONSTRUKCI / Velkorysé přestavby zemského povrchu • KRÁL OPERY / Placido Domingo - hvězda operního nebe • BRITSKÁ TOVÁRNA NA SNY / Role královské dynastie v životě Velké Británie • URUGUAY / Znovu civilní vláda • DÉMONI A DÓMOVÉ / Setkání s vládcem indických pohřebních stanic • DVĚ OSMITISÍCOVKY NARÁZ / Mimořádný výkon horolezců Messnera a Kammerlandera • POVÍDKY: NEPLODNÁ; HOROSKOP PANÍ DŮVĚŘIVÉ

Osud škôlky ešte nie je spečatený

VRÚTKY - O záchrane Materskej školy na Ulici Cyrila a Metoda vo Vrútkach budú dnes rokovať zástupcovia Závodu služieb železníc (ZSŽ) a mesta Vrútky. Hrozí totiž, že ZSŽ z finančných dôvodov 1. marca škôlku zatvorí.

„Verím, že obe strany spravia ústretové kroky a materská škola bude ďalej fungovať," povedal riaditeľ ZSŽ Peter Výbošťok. V rovnakom zmysle sa vyjadril aj primátor Vrútok Ľubomír Bernát. Mali by si vyjasniť názory na riešenie problému, predovšetkým na financovanie fungovania škôlky.

ZSŽ odôvodnil prerušenie prevádzky so 60 deťmi tým, že sa nedohodli na spolufinancovaní škôlky s tamojším okresným a mestským úradom. V prípade, že by škôlka, ktorú železnice financujú už dvadsať rokov, prešla pod správu mesta, požadovali by nájom za priestory. Ročná prevádzka ich stojí 2,2 milióna Sk. Z návštevníkov škôlky je pritom len desať percent detí zamestnancov železníc.

(er, foto Filip Stopka)

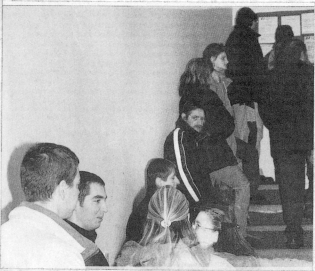

Kolotočiari: Jar znamená výdavky

LEVICE - Život kolotočiarov je ťažký. Hoci sa usilujú prežiť, mnohí krachujú. Aj levickú rodinu Sajkovcov, druhý najstarší kolotočiarsky klan u nás i v Česku, tlačí nedostatok peňazí.

Prichádzajúca jar pre nich znamená kopu výdavkov. Na údržbu atrakcií, traktorov, maringotiek či strelnice vydajú do 200-tisíc korún. „Len farby stoja okolo 30-tisíc. Štát nás nepodporí ani korunou," hovorí František Sajka

(54). Jeho rodina brázdi Slovensko s kolotočmi osem mesiacov v roku. „Hoci zlyhá aj najdokonalejšia technika, my si riziko nesmieme dovoliť! Kolotoče musia byť stopercentne bezpečné. Preto pedantne vymieňame každú zastaranú skrutku. Výdavky sa nám však nevracajú, ľudia majú čoraz menej peňazí. Poplatky za priestranstvo platíme vopred. No keď cez hody prší, ledva sa nám vrátia peniaze za naftu," hovorí F. Sajka.

Najhoršie je to v obciach, kde je vysoká nezamestnanosť. Kým v dedine so 800 obyvateľmi sa prišlo pred 15 rokmi denne na kolotočoch povoziť päťsto ľudí, dnes ich je maximálne sto. „Vlani pri kolotoči postávali dvaja súrodenci. Plakali, lebo nemali peniaze. Nešťastná mama mi vysvetlila, že sú radi, keď sa poriadne najedia. Čo som mal s nimi robiť? Vzal som ich zadarmo. Tá vďačnosť však stála za to," dodáva F. Sajka. *(min, foto autor)*

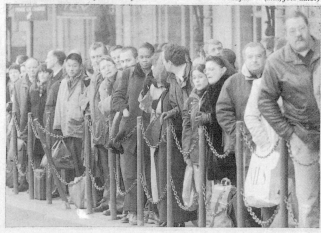

SME – ĽUBOŠ PILC

Zákazníci napadli čašníkov

DONOVALY - Nechceli ich obslúžiť, tak použili násilie. Polícia preveruje udalosti z utorkového rána v hoteli Vesel na Donovaloch. Okolo 23. hodiny prišli do hotela dvaja muži - päťdesiatnici. Posilnení alkoholom sa domáhali obsluhy. Keď ich požiadavky barman odmietol, muži hotel opustili. Po polnoci sa však do zaria-denia vrátili. Barman i čašník sa im snažili opäť vysvetliť, že obslúženie nebudú. Ohrdnutým hosťom sa to nepáčilo, preto zamestnancov hotela napadli. Barmana, ktorého zranili na hlave, museli ošetriť v nemocnici. Bitka päťdesiatnikom asi nestačila, do sklenej vitríny ešte hodili kvetináč.

(pav, foto autor)

Kradol knihy, ale nečítal ich

PRIEVIDZA - Kradol knihy, nie však preto, aby sa vzdelával, ale aby ich predal. 31-ročný Miroslav z Banskej Bystrice v hypermarkete v Prievidzi od novembra minulého roku vzal tovar za 10-tisíc korún. Najviac sa mu páčili veľké obrázkové encyklopédie. Nepohrdol ani Guinnessovou knihou rekordov. Policajti ho zadržali v utorok. Priznal sa, že nie je žiadny intelektuál, študovať preto nechcel. Mal za lubom, že nakradnutú literatúru výhodne predá. *(hc)*

Rambling in the Future, 2003
Videoinstallation, Graz
Video installation, Graz

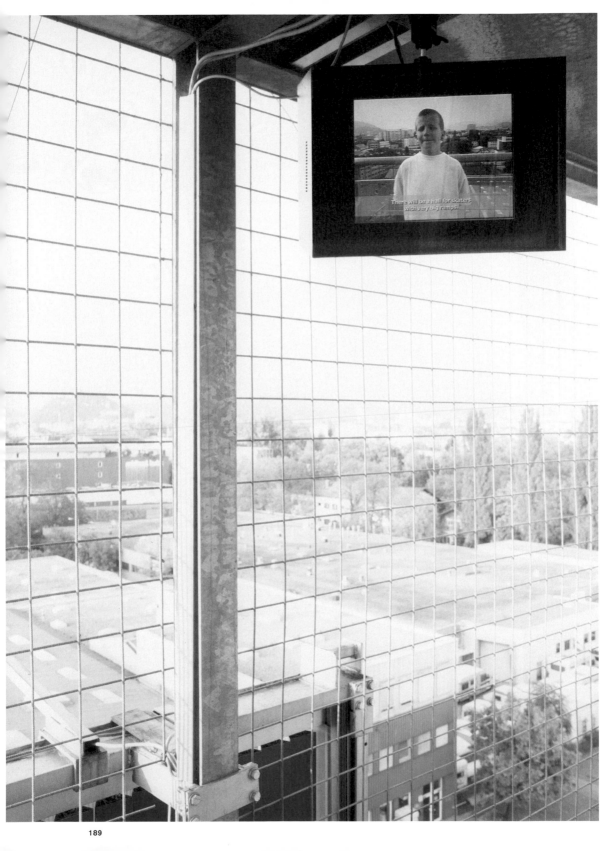

Untitled Journey, 2003

Serie bestehend aus 10 Zeichnungen, die von
Freunden und Verwandten Ondáks angefertigt
wurden, nachdem er jedem genau dieselbe
Beschreibung einer von ihm unternommenen
Zugreise gegeben hatte.

Series of 10 drawings made by Ondák's friends
and relatives to whom he had given identical
descriptions of him travelling in a train carriage.

Ich war sein Komplize
Frank Frangenberg

Ich war ein leichtes Opfer, ich bekomme gerne Geschenke und schätze die informelle
Verbindlichkeit, die sich durch diese sympathische Geste entwickeln kann, aber nicht
muss. Er hatte schon sein Netz gespannt und im Kölnischen Kunstverein den Mars
ausgebreitet, ich musste hineinlaufen. Wann bekommt man die unendlichen Weiten
des Weltraums schon auf dem Silbertablett für ein paar Taler geboten. Zudem hatte
ich gerade erst, kurz vor Betreten der Marsoberfläche, eine erhebliche Sinnkrise durch-
litten und mein Leid an meiner Gesellschaft in die jedem geläufigen Ausdrücke ge-
fasst, da ich weder für Parken noch Pipimachen passende Münzen fand. Wo alles in
Verwertungszusammenhängen steht, können Geschenke einen verführerischen Charme
entwickeln. Und dieser Mann schenkte mir sogar das Gefühl, auf dem Mars zu stehen.
Dankbarkeit sucht ihr Opfer. Ich suchte nach dem Urheber der geglückten Suggestion
eines roten Planeten, nach einem großzügigen Geist.

Während ich in dem mir empfohlenen Katalog blätterte, stieß ich auf einen Satz,
der äußerst bescheiden eine Selbstverständlichkeit aussprach. Mir gefiel das Zurück-
genommene, leicht Arrogante im Sprachduktus des Autors: „An interesting aspect
of several … works is that they do not necessarily need to be understood as works of
art." Verblüffend, wie sicher ich gewesen war, dass es sich bei dem, was ich erlebt
hatte, um mehr handeln sollte als um Kunstwerke. Was sie waren, erschien mir neben-
sächlich. Schließlich hatte ich ihre Wirkung erlebt und war schon zufrieden, einmal
in meinem Leben auf dem Mars gewesen zu sein. Mich faszinierte die ausgefeilte
Strategie des Mannes, der zugab, sich als Regisseur zu begreifen. Seine Taktiken zu
verstehen und von ihm zu lernen, hieße, so spekulierte ich, eine weitere Technik des
Glücks zu beherrschen.

Schnell hatte ich herausgefunden, dass in fast allen seinen Arbeiten eine Geste im Mittelpunkt stand, die mir sein Geschick besser zu erklären vermochte. Eine leicht zu verstehende Geste: der Mann vergab Geschenke wie ein Südseeinsulaner. Das unweigerlich dieser Geste folgende Gefühl seines Publikums konnte nur sein, sich beschenkt zu fühlen. Ich hatte kürzlich erst über Stämme im Bismarckarchipel gelesen, bei denen der Häuptling, genannt bikmen, eine große Party ausrichtet, nur damit alle Eingeladenen ihm zum Dank dafür noch mehr Muschelgeld über sein Haus hängen. Ganz unterschiedliche Partys hatte mein Mann bisher inszeniert, Beispiele dafür fand ich auf vielen Seiten des Katalogs reproduziert.

Einem in seinem Bestand gefährdeten deutschen Kunstverein verlieh er Ausdruck, als seine täglich zur Warteschlange gereihte Menschengruppe vor dem Hause kunstinteressierte Bürger darstellte. Seine reiseunwilligen Verwandten und Bekannten schickte er zuletzt doch noch auf Weltreise, als er Postkarten ihrer Fotoporträts von Touristen in die ganze Welt versenden ließ. Zuhause erzählte er seinen Leuten von den Orten, an die er gereist war, so dass sie nach seinen Erzählungen Bilder malten, Objekte bauten, Orte entwarfen, an denen sie nie gewesen waren. (Überhaupt gingen die meisten Geschenke, so schien es, an Verwandte und Bekannte, die im Gegensatz zu ihm Bratislava selten verließen. Es sei denn, sie fuhren eine Armada Skodas in seinem Auftrag von Bratislava nach Wien, wie es im Katalog beschrieben war.) In einer Galerie brachte eine junge Frau ihrem Kind das Gehen bei, und alle durften zusehen, wie am Ende der Ausstellung ein weiterer Mensch sich hinstellen und gehen konnte. Und mir hatte er das Gehen auf dem Mars geschenkt.

Das war der Mars – na und? Die bekannte, rötlich staubige, mit Steinen übersäte Marsoberfläche füllte den beidseitig verglasten Schlauch des Ausstellungsraums aus, so dass die transparenten Wände den Blick Außenstehender auf mich, den Marsianer, freigaben. Zurückwinken? Ich drehte mich um die eigene Achse, testete mit vorsichtigem Schritt kleine Felsformationen – wie es die kleinen Roboter Spirit und Opportunity wahrscheinlich in diesem Moment auf dem wahren Mars ebenso taten – und merkte nach einigen lang gedehnten Augenblicken, dass ich auf diesem Mars genauso wenig anfangen konnte wie auf dem wahren Mars. Sich vorzustellen, man sei Tausende von Kilometern und Tagen geflogen, nur um auf einer unwirtlichen Ebene rote Steine zu kicken. Die Lavasteine kamen aus der benachbarten Eifel, die an einigen Stellen tatsächlich an einen unbewohnten Planeten erinnert; beim rötlichen Staub des Mars handelte es sich um den zusammengekehrten Belag alter Tennisplätze; die Oberfläche des roten Planeten, Kölner Version, war verstärkt von vielen Kubikmetern Zement.

So offensichtlich dieser Mars sich nur inszenierte, dennoch: Es ging ein unwiderstehlicher Reiz von seiner Suggestion aus, den ich mir kaum erklären konnte, wie ich mir eingestand. Vielleicht ging es hierbei um mehr als nur einen symbolischen Akt? Um eine willentliche Umdeutung der Materie, wie sie mir aus der katholischen Liturgie,

in der Brot und Wein verwandelt werden, um eine neue Wirklichkeit zu setzen, durchaus vertraut war?

Hier war der Mars. Und warum nicht. Zu meinen Füßen roter namenloser Staub, die großen Fensterscheibenwände zeigten mir, dem Marsianer, auf der einen Seite das Straßenleben einer mitteleuropäischen Großstadt – Köln, klar – und gaben zur anderen Seite den Blick frei (nur den Blick, kein Fuß durfte sich hinüberwagen) auf, na was schon: Amerika. Das echte, tatsächliche Amerika. Den Innengarten des hoch abgeschirmten Kölner Amerikahauses. Ob Mitteleuropa nun näher am Mars lag als Amerika schien kaum zu klären, auf jeden Fall, soviel stand fest, lag der rote Planet dazwischen. Für welche Wirklichkeit ich mich entscheiden würde, konnte da leicht zur Geschmacksfrage werden. Zumindest glaubte ich an die Existenz Kölns, draußen vor den Fenstern. Ich glaubte auch an die Existenz Amerikas, das angeblich direkt nebenan lag. Würde ich nicht akzeptieren auf dem Mars zu stehen, fiel mir ein Gedanke wie ein Medizinball vor die Füße – in dieser Marsluft purzelten die Gedanken langsam wie schwere Bälle vor sich her –, müsste ich nicht zwangsläufig die Realität von Amerika nebenan akzeptieren. Entscheiden Sie sich für das freundliche Angebot, dachte ich mir und fühlte mich äußerst beschenkt, die Wahl haben zu dürfen.

Ich begriff, dass der Mann den Mars mir als Geschenk mitgebracht hatte, damit ich darauf herum laufen konnte, womit sein Wirken schon beschlossen war. Ein Angebot, das ich ebenso wenig auszuschlagen vermochte wie die Pariser Bürger das von Napoleon dem Dritten, der ihnen den Bois de Boulogne übereignete.

Geschenke machen außer ihrer unweigerlichen Konsequenz Dankbarkeit hervorzurufen keine weiteren Probleme. Konnte ich aber demjenigen, der mir das Geschenk machte, trauen? In einem Interview hatte mein Mann, der in Bratislava zwischen 1988–1994 an der Akademie der bildenden Künste studiert hatte, in lakonischer Trockenheit angegeben, im ersten Jahr sei auf dem Stundenplan gestanden: Zeichnen; im zweiten Jahr hätte Malerei folgen sollen, tatsächlich sei damals auf dem Plan gestanden: Revolution.

Wem die Malerei durch die Revolution ersetzt wird, darf man sich vertrauensvoll überantworten, fand ich heraus. Die meisten seiner Arbeiten glichen sich darin, dass er die Konzeption lieferte. Er entwarf die Szene, oft Schauplätze alltäglicher Verhaltensweisen, und gab damit eine vage Anleitung, ohne zu sagen, was zu tun sei, wie Geschenke ja selten mit Bedienungsanleitungen überreicht werden. Sein Publikum füllte die Situationen mit seiner Präsenz und seinen Reaktionen. Und wurde so, vielleicht ohne es zu wissen, zum Komplizen seiner Arbeit. Ich konnte dem Mann trauen, denn in weit größerem Maße als dieses auf ihn, war er auf sein Publikum angewiesen. Seine Arbeiten lebten von seinem Publikum und von dessen Mithilfe. Auch der Mars würde nur solange im Kölnischen Kunstverein liegen, wie er und ich es glauben wollten.

Die erste Regel seiner erfolgreichen Taktik, Prunkstück seiner von mir so bewunderten Technik, würde lauten: Mach dein Publikum zum Komplizen deiner Arbeit! Jeder konnte zu seinem Komplizen werden, auch jemand, der sich für Kunst nicht interessierte. Der Mann, der mir den Mars schenkte, gab vielen Menschen Geschenke und schloss, soweit ich sah, niemanden aus. Das Wesen der Komplizenschaft trägt, fern inkriminierter Zusammenhänge, ausgesprochen sympathische Züge, da es Menschen zusammenbringt, die ein gemeinsames Interesse verbindet. Ausgrenzungsrituale, Provokationen gegen die humane Moral fand ich bei meinem Mann natürlich nicht. Er mutete seinem Publikum nur Situationen zu, in denen es sich beschenkt fühlen durfte. Ich war ein glückliches Opfer, sein Komplize.

I Was an Accomplice
Frank Frangenberg

I was an easy victim, I like receiving gifts and value the informal commitment that
sometimes follows this friendly gesture. He had already cast his net and spread out
his Mars in the Cologne Kunstverein, I was destined to be trapped. Where else is end-
less space presented to you on a silver tray for so little money. Furthermore, I had just
gone through a serious mental crisis shortly before stepping onto the surface of Mars,
when I had no change for parking or making a wee and expressed my frustration with
society in commonly known terms. Everything suddenly cost money. When everything
has been commercialised, gifts can develop a seductive charm. And this man even
presented me with the experience of standing on Mars. Gratitude seeks its own victim.
I sought the creator of the convincing image of a red planet, sought a generous spirit.

While paging through the recommended catalogue, I came across a sentence that
subtly referred to a self-evident truth. I liked the author's unpretentious, slightly arro-
gant style: "An interesting aspect of several … works is that they do not necessarily
need to be understood as works of art." It is astonishing how I knew that what I had
experienced was intended to be more than artworks. What they were was insignificant
to me. I had experienced their effect and was happy to have experienced standing
on Mars once in my life. I was fascinated by the complex strategy of this man, who
confessed that he considered himself something like a film director. To understand his
tactics and to learn from them meant to master another technique of happiness, I
speculated.

I had soon discovered that nearly all of his works centred around a gesture, which
was best explained by his skill. A gesture that was easy to understand: the man hand-
ed out presents like a South Sea islander. This gesture inevitably evoked a feeling
of gratitude among the audience. I had only recently read about tribes in the Bismarck
Archipelago, where the chief, called bikmen, arranges large parties for the only pur-

pose that his guests then have to thank him by hanging more shell money on his house. My man had arranged a variety of parties, examples of which were depicted on many pages of the catalogue.

He brought an endangered German Kunstverein back onto the art map when he arranged a group of people to queue outside the building each day, representing citizens interested in art. He sent his relatives and friends, who were unwilling to travel, around the world by asking tourists to send postcards depicting portraits of them to places all over the world. At home he told his friends of the places he had been to and then asked them to paint, build objects, design places they had never been to based on what he had told them. (Most of his gifts, it seems, were presented to relatives and friends, who, unlike him, never left Bratislava. Unless they drove an armada of Skodas to Vienna upon his request, as was described in the catalogue.) In an art gallery a young woman taught her child how to walk, with everyone watching how by the end of the exhibition a new person had learnt to stand up and walk. And he presented me with the experience of standing on Mars.

That was Mars – so what? The well-known, red, dusty and stony surface of Mars filled the exhibition room. The glass walls permitted people outside to see me, the Martian, within. Wave back? I turned around, carefully probed a small rock formation with my feet – like the small robots Spirit and Opportunity, who were probably doing just the same thing at that same moment on the real Mars – and noticed after a few long moments, that I could do as little on this Mars as on the real Mars. Imagine I had flown thousands of kilometres and days only to kick red stones on an uninhabitable surface. The lava rocks were from the neighbouring Eifel, which actually looks like an uninhabited planet in some places; the red Mars dust was from old tennis courts; the surface of the Red Planet, Cologne version, was made of many cubic metres of cement.

This Mars was so obviously artificial, but nevertheless: its suggestiveness emanated an irresistible charm, which, admittedly, I found hard to explain. Perhaps this was more than a symbolic act? An intentional reinterpretation of matter similar to the familiar Catholic liturgy, in which bread and wine are transformed to create a new reality?

Here was Mars. And why not. Nameless red dust at my, the Martian's feet, the large glass walls revealing on the one side the street life of a central European city – Cologne, of course – and on the other side a glimpse (and only a glimpse, as no one would ever be allowed to set foot here) of ..., well, of what?: America. The true and real America. The back garden of the well protected Cologne America House. Whether central Europe was closer to Mars or America was not evident, but it was obvious that Mars was between the two. The choice between the two realities could easily become a question of taste. I did believe in the existence of Cologne on the other side of the windows. I also believed in the existence of America, which was supposedly next door.

If I did not accept that I was standing on Mars, this idea fell heavily down to the ground
– in this Mars atmosphere thoughts fell around slowly like heavy balls –, I would have
to accept the reality of America next door. Accept the friendly offer, I thought, and felt
honoured to be given the choice.

I understood that the man had brought Mars along as a gift to me, so that I could
walk on it; his work had thus ended. An offer I was unable to decline, like the Parisians
when Napoleon III gave them the Bois de Boulogne.

Apart from their effect of evoking gratitude without fail, gifts are completely unprob-
lematic. Could I trust the person who gave me the gift, however? In an interview, my
man, who had studied at the Academy of Fine Arts in Bratislava from 1988 to 1994,
had said laconically that his schedule for the first year comprised drawing; painting
was supposed to follow in the second year, but the schedule had been changed to:
Revolution.

I discovered that one *can* trust someone who was taught revolution instead of paint-
ing. Most of his works were similar in that he provided the concept. He designed the
scenes, often venues of every-day behaviour, thus giving us a vague instruction without
telling us what to do, just as gifts are rarely presented with instructions. His audience
filled the situations with their presence and their reactions. This made them, perhaps
unknowingly, accomplices of his work. I could trust the man, because he was depend-
ent on his audience to a far greater extent than his audience on him. His works were
brought to life by himself and his audience together. Mars, too, would remain in the
Cologne Kunstverein only as long as he and I wanted to believe.

The first rule of his successful strategy, the showpiece of the technique I admired
so much, would be: Make your audience the accomplice of your work! Anyone could
become his accomplice, even someone who showed no interest in art. The man who
presented Mars to me gave presents to many people, never excluding anyone, as far
as I was aware. The nature of this alliance is by no means incriminating, but rather
has distinctly positive features, as it unites people with a common interest. This man
never employed elimination rituals or provoked the human morale. He only exposed
his audience to situations in which they were able to feel like recipients of a gift. I was
a happy victim, his accomplice.

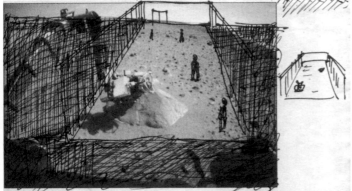

Spirit je po týždni problémov opäť v akcii. FOTO- REUTERS

Gezeichneter Vorentwurf für die
Installation „Spirit and Opportunity", 2004
Tintenstift auf Zeitungsbild

Preparatory drawing for the installation
'Spirit and Opportunity', 2004
Pen on a newspaper photograph

Transitory Hall, 2004

Um den typischen Charakter von Warte- und Transiträumen in Bahnhöfen und Flughäfen zu simulieren, wurden die Fenster im Foyer des Kölnischen Kunstvereins durch Spiegel ersetzt. Installation

With the aim of simulating the character of spaces that function as waiting rooms for transit, such as in train stations and airport halls, windows were replaced by mirrors in the foyer of Kölnischer Kunstverein. Installation

Spirit and Opportunity, 2004

Im Ausstellungsraum wurde auf der Basis von Bildern aus Zeitungen und Zeitschriften die Marsoberfläche rekonstruiert.
Beton, Tennisplatzsand, Lavagestein
Installation Kölnischer Kunstverein

The surface of Mars was reconstructed in the gallery on the basis of images published in newspapers and magazines.
Concrete, tennis court clay, lava stones
Installation Kölnischer Kunstverein

S./pp. 204–205

Transitory Hall, 2004

Detailansicht der Installation
A detail of the installation

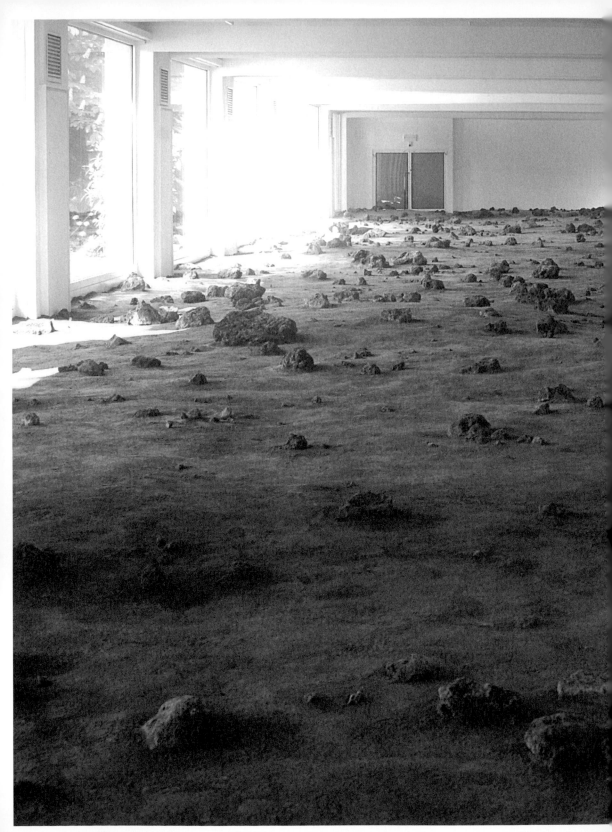

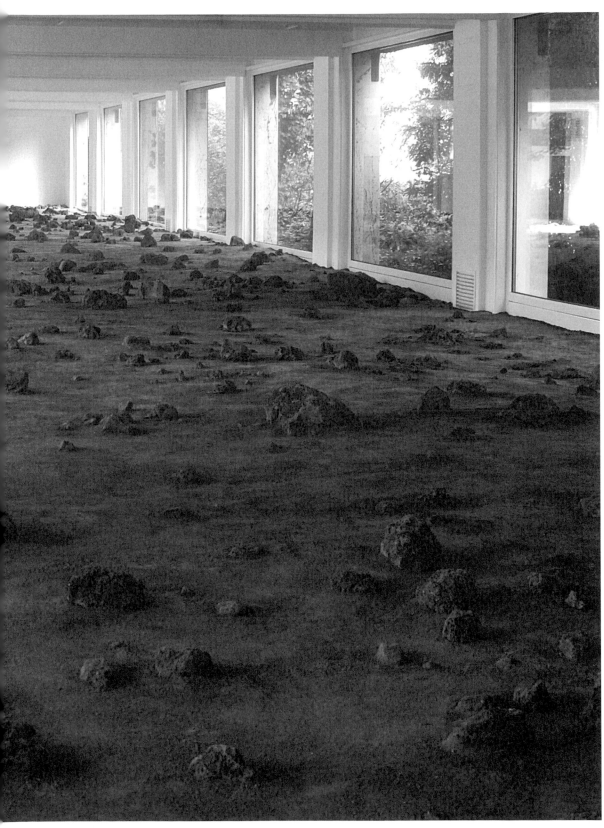

Die Performance fand während der Ausstellungseröffnung statt. Ondák kontaktierte Freunde von Mitgliedern des Kunstvereins, die sich bis dahin nicht für zeitgenössische Kunst interessiert hatten und deshalb gewöhnlich nicht zu Ausstellungseröffnungen kommen. 80 Personen haben sich bereit erklärt, eine halbe Stunde vor Ausstellungseröffnung in den Kunstverein zu kommen, ohne jedoch zu wissen, was sie dort genau erwartete. Diese ungewohnten Gäste wurden durch den Seiteneingang in das Kunstvereinsgebäude geleitet und warteten eine halbe Stunde im Ungewissen in den für die Ausstellungsbesucher nicht zugänglichen Büroräumlichkeiten. Schließlich drängten sie über das Treppenhaus ins Foyer, wo die echten Vernissagebesucher, wie gewohnt, auf den Einlass in die Ausstellung warteten und den Begrüßungsworten des Vorsitzenden des Kunstvereins zuhörten.

The performance took place during the exhibition opening. Ondák contacted friends of members of the Kunstverein who had not previously been interested in contemporary art and did not, therefore, usually come to exhibition openings. Eighty people agreed to come to the Kunstverein half an hour before the opening of the exhibition, but without knowing exactly what to expect there. These unfamiliar guests arrived through the side entrance to the Kunstverein building where they were kept waiting for half an hour in the office area, not usually accessible to exhibition visitors. They flooded into the foyer by way of the staircase while real visitors to the exhibition opening were waiting in the foyer and listening to the chairman's opening speech.

Crowd, 2004

Performance mit einem echten und einem
falschen Publikum; Stills aus einer Video-
dokumentation einer Performance im
Kölnischen Kunstverein

Performance with a real and fake audience;
stills from a video document of a performance
at Kölnischer Kunstverein

Good Feelings in Good Times, 2003/4

Eine kleine Gruppe bewegt sich von einem
Ort zum anderen, wobei sie ständig eine „kün-
stliche" Warteschlange an verschiedenen Stel-
len innerhalb und außerhalb des Zelts simuliert.
Diese „künstliche" Warteschlange entsteht
unabhängig von jeglichen „echten" Warte-
schlangen, die sich vor dem Zelt bilden könn-
ten. Sie handelt davon, wie man die Zeit als
langsam vergehend erlebt, wenn man Schlange
steht – als etwas, das parallel existiert, jedoch
nichts mit den sonstigen Geschehnissen auf
der Kunstmesse zu tun hat.

Projekt und Vorentwurf für eine Performance
bei der Frieze Art Fair, London
Bleistift auf Papier

There should be a small group of people moving
from one place to another and constantly simulat-
ing an 'artificial' queue at various points inside and
outside the tent. This 'artificial' queue will be in
spite of any 'real' queues formed in front of the tent.
It will be about how one experiences time as slow
while waiting in a queue – as something existing in
parallel but discontinuous to what will be happening
at the art fair around it.

Project and preliminary drawing for performance
at the Frieze Art Fair, London
Pencil on paper

Good Feelings in Good Times, 2003/4
Performance, Frieze Art Fair, London

Werkliste / List of works

35 **Untitled**, 1992
Tusche auf einer Buchillustration
Ink on a book illustration
11 x 6,5 cm

36 **Twins**, 1992
Tusche auf Papier
Ink on paper
14 x 19,5 cm

37 **Waiting Room**, 1997
Sitze für Ausstellungswächter, gefertigt aus
einem Teil der Holzwand der Galerie.
Entwurf für die Installation, Tintenstift auf Papier
Seats for attendants made from a section
of the gallery's wooden wall.
Proposal for the installation, pen on paper
17 x 21 cm

38 **Untitled**, 1997
An die Wand geklebte Steckdosen-Attrappen.
Installation im Atelier des Künstlers
Fake electric sockets glued to the wall.
Installation in the artist's studio

39 **Untitled**, 1998
Abmontierte Steckdosen, befestigt auf Metallstiften
Installation Webster Universität, Wien
Dismounted electric sockets on metal rods
Installation Webster University, Vienna

40/41 **Closer to Each Other**, 1997
Abmontierte Steckdosen, befestigt auf Metallstiften
Installation PGU, Žilina
Dismounted electric sockets on metal rods
Installation PGU, Žilina

42/43 **Descending Door**
Retreating Door, 1997
2 C-Prints aus einer Serie von 4
2 Editionen 5 + 2 A.P., 32 x 40 cm und 100 x 127 cm
Sammlung MUMOK, Wien
2 C-prints from a series of 4
2 editions 5 + 2 A.P., 32 x 40 cm and 100 x 127 cm
Collection MUMOK, Vienna

44 **Unit**, 1998
Sockel und elektrischer Ventilator
Variable Dimensionen
Installation SNG, Bratislava
Pedestal and electric fan
Dimensions variable
Installation SNG, Bratislava

45 **Unit**, 1998
Tintenstift auf Papier
Pen on paper
40 x 31,7 cm

46 **Remind me again**, 1998
Steckdosen, Lüftungsklappen und Alarmsensor
von der Wand abgenommen und auf einem ver-
kleinerten Modell des Ausstellungsraums montiert.
MDF, Farbe, Beschläge von den Wänden
Variable Dimensionen
Installation ICA, Dunaújváros
Electric sockets, ventilation covers and alarm
sensor removed from the walls and mounted onto
a miniature model of the gallery.
MDF, paint, fittings from the walls
Dimensions variable
Installation ICA, Dunaújváros

47 **If I don't forget**, 1998
Elektrisches Heizgerät von der Wand abgenommen
und an der Seite eines Sockels fixiert, ausgeschnittenes
Element einer Tür.
Verschiedene Dimensionen je nach Installation
Installation SG, Banská Bystrica
Electric heater removed from the wall and fixed to
the side of a pedestal, cut-out part of a door.
Dimensions vary with installation
Installation SG, Banská Bystrica

48 **Resting Corner**, 1999
Sofa und Trennwand wurden aus dem Aufenthaltsraum der
Museumsangestellten in den Ausstellungsraum versetzt.
Installation Galerie Tatranská, Poprad
Sofa and shelving unit from the museum's staff room
relocated in the gallery.
Installation Tatranská Gallery, Poprad

49 **This Way, Please**, 1999
Aufstellung der Wächter dem Alter nach, vom
jüngsten bis zum ältesten, während der Besucher
durch die Ausstellung geht.
Vorentwurf für eine Performance, Tintenstift und
Ölfarbe auf Papier
Attendants arranged in order of age from the youngest
to the oldest as the visitor passes through the exhibition.
Preliminary drawing for performance,
pen and oil paint on paper
21 x 29,7 cm

50 **Silence, Please**, 1999
Vorentwurf für eine Performance, Tintenstift auf Papier
Preliminary drawing for performance, pen on paper
21 x 15,2 cm

51–53 **Silence, Please**, 2004
Wächter tragen Originaluniformen der Museums-
wächter aus der Zeit ihrer Geburt.
Performance im Stedelijk Museum, Amsterdam
Attendants dressed in museum attendant's uniforms
dating from the period in which they were born.
Performance at Stedelijk Museum, Amsterdam

54 **Daily News**, 1998
Tintenstift und Tempera auf Papier
Pen and tempera on paper
35 x 49,7 cm

55 **Sharing the Room**, 1998
Ein Vogelhaus wird aus einem Baum in ein
naheliegendes Hotelzimmer versetzt.
Bird-box relocated to a hotel room from a nearby tree.

56/57 **Sharing the Room**, 1998
Hotelzimmer, im Fenster aufgehängtes Vogelhaus,
ausgeschnittene Öffnung in einem Fensterglas
Installation im Hotel Unterbergnerhof in den
österreichischen Alpen
Hotel room, bird-box hung on a window, cut-out opening
in window pane
Installation in the Hotel Unterbergnerhof, Austrian Alps

58/59 Colour and Size, 1999
Ausgeschnittene Öffnungen in Schuhschachteln,
die mit „Farbe" und „Größe" etikettiert wurden;
die Schuhschachteln wurden wie Vogelhäuser an
verschiedenen Stellen um eine Galerie herum montiert.
Installation Galerie Sýpka, Brno
Openings made in shoe boxes bearing labels 'colour'
and 'size'; shoe boxes installed like bird-boxes in
different locations around gallery.
Installation Sýpka Gallery, Brno

60 I remember this, 1998
Steckdosen, Notausgangslampe und Alarmsensor
wurden von den Wänden abgenommen und auf einem
verkleinerten Modell des Ausstellungsraumes montiert.
MDF, Farbe, Beschläge von den Wänden
Höhe 120 cm, variable Gesamtdimensionen
Installation Städtische Galerie, Prag
Electric sockets, emergency exit lamp and alarm
sensor removed from the walls and mounted on
a miniature model of the gallery.
MDF, paint, fittings from the walls
Height 120 cm, overall dimensions variable
Installation City Gallery, Prague

61 Drawn Retrospective, 2000
Zeichnung aus einer Serie von 36, Farbstift auf Papier
Drawing from a series of 36, colour pencil on paper
21 x 29,7 cm

62 I can't recall this, 1998
Tintenstift auf Papier
Pen on paper
35 x 50,5 cm

63 I can't recall this, 1998
Gipskartonplatte, Farbe, Heizgeräte- und
Steckdosen-Attrappen
Höhe 270 cm, variable Gesamtdimensionen
Installation Städtische Galerie, Prag
Plasterboard, paint, fake radiators and electric sockets
Height 270 cm, overall dimensions variable
Installation City Gallery, Prague

64/65 Is that the way it was?, 1998
Bank, aus einem Teil der falschen Holzwand der Galerie
angefertigt, ausgeschnittene Öffnung in einem
Fensterglas, Vogelhaus von außen an ein Fenster montiert.
Unterschiedliche Dimensionen je nach Installation
Installation Städtische Galerie, Prag
Bench made from a section of the gallery's false
wooden wall, cut-out opening in a window pane,
bird-box attached from outside onto window.
Dimensions vary with installation
Installation City Gallery, Prague

66/67 Infocentrum, 1999
Ondák besuchte einheimische Hobbymaler und lud sie ein,
mit ihm und anderen professionellen Künstlern an einer
Gruppenausstellung in einer Galerie teilzunehmen. Um
den Nachteil des „Nicht-Professionell-Seins" auszugleichen,
wurde den Hobbymalern angeboten, ihre Originale
auszustellen, während von den Professionellen lediglich eine
Diadokumentation gezeigt wurde. Die Galerie wurde von
Ondák mit weißen Ziegeln und Gipskartonplatten adaptiert,
um sie dem modernistischen Ideal eines Ausstellungs-
raumes anzupassen.
Veranstaltung und Installation in der Galerie Emil Filla,
Ústí nad Labem

Ondák visited and invited local amateur painters to
exhibit in a group exhibition in a public gallery together
with professional artists, including the artist himself.
To make up for the disadvantage of being 'unpro-
fessional', the amateurs were given the opportunity
to show their original paintings, while the work of
the 'professionals' was only presented in slide form.
Ondák refurnished the gallery by white bricks and
plasterboard sheets to give it the ideal modernistic
appearance thought to be suitable for the presentation
of contemporary art.
Event and installation at Gallery Emil Filla, Ústí nad
Labem

68 Exposure, 1998
Bleistift, Tintenstift und Klebeband auf Papier
Pencil, pen and tape on paper
49 x 70 cm

69–71 Exposure, 1998
Ausgeliehene Kunstwerke aus der Sammlung des
Museums und sonstige Elemente aus dem Depot
wurden arrangiert, um eine „Ausstellung" zu simulieren.
Installation in zwei Räumen des Ujazdowski-Schlosses,
Warschau
Artworks borrowed from the museum's permanent
collection and other elements removed from the
museum's stores were arranged to simulate 'the
exposition'.
Installation in two rooms of Ujazdowski Castle,
Warsaw

72/73 Museum/Storage, 1999
Wasserkühler, Kaffeemaschine und Stuhl wurden
von den Museumswächtern benutzt; die Gegenstände
in einer Kiste stammen aus den Museumdepots und
den Personalräumen.
Variable Dimensionen
Installation Nationalgalerie, Praha
Water cooler, coffee machine and chair used by
museum's attendants. Items inside box were
collected from the museum's stores and staff rooms.
Dimensions variable
Installation National Gallery, Praha

76 Through the Eye Lens, 1999
Bleistift und Tintenstift auf Papier
Pencil and pen on paper
40,8 x 59 cm

74–75, 77 Through the Eye Lens, 1999
Vom Ausstellungsraum aus wurde eine Öffnung direkt
zur Küche des Museumsrestaurants gegraben. Ondák
stellte in dieser Öffnung ein kleines Zelt auf und
rüstete sich mit dem Werkzeug eines Archäologen aus.
Während einiger Tage vor der Ausstellung sammelte
er diverse vom Kochen übrig gebliebene Gegenstände
aus der Küche ein, die er durch die Öffnung in den
mit Seilen markierten Bereich trug, als ob sie archäo-
logische Funde wären. Die Ausstellungsbesucher
konnten die ständigen Bewegungen der in der Küche
arbeitenden Menschen hören und beobachten.
Verschiedene Dimensionen
Installation Museum Ludwig, Budapest
An opening was made into the kitchen of the
museum's restaurant directly from the exhibition space.
Ondák inserted a small tent into the opening and
equipped himself with archaeologist's tools. In the
days preceding the exhibition, the artist collected
several objects from the kitchen left over from cooking
and brought them, as if they were archaeological

finds, through the opening in the wall into an area of the gallery marked by a rope. Afterwards, visitors to the exhibition also had the chance to partially hear and observe the continuous activities of people working in the kitchen.
Installation Museum Ludwig, Budapest

78/79 **Storyboard**, 2000
Ondák hat seinen Freunden und Verwandten den leeren Raum einer Galerie beschrieben. Eine Serie von 40 Zeichnungen, die sie anfertigten, war dann das einzige, das in der Ausstellung gezeigt wurde.
Installation MK Galerie, Rotterdam
Ondák described the empty space of the gallery to his friends and relatives. They then made a series of 40 drawings based on his description, which were the only items in the exhibition.
Installation MK Gallery, Rotterdam

80 Das Foto zeigt den Vater des Künstlers zeichnend, 2000
Artist's father drawing, 2000

81 **Untitled (Empty Gallery)**, 2000
Ondák hat seinen Freunden und Verwandten den leeren Raum der Galerie beschrieben. Eine Serie von 24 Zeichnungen, die sie anfertigten, war dann das einzige, das in seiner Ausstellung gezeigt wurde.
Installation Galerie Knoll, Wien
Ondák described the empty space of the gallery to his friends and relatives. They then made a series of 24 drawings based on his description, which were the only items in the exhibition.
Installation Knoll Gallery, Vienna

82–85 **Common Trip**, 2000
Zeichnungen und Gegenstände, die von Menschen angefertigt wurden, denen Ondák die einprägsamsten Orte, die er je besucht hat, beschrieb.
128 Elemente, unterschiedliche Gesamtdimensionen je nach Installation
Installation gb agency, Paris
Drawings and objects made by people to whom Ondák described the most memorable places he had ever visited.
128 elements, overall dimensions vary with installation
Installation gb agency, Paris

86/87 **Antinomads**, 2000
Freunde und Verwandte des Künstlers wurden gefragt, ob sie sich als Nomaden oder als Antinomaden verstehen. Fotografien derjenigen unter ihnen, die sich selbst als Antinomaden sahen, wurden in Serien mit jeweils 12 Postkarten gedruckt und bei Ausstellungen zur freien Entnahme aufgelegt.
Postkarten je 10,5 x 14,8 cm
Endloser Nachdruck
Edition 1 + 2 A.P.
Friends and relatives of the artist were interviewed as to whether they consider themselves to be either nomads or antinomads. Photographs of those who considered themselves to be 'Antinomads' were then published as a series of 12 postcards which were available to take away at exhibitions.
Each postcard 10,5 x 14,8 cm
Endless reprint
Edition 1 + 2 A.P.

88/89 **Antinomads**, 2000
Installation in der Nationalgalerie, Prag und in einem Zeitungskiosk in Bratislava
Installation National Gallery, Prague and newsstand in Bratislava

90/91 **Drawn Retrospective**, 2000
Serie bestehend aus 36 Zeichnungen, Farbstift auf Papier, je zwischen ca. 17 x 22 cm und 21,5 x 30,5 cm
Sammlung Fonds National d'Art Contemporain, Paris
Drawings from a series of 36, colour pencil on paper, between approx. 17 x 22 cm and 21,5 x 30,5 cm each
Collection Fonds National d'Art Contemporain, Paris

92/93 **Double**, 2001
Genaue Nachbildungen der Schilder und Fahnen einer Galerie wurden an der Fassade eines gegenüberliegenden Gebäudes montiert.
Installation BAK, Utrecht
Exact replicas of the gallery's signs and banners were mounted on the façade of a building across the street.
Installation BAK, Utrecht

94/95 **Dubbing**, 2001
Serie von 30 Zeichnungen, die von den Verwandten Ondáks, basierend auf seinen Beschreibungen einer Gruppenausstellung, an der er teilnahm, angefertigt wurden.
Installation BAK, Utrecht
Series of 30 drawings made by Ondák's relatives based on his description of a group exhibition in which he participated.
Installation BAK, Utrecht

96 **Untitled (Traffic)**, 2001
Tintenstift, Farbstift und Klebeband auf Papier
Pen, colour pencil and tape on paper
38 x 46 cm

97 **Untitled (Traffic)**, 2001
Hämmer von Notausgängen in öffentlichen Bussen
Installation in verschiedenen Einrichtungen, Slavonski Brod, Kroatien
Bus emergency-exit hammers
Installation at various premises, Slavonski Brod, Croatia

127 **Slovakoczechia**, 2001
Sticker, Edition
je 4,5 x 12,5 cm
Edition of stickers
4,5 x 12,5 cm each

128 Skodas unterwegs von Bratislava nach Wien, November 2001
Transit of Skodas from Bratislava to Vienna, November 2001

129–131 **SK Parking**, 2001
Slowakische Skodas wurden zwei Monate hinter dem Gebäude der Secession in Wien geparkt.
Aktion und Installation in der Secession, Wien
Slovakian Skodas were parked behind the Secession building in Vienna for two months.
Event and installation at Secession, Vienna

132 Einladungskarte für „Guided Tour", Zagreb, 2002
Invitation card for 'Guided Tour', Zagreb, 2002

133–137 **Guided Tour**, 2002
Von einem eigens angeheuerten professionellen
Touristenführer wurden Führungen angeboten, welche
den leeren Galerieraum sowie den Alltag auf dem Platz
davor kommentierten.
Performance in der Galerie Josip Racic, Zagreb
Tours commenting on the empty gallery space and on
contemporary reality on the square in front of the gallery
were given by a professional guide hired for this occasion.
Performance at Gallery Josip Racic, Zagreb

138/139 Ein Porträt des jungen Touristenführers wurde in Auftrag
gegeben, um seine „Guided Tour" zu bewerben, 2002.
A portrait of the young tourist guide was commissioned
for the advertisement of his 'Guided Tour', 2002.

141–143 **Guided Tour (Follow Me)**, 2002
Führungen wurden von einem 12-jährigen Jungen
angeboten, dessen Kommentare ausschließlich in
der Zukunftsform gehalten waren.
Performance und Videodokumentation, 5 min., Farbe, Ton
Edition 3 + 2 A.P.
Performance in der Galerie Gradska Loza, Zadar
Tours were provided by a 12-year-old boy whose
commentary was given entirely in the future tense.
Performance and video document, 5 min., colour, sound
Edition 3 + 2 A.P.
Performance at Gallery Gradska Loza, Zadar

144/145 **Das Dritte Denkmal**, 2002
Auf den Gehsteig gesprühte Inschrift
Installation in Erlauf, Österreich
Sprayed inscription on a pavement
Installation in Erlauf, Austria

146–149 **Tomorrows**, 2002
Serie von 6 Plakaten, je 41 x 58,5 cm
6 Fuji C-Prints auf Archivpapier
je 30 x 41,8 cm
Edition 5 + 2 A.P.
Installation mit Plakaten in Erlauf, Österreich
Series of 6 posters, 41 x 58,5 cm each
6 Fuji archival C-type prints
each 30 x 41,8 cm
Edition 5 + 2 A.P.
Installation with posters in Erlauf, Austria

150 Aufnahme von „Announcement" im Studio des
slowakischen Rundfunks, Bratislava, 2002
Recording of 'Announcement' in the studio of
the Slovak Radio, Bratislava, 2002

151 **Tomorrows (Interview)**, 2002
Nachdem die Kinder für „Tomorrows" fotografiert wurden,
interviewte sie ein lokales Fernsehteam.
Fuji C-Print auf Archivpapier
40 x 59 cm
Edition 5 + 2 A.P.
Children interviewed by local television after they had
been photographed for 'Tomorrows'.
Fuji archival C-type print
40 x 59 cm
Edition 5 + 2 A.P.

152 Aus einem Buch ausgeschnittenes Bild, Pittsburgh, 1995
Cutting from a book, Pittsburgh, 1995

153 **Tickets, Please**, 1999
Projekt für eine Performance, Text auf Papier gedruckt
Project for performance, text printed on paper
29,7 x 21 cm

154 **Tickets, Please**, 1999
Vorentwurf für eine Performance, Tintenstift und
Bleistift auf Papier
Preliminary drawing for performance, pen and
pencil on paper
30 x 40 cm

155 **Teaching to Walk**, 2004
Eine junge Frau wurde eingeladen, mit ihrem
einjährigen Sohn in die Galerie zu kommen, um ihm
dort das Gehen beizubringen. Die Performance fand
täglich statt und dauerte jeweils eine halbe Stunde.
Performance in der Galerie Display, Prag
A young woman was invited to come to the gallery
with her one-year-old boy to teach him to walk there.
The performance was repeated every day for half an hour.
Performance at Gallery Display, Prague

156/157 **Tickets, Please**, 2002
Der Kartenverkäufer verkaufte gemeinsam mit seinem
Enkelsohn Eintrittskarten für die Ausstellung. Der
Enkelsohn verlangte im Erdgeschoss des Ausstellungs-
gebäudes die Hälfte des üblichen Eintrittspreises, der
Großvater kassierte im ersten Stock die ausstehende
zweite Hälfte.
Performance und Fotodokumentation
4 Fuji C-Prints auf Archivpapier, 62,5 x 92,7 cm und
28 x 40 cm, Text auf Papier gedruckt, 29,7 x 21 cm
Edition 5 + 2 A.P.
Performance in der Galerie Spala, Prag
The ticket-seller was selling tickets for the exhibition
with his grandson. The grandson was requesting half
the usual entrance fee on the ground floor and his
grandfather was collecting the remaining half of the
entrance fee on the first floor.
Performance and photo document
4 Fuji archival C-type prints, 62,5 x 92,7 cm and
28 x 40 cm, text printed on paper, 29,7 x 21 cm
Edition 5 + 2 A.P.
Performance at Gallery Spala, Prague

158/159 **Teaching to Walk**, 2002
Eine junge Frau wurde eingeladen, mehrmals mit ihrem
einjährigen Sohn in die Galerie zu kommen, um ihm
dort das Gehen beizubringen. Die Performance fand
täglich statt und dauerte jeweils eine halbe Stunde.
Performance in der Galerie Spala, Prag
A young woman was invited to come to the gallery with
her one-year-old boy to teach him to walk there. The
performance was repeated every day for half an hour.
Performance at Gallery Spala, Prague

161 **Short Drawn Retrospective**, 2002
Serie bestehend aus 12 Zeichnungen, Farbstift auf
Papier, je ca. 21 x 29,7 cm
Sammlung EVN, Wien
Drawing from a series of 12 , colour pencil on paper,
approx. 21 x 29,7 cm each
Collection EVN, Vienna

162 **Bad News Is a Thing of the Past Now**, 2003
Diptychon, s/w Fotografien, je 40 x 50,5 cm
Edition 5 + 2 A.P.
Diptych, b/w photographs, 40 x 50,5 cm each
Edition 5 + 2 A.P.

163 **Drawn B&W Retrospective**, 2003
Serie bestehend aus 18 Zeichnungen, Farbstift auf
Papier, je ca. 21 x 29,7 cm
Privatsammlung, Brüssel
Drawing from a series of 18, colour pencil on paper,
approx. 21 x 29,7 cm each
Private collection, Brussels

164 **I'm just acting in it**, 2004
Auf der Basis einer Beschreibung des Kurators zeichneten
zehn Menschen Ondák, wie er im leeren Ausstellungsraum
herumgeht.
Serie bestehend aus 10 Zeichnungen
Based on the curator's description, ten people drew
Ondák wandering in the empty exhibition space.
Drawing from a series of 10

165 **Announcement**, 2002
Folgende Ankündigung wird alle viereinhalb Minuten
wiederholt: „Als ein Zeichen Ihrer Solidarität mit den
jüngsten Ereignissen in der Welt bitten wir Sie, die
Tätigkeiten, die Sie gerade ausüben, für die nächste
Minute nicht zu unterbrechen."
Klanginstallation, Radioempfänger, Radiosendung
auf CD, 60 min., Loop
Edition 3 + 3 A.P. (Deutsch, Französisch, Englisch)
Sammlung Museum Ludwig, Köln
The following announcement is repeated every 4.30 min:
'As a sign of solidarity with recent world events, for the
next minute do not interrupt the activity you are doing at
this moment.'
Sound installation, radio set, radio broadcast on CD,
60 min., loop
Edition 3 + 3 A.P. (German, French, English)
Collection Museum Ludwig, Cologne

166/167 **Self-portraits of Two Artists as Young Men**, 2003
Selbstporträt und Fotografie eines Freundes des
Künstlers aus den 50er Jahren, Bleistift auf Papier,
30 x 20 cm und s/w Fotografie, 8,3 x 12,8 cm
Selbstporträt und Fotografie des Künstlers aus den
80er Jahren, Bleistift auf Papier, 42 x 29,5 cm und
s/w Fotografie, 8,3 x 12 cm
Self-portrait and photograph of the artist's friend from
the 50s; pencil on paper, 30 x 20 cm and b/w photograph,
8,3 x 12,8 cm
Self-portrait and photograph of the artist himself from the
80s; pencil on paper, 42 x 29,5 cm and b/w photograph
8,3 x 12 cm

168/169 **Another Day**, 2003
Die Kartenverkäuferin wurde gemeinsam mit ihrem
Ladentisch und den Katalogen vom Foyer in den
Ausstellungsraum übersiedelt, wo sie den Karten-
verkauf fortsetzte.
Performance bei Dum umĕní, Brno
The ticket-seller and her counter with catalogues were
removed from the foyer to the exhibition space where
she continued to sell tickets.
Performance at Dum umĕní, Brno

170–173 **Slowed-down Journey**, 2003
Acht Menschen wurden gebeten, sich Ondák unter-
wegs beim Gehen durch verschiedene Städte vorzu-
stellen und ihn dabei zu zeichnen.
Serie bestehend aus 8 Zeichnungen
Sammlung der Kadist Stiftung, Paris

Eight people were asked by Ondák to imagine and
draw him walking in different cities while on his travels.
Drawings from a series of 8
Collection Kadist Foundation, Paris

175 **His Affair with Time**, 2003
Diptychon, Fuji C-Prints auf Archivpapier,
je 61,2 x 40,8 cm
Edition 5 + 2 A.P.
Diptych, Fuji archival C-type prints, 61,2 x 40,8 cm each
Edition 5 + 2 A.P.

177 **Occupied Balcony**, 2002
Installation
Rathaus, Graz
Installation
Town Hall, Graz, Austria

178 **Awaiting Enacted**, 2003
16-seitige Zeitung, die ausschließlich mit Bildern von
Menschen illustriert ist, die in einer Warteschlange stehen.
46 x 31 cm
Endloser Nachdruck
Edition 1 + 2 A.P.
A 16 page newspaper filled entirely with pictures of
people waiting in queues.
46 x 31 cm
Endless reprint
Edition 1 + 2 A.P.

179 **Letter**, 2003
Text, Stempel und Unterschrift auf Papier, 29,7 x 21 cm
Projekt für Utopia Station, 50. Biennale von Venedig, 2003
Text, stamp and signature on paper, 29,7 x 21 cm
Project for Utopia Station, 50. Venice Biennial, 2003

182 **Announcement**, 2003
Offsetdruck auf der Rückseite einer Mitgliedskarte,
5 x 8 cm
Edition 2000
Kölnischer Kunstverein
Offset print on the back of a membership card, 5 x 8 cm
Edition 2000
Courtesy Kölnischer Kunstverein

180/181 **Good Feelings in Good Times**, 2003
183 Künstlich inszenierte Warteschlange, die sich täglich vor
dem Haupteingang zum Kölnischen Kunstverein bildete.
Performance
Queue formed artificially every day in front of the main
entrance to Kölnischer Kunstverein.
Performance

184 **Awaiting Enacted**, 2003
Work in progress

185–187 **Awaiting Enacted**, 2003
Serie bestehend aus 16 Zeitungscollagen, je zwischen
ca. 27,8 x 18,8 cm und 47,6 x 31,2 cm
Newspaper collages from a series of 16, between
approx. 27,8 x 18,8 cm and 47,6 x 31,2 cm each

189 **Rambling in the Future**, 2003
Videoinstallation, 4 min., Farbe, Ton
Edition 3 + 2 A.P.
Installation Rotor, Graz
Video installation, 4 min., colour, sound
Edition 3 + 2 A.P.
Installation Rotor, Graz, Austria

190/191 **Untitled Journey**, 2003
Serie bestehend aus 10 Zeichnungen, die von Ondák's
Freunden und Verwandten angefertigt wurden, nachdem
er jedem genau dieselbe Beschreibung einer von ihm
unternommenen Zugreise gegeben hatte.
Series of 10 drawings made by Ondák's friends and
relatives to whom he had given identical descriptions of
him travelling in a train carriage.

200 Gezeichneter Vorentwurf für die Installation
„Spirit and Opportunity", Kölnischer Kunstverein, 2004
Tintenstift auf Zeitungsbild
Preparatory drawing for the installation 'Spirit and
Opportunity', Kölnischer Kunstverein, 2004
Pen on a newspaper photograph
6,7 x 11,7 cm

201 **Transitory Hall**, 2004
Um den typischen Charakter von Warte- und
Transiträumen in Bahnhöfen und Flughäfen zu
simulieren, wurden die Fenster im Foyer des
Kölnischen Kunstvereins durch Spiegeln ersetzt.
Installation
With the aim of simulating the character of spaces
that function as waiting rooms for transit, such as
in train stations and airport halls, windows were
replaced by mirrors in the foyer of Kölnischer Kunstverein.
Installation

203 **Transitory Hall**, 2004
Detailansicht der Installation
A detail of the installation

204/205 **Spirit and Opportunity**, 2004
Im Ausstellungsraum wurde auf der Basis von Bildern
aus Zeitungen und Zeitschriften die Marsoberfläche
rekonstruiert.
Beton, Tennisplatzsand, Lavagestein
Gesamtdimensionen 10 x 40 x 0,5 m
Installation Kölnischer Kunstverein
The surface of Mars was reconstructed in the gallery
on the basis of images published in newspapers
and magazines.
Concrete, tennis court clay, lava stones
Overall dimensions 10 x 40 x 0,5 m
Installation Kölnischer Kunstverein

206/207 **Crowd**, 2004
Performance mit einem echten und einem falschen
Publikum; Videodokumentation, 13'20", Farbe, Ton
Kamera: Michael Strassburger, Jovan Arsenic
Edition 3 + 2 A.P.
Performance im Kölnischen Kunstverein
Die Performance fand während der Ausstellungseröffnung
statt. Ondák kontaktierte Freunde von Mitgliedern
des Kunstvereins, die sich bis dahin nicht für zeitgenös-
sische Kunst interessiert hatten und deshalb gewöhnlich
nicht zu Ausstellungseröffnungen kommen. 80 Personen
haben sich bereit erklärt, eine halbe Stunde vor Ausstel-
lungseröffnung in den Kunstverein zu kommen, ohne jedoch
zu wissen, was sie dort genau erwartete. Diese unge-
wohnten Gäste wurden durch den Seiteneingang in das
Kunstvereinsgebäude geleitet und warteten eine halbe
Stunde im Ungewissen in den für die Ausstellungsbesucher
nicht zugänglichen Büroräumlichkeiten. Schließlich
drängten sie über das Treppenhaus ins Foyer, wo die
echten Vernissagebesucher, wie gewohnt, auf den Einlass
in die Ausstellung warteten und den Begrüßungsworten
des Vorsitzenden des Kunstvereins zuhörten.

Performance with a real and fake audience;
video document, 13'20", colour, sound
Camera: Michael Strassburger, Jovan Arsenic
Edition 3 + 2 A.P.
Performance at Kölnischer Kunstverein
The performance took place during the exhibition opening.
Ondák contacted friends of members of the Kunstverein
who had not previously been interested in contemporary
art and did not, therefore, usually come to exhibition open-
ings. Eighty people agreed to come to the Kunstverein
half an hour before the opening of the exhibition, but
without knowing exactly what to expect there. These
unfamiliar guests arrived through the side entrance to the
Kunstverein building where they were kept waiting for
half an hour in the office area, not usually accessible to
exhibition visitors. They flooded into the foyer by way of
the staircase while real visitors to the exhibition opening
were waiting in the foyer and listening to the chairman's
opening speech.

209 **Good Feelings in Good Times**, 2003/4
Eine kleine Gruppe bewegt sich von einem Ort zum
anderen, wobei sie ständig eine „künstliche" Warte-
schlange an verschiedenen Stellen innerhalb und außer-
halb des Zelts simuliert. Diese „künstliche" Warte-
schlange entsteht unabhängig von jeglichen „echten"
Warteschlangen, die sich vor dem Zelt bilden könnten.
Sie handelt davon, wie man die Zeit als langsam ver-
gehend erlebt, wenn man Schlange steht – als etwas,
das parallel existiert, jedoch nichts mit den sonstigen
Geschehnissen auf der Kunstmesse zu tun hat.
Projekt und Vorentwurf für eine Performance bei der
Frieze Art Fair, London
Bleistift auf Papier, 21 x 29,7 cm
There should be a small group of people moving from
one place to another and constantly simulating an
'artificial' queue at various points inside and outside the
tent. This 'artificial' queue will be in spite of any 'real'
queues formed in front of the tent. It will be about how
one experiences time as slow while waiting in a queue –
as something existing in parallel but discontinuous to
what will be happening at the art fair around it.
Project and preliminary drawing for performance at the
Frieze Art Fair, London
Pencil on paper, 21 x 29,7 cm

210/211 **Good Feelings in Good Times**, 2003/4
Performance, Frieze Art Fair, London
Tate Collection, London

Roman Ondák

Geboren/born 1966 in Žilina, Slovakia
Lebt und arbeitet/lives and works in Bratislava, Slovakia

Einzelausstellungen (Auswahl)/Solo exhibitions (selection)
2004 *Passage*, CCA, Kitakyushu, Japan
Domaine de Kerguéhennec, Bignan (mit/with Didier Courbot)
Spirit and Opportunity, Kölnischer Kunstverein, Köln
2003 *Another Day*, Dum umění, Brno
Talker, gb agency, Paris
Teenagers, Gallery Display, Praha (mit/with Július Koller)
2002 *Pause for a Moment*, Gallery Priestor, Bratislava (mit/with Josef Dabernig)
Guided Tour, Moderna galerija, Zagreb
2000 MK gallery, Rotterdam
Room Extension, Kunsthof, Zürich
1999 *Through the Eye Lens*, Ludwig Museum, Budapest
1998 *Discrepancies*, Spala Gallery, Praha
City Gallery, Praha
Exposure, Ujazdowski Castle, Warszawa
1997 MK Gallery, Rotterdam
1996 Gallery Ruce, Praha
1995 *Artest BINZ '39*, Zürich

Gruppenausstellungen (Auswahl)/Group exhibitions (selection)
2005 *Universal Experience: Art, Life and the Tourist's Eye*, Museum of Contemporary Art, Chicago
Water Event, Astrup Fearnley Museet for Moderne Kunst, Oslo
2004 *Instant Europe*, Villa Manin Centro d'Arte Contemporanea, Passariano
The Future is not what it used to be, Galerie für Zeitgenössische Kunst, Leipzig
Cordially Invited, BAK, Utrecht
Time and Again, Stedelijk Museum, Amsterdam
Frieze Art Fair Projects, Frieze Art Fair, London
Czech Made, Gallery Display, Praha
Unbalanced Allocation of Space, Galerie für Zeitgenössische Kunst, Leipzig
Socle du Monde 04, Herning Kunstmuseum, Herning
Densité ±0, Fri-Art Kunsthalle, Fribourg
ev+a 2004 'Imagine Limerick', Limerick City Gallery of Art, Limerick
Eintritt frei, Bawag Foundation, Wien
Le Proche et le lointain, Domaine de Kerguéhennec, Bignan
Densité ±0, École Nationale Supérieure des Beaux-Arts, Paris
That bodies speak has been known for a long time, Generali Foundation, Wien
2003 *Utopia Station Poster Project*, Haus der Kunst, München
Phalanstère, Centre d'Art Contemporain, Brétigny
Links, gb agency, Paris
Trautes Heim, Galerie für Zeitgenössische Kunst, Leipzig
Beautiful Banners, Prague Biennial, Praha
Utopia Station, 50. Venice Biennial, Venezia
Real Utopia, Rotor, Graz
Wir müssen heute noch..., Kölnischer Kunstverein, Köln
Durchzug/Draft, Kunsthalle Zürich
Sight.Seen, 4. Austrian Triennial on Photography, Graz

2002 UKS gallery, Oslo
 Inter Muros, Gallery Gradska Loza, Zadar
 I promise it's political, Ludwig Museum, Köln
 Erlauf erinnert sich, Öffentlicher Raum/public spaces in Erlauf
 In Prague, Spala Gallery, Praha
 Fair, Royal College, London
 An Artist who doesn't speak english, Kunstihoone, Tallin

2001 *Ausgeträumt…*, Secession, Wien
 Central, Museum Morsbroich, Leverkusen
 Die Sammlung, MUMOK, Wien
 Slowakische Träume, Museum Moderner Kunst, Passau
 Central, Museumsquartier, Wien
 Glued Intimity, Galerie Jelení, Praha
 8. Triennial of smallscale sculpture, Fellbach
 Common Ground, Begane Grond, Utrecht
 Hors-Jeu, gb agency, Paris

2000 *An Artist who doesn't speak english*, Kunstverein Aschersleben
 After the Wall, Hamburger Bahnhof, Berlin
 Chinese Whispers, Apex Art C.P., New York
 Changes of Order, Trade Fair Palace, Praha
 Manifesta 3, Moderna Galerija, Ljubljana
 After the Wall, Ludwig Museum, Budapest
 Guarene Arte, Fondazione Sandretto Re Rebaudengo per l'Arte, Torino

1999 *Aspects-Positions 1949–1999*, Museum Moderner Kunst, Wien
 After the Wall, Moderna Museet, Stockholm
 Distant Resemblance, Trade Fair Palace, Praha
 Slovak Art For Free, Slovak Pavilion on Venice Biennial, Venezia
 Rondo, Ludwig Museum, Budapest

1998 *Made in SK*, Galerie Knoll, Wien
 Zimmer frei, Unikum, Klagenfurt

1997 *D-signed in SK*, Gallery Knoll, Budapest
 60/90, Former Photostudio Rembrandt, Bratislava
 Samizdat, Reed College, Portland, Oregon
 Selest Art, FRAC, Sélestat

1996 *Interior vs Exterior*, Cosmos, Bratislava
 Manifesta 1, Natural History Museum, Rotterdam
 MK Expositieruimte, Rotterdam
 Triple Possibility, Spala Gallery, Praha

1995 *Artists of Central and Eastern Europe*, Mattress Factory, Pittsburgh

1994 *Fragmente*, Heiligenkreuzhof, Wien

1992 *Germination 7*, Le Magasin, Grenoble

Bibliografie / Bibliography (Auswahl/selection)

Jan Verwoert, *Taking a Line for a Walk*, in: Frieze, No. 90, 2005
Jessica Morgan, *First Take*, in: Artforum International, January, 2005
Adrian Searle, *Her dark materials*, in: The Guardian, 19.10.2004
Catrin Lorch, *Roman Ondák*, in: Frieze, No. 85/2004
Hans-Jürgen Hafner, *Roman Ondák*, in: Kunstforum, No. 171, 2004
Frank Frangenberg, *Roman Ondák: Spirit and Opportunity*, in: Springerin, Sommer 2004
Catrin Lorch, *Wo bitte geht's zum Mars?*, in: Frankfurter Allgemeine Zeitung, 25.5.2004
Nicole Scheyerer, *That bodies speak has been known for a long time*, in: Frieze, No. 83/2003
Heinz Schütz, *real*utopia*, in: Kunstforum, No. 166, 2003
Frank Frangenberg, *Wir müssen heute noch...*, in: Kunstforum, No. 166, 2003
Igor Zabel, *Cream 3*, Phaidon Press 2003
Werner Fenz, *Sight.Seeing*, Ausstellungskatalog/exhibition catalogue, Graz 2003
Catrin Backhaus, *I promise it's political – Performativität in der Kunst*, in: Kunstbulletin, No. 8, 2002
Kathrin Rhomberg, *Keine Kunst ohne Politik*, in: Kunstforum, No. 160, 2002
Dieter Buchhart, *Ausgeträumt...*, in: Kunstforum, No. 158, 2002
Georg Schölhammer, *„Generation Skoda. Eine Reversion"*, in: Springerin, No. 1, 2002
Kathrin Rhomberg, *Ausgeträumt...*, Ausstellungskatalog/exhibition catalogue, Secession, Wien 2001
Carolee Thea, *Foci*, Interviews with ten international curators, Apex Art, New York 2001
Kim Levin, in: Village Voice, July 26 – August 1, 2000
Manifesta 3, Ausstellungskatalog/exhibition catalogue, Ljubljana 2000
Mária Hlavajová, *Guarene Arte 2000*, Ausstellungskatalog/exhibition catalogue, Fondazione Sandretto Re Rebaugengo, Torino 2000
Christoph Schenker, *Roman Ondák im Kunsthof*, in: Kunstbulletin, No. 5, 2000
Dóra Hegyi, *Roman Ondák*, Ausstellungskatalog/exhibition catalogue, Museum Ludwig, Budapest 1999
After the Wall, Ausstellungskatalog/exhibition catalogue, Moderna Museet, Stockholm 1999
Judith Stein, *Out of East*, in: Art in America, No. 4, 1998
Pavel Liška, *Die Kunst Bleibt Frei...*, in: Neue Bildende Kunst, No. 2, 1995

Autoren/Authors

Igor Zabel, geboren 1958 in Ljubljana, Slowenien, absolvierte die Universität Ljubljana (Vergleichende Literaturwissenschaften, Kunstgeschichte und Philosophie), M.A. an der Universiät Ljubljana 1989. Als Senior-Kurator des Museum für Moderne Kunst in Ljubljana kuratierte er zahlreiche Einzel- und Gruppenausstellungen mit Künstlern slowenischer und internationaler Herkunft. Er war Koordinator der *Manifesta 3* (Ljubljana 2000) und ist Mitherausgeber (mit Viktor Misiano) des *MJ – Manifesta Journal*. Er publizierte zwei Essaysammlungen zur zeitgenössischen Kunst und verfasste zahlreiche Ausätze und Artikel für Zeitschriften (z. B. *Art Journal, Art Press, Flash Art, Index, Moscow Art Magazine*) sowie für Kataloge und andere Publikationen (z. B. *Connected Cities*, Wilhelm-Lehmbruck Museum, Duisburg, 1999; *After the Wall*, Moderna Museet, Stockholm, 1999; *L'autre moitié de l'Europe*, Jeu de Paume, Paris, 2000; *Words of Wisdom*, Independent Curators International, New York, 2001; *Ausgeträumt…*, Secession, Wien, 2002; *Vitamin P*, Phaidon Press, 2002, *Primary Documents: Critical Writing on Critical Art in East-Central Europe: A Primer*, MoMA, New York, 2002, *Haven't we had enough? Newsletter 2004, #3*, BAK, basis voor actuele kunst, Utrecht).

Igor Zabel was born 1958 in Ljubljana, Slovenia. Senior curator at the Moderna Galerija (Museum of Modern Art), Ljubljana. Curated a number of solo and group exhibitions with Slovene and international artists. He was the co-ordinator of *Manifesta 3* (Ljubljana 2000). Co-editor (with Viktor Misiano) of the *MJ – Manifesta Journal*. He published two books of essays on contemporary art and a number of essays and articles in magazines (e.g. *Art Journal, Art Press, Flash Art, Index, Moscow Art Magazine* and others), as well as in different catalogues and other publications (e.g. *Connected Cities*, Wilhelm-Lehmbruck Museum, Duisburg, 1999; *After the Wall*, Moderna Museet, Stockholm, 1999; *L'autre moitie de l'Europe*, Jeu de Paume, Paris, 2000; *Words of Wisdom*, Independent Curators International, New York, 2001; *Ausgeträumt…*, Secession, Vienna, 2002; *Vitamin P*, Phaidon Press, 2002, *Primary Documents: Critical Writing on Critical Art in East-Central Europe: A Primer*, MoMA, New York, 2002, *Haven't we had enough? Newsletter 2004, #3*, BAK, basis voor actuele kunst, Utrecht).

Hans Ulrich Obrist, geboren 1968 in Zürich, lebt und arbeitet in Paris. Er gründete 1993 das migratorische „Robert Walser Museum" und initiierte das Programm „Migrateurs" am Musée d'Art Modèrne de la Ville de Paris, wo er derzeit als Kurator für zeitgenössische Kunst arbeitet. Er ist Kurator für „museum in progress", Wien und unterrichtet an der Facolta delle Arti, IUAV in Venedig. Seit 1991 kuratierte er zahlreiche internationale Ausstellungen, u. a.: „The Broken Mirror" (mit Kasper König), Wiener Festwochen (1993); „Life/Live" (mit L. Bossé), Musée d'Art Modèrne de la Ville de Paris und Centro Belem, Lissabon (1996); „Do it"; „Cities on the Move" (mit Hou Hanru), u. a. Secession, Wien (1997); „Laboratorium" (mit Barbara Vanderlinden), Antwerp Open (1999); „Retrace your Stepps: Remember tomorrow", Sir John Soanes Museum, London (1999/2000); „Utopia Station", 50. Biennale von Venedig (2003). Er ist Herausgeber zahlreicher Künstlerbücher.

Hans Ulrich Obrist was born 1968 in Zurich, and currently lives and works in Paris. In 1993, he founded the migratory Museum Robert Walser and began to run the Migrateurs programme at the Musée d'Art Modèrne de la Ville de Paris where he now serves as a curator for contemporary art. He has been a frequent curator for the „museum in progress", Vienna and lecturer at Facolta delle Arti, IUAV in Venice. Since 1991 he has curated numerous international exhibitions including: „The Broken Mirror" (with Kasper König), Vienna Festival (1993); „Life/Live" (with L. Bossé), Musée d'Art Modèrne de la Ville de Paris and Centro Belem, Lissabon (1996); „Do it"; „Cities on the Move" (with Hou Hanru), Secession, Wien (1997); „Laboratorium" (with Barbara Vanderlinden), Antwerp Open (1999); „Retrace your Stepps: Remember tomorrow", Sir John Soanes Museum, London (1999/2000); „Utopia Station", 50. Venice Biennale (2003). He is editor of a series of artist books.

Georg Schöllhammer ist Autor und leitender Redakteur von *springerin – Hefte für Gegenwartskunst* und lebt in Wien.

Georg Schöllhammer is author and editor in chief of *springerin – Hefte für Gegenwartskunst* and lives in Vienna.

Frank Frangenberg, 1963 in Köln geboren, Autor, lebt im Rheinland.

Frank Frangenberg, born 1963 in Cologne, author, lives in the Rhineland.

Roman Ondák dankt/wishes to thank
Maja Ondáková, Adam Ondák, Martin Ondák, Anna Ondáková, Jozef Ondák, Kathrin Rhomberg, Solène Guillier, Nathalie Boutin, Július Koller, Hans Ulrich Obrist, Kasper König, Igor Zabel, Hedwig Saxenhuber, Georg Schöllhammer, Catrin Lorch, Frank Frangenberg, Francesco Bonami, Karel Srp, Pawel Althamer, Andreas Kofler, Katalin Néray, Mária Hlavajová, Laco Teren, Boris Ondreička, Denisa Lehocká, Matej Gavula, Milan Titel, Bohdan Hostiňák, Cyril Blažo, Edo Kudláč, Lucia Gavulová, Vít Havránek, Ján Mancuška, Tomáš Vaněk, Michal Koleček, Zbyněk Baladrán, David Kulhánek, Karel Císař, Jana Sevčíková, Jiří Sevčík, Dóra Hegyi, Lívia Páldi, Vladimír Beskid, Dušan Brozman, Katarína Rusnáková, Alena Vrbanová, Martin Marenčin, Martin Ward, Jaroslav Krbušek, Emmo Grofsmid, Karmin Kartowikromo, Hans Knoll, Patrizia Grzonka, David Elliott, Iris Müller-Westermann, Helga Nowotny, Roland Wäspe, Darko Senekovic, Lino Sibillano, Regula Schaelchli, Christoph Schenker, Sibylle Omlin, Alex Kleinberger, Henry Levy, Serkan Ozkaya, Josef Dabernig, Ana Devic, Sabina Sabolovic, Natasa Ilic, Branka Stipancic, Darko Simicic, Pavel Liška, Matthias Herrmann, Annette Südbeck, Katharina Blaas, Iara Boubnova, Pravdo Ivanov, Nedko Solakov, Luchezar Boyadjiev, Mr. Šavrda and his grandson, Viktor Stoilov, his wife and son, Silva Kalcic, Radmila Iva Jankovic, Stipe, Heidrun and Peter Hess, Marjorie Jongbloed, Dorothea von Hantelmann, Christine Litz, František Kowolowski, Werner Fenz, Frederic Bonnet, Anton Lederer, Margarethe Makovec, Barbara Luderowski, Michael Olyjnik, Fernand de Waziers, Jocelyne and Fabrice Petignat, Frederic Simon, Julia Schäfer, Barbara Steiner, Beatrix Ruf, Boris Marte, Sabine Breitwieser, Hemma Schmutz, Tanja Widmann, Martina Hochmuth, Elena Filipovic, Caroline Ferreira, Marianne Lanavere, Frédéric Paul, Pierre Bal-Blanc, Sarah Zurcher, Marco Scotini, Zdenka Badovinac, Christine Kintisch, Barbara Hess, Jacob Fabricius, Leontine Coelewij, Geurt Imanse, Deimantas Narkevicius, Christine Peters, Polly Staple, Amanda Sharp, Matthew Slotover, Kitty Anderson, Christian Sievers, Akiko Miyake, Wilfried Huet, Didier Courbot, Maeve Polkinhorn, Jessica Morgan, Evi Baniotopoulou…

Unser besonderer Dank geht an/Special thanks to
Roman Ondák für die großartige Zusammenarbeit und das uns entgegengebrachte Vertrauen.
Roman Ondák for the wonderful cooperation and the trust in us.

Dank an/thanks to: Nathalie Boutin, Frank Frangenberg, Solène Guillier, Maria Hlavajová, Walther König, Boris Marte, Hans Ulrich Obrist, Boris Ondreička, Georg Schöllhammer, Martha Stutteregger, Regina Wyrwohl, Igor Zabel und allen Performern/and all performers.

Für die großzügige Unterstützung danken wir/for the generous support we would like to thank:
Kulturstiftung NRW, Kunststiftung des Bundes, gb agency, Paris (www.gbagency.fr) avec le concours du Ministère de la culture et de la communication – Centre national des arts plastiques (aide à la première exposition), AWA GmbH Member of the IKO Group, Georgi Abfalltechnik, INCAMPO Sport- und Beregnungsanlagen e.K., Readymix Westzement GmbH, Crowne Plaza City Centre Köln

Kölnischer Kunstverein

Vorstand
Johannes Becker, Schatzmeister
Götz von Bleichert, stellvertretender Schatzmeister
Daniel Buchholz
Christian DuMont Schütte
Dr. Rolf-Dieter Halswick
Dr. Mariana Hanstein, stellvertretende Schriftführerin
Walther König
Bernhard G. Reichard RA, Schriftführer
Dr. Wolfgang Strobel, Vorsitzender
Claudia von Velsen, stellvertretende Vorsitzende
Prof. Erwin H. Zander
Ernst Brücher, Ehrenvorstandsmitglied

Ausschuss
Wolfgang Bornheim
Stephanie Friebe
Eberhard Garnatz
Ralph Andreas Grosz
Dr. Klaus Günther
Birgit Hansen
Andreas Hecker
Dr. Andreas Hölscher
Irmgard Könemann
Ingeborg Loos
Dr. Peter Lütke-Bornefeld
Dr. Doris Neuerburg-Heusler
Dr. Jürgen R. Neuhaus
Jeane Freifrau von Oppenheim
Eugen Alexander Pirlet
Yvonne Quirmbach
Rosemarie Reygers
Dietmar Schneider
Detlef Meyer Voggenreiter
Dr. Caspar Wassermeyer

MitarbeiterInnen
Ulla Bönnen
Hilla Fittges
Kosta Katsikaris
Werner Matrisch
Kathrin Rhomberg, Direktorin
Julia Wack
Marianne Walter

Projekt Migration
Akiko Bernhöft
Virginia Friedlaender
Claudia Jericho
Catrin Millmann
Daniela Müller
Marion Ritter

Förderer und Mäzene
AXA ART Versicherung AG
Bayer AG Leverkusen
Dipl. Kfm. Wolfgang Bornheim
Buchhandlung Walther König
CENTRAL Krankenversicherung AG
Corpus Immobiliengruppe GmbH & Co. KG
Crowne Plaza City Centre Köln
Deutsche Bank 24 AG
Deutsche Krankenversicherung AG
DHPG Dr. Harzem & Partner KG
Aloys F. DORNBRACHT GmbH & Co. KG
Dresdner Bank AG
Christian DuMont Schütte
Sabine DuMont Schütte
DuMont Buchverlag
Firmenich GmbH
Ford-Werke AG, Köln
Anna Friebe-Reininghaus, Köln
Privatbrauerei Gaffel Becker & Co.
Geylenberg Immobilien GmbH
Dr. Rolf-Dieter Halswick
Hasenkamp Internationale Transporte GmbH & Co. KG
Hochtief Construction AG
Matthias Hölscher
IHK zu Köln
Kienbaum Consultants International GmbH
Dipl.-Ing Franz-Josef Kleinmann
Kölnische Rückversicherung-Ges. AG
Kölnmesse GmbH
Paul Köser
Hanspeter Kottmair, Köln
Kreissparkasse Köln
McKinsey & Company
Metro AG
Moderne Stadt Ges. zur Förderung des Städtebaus
Klaus Müller
Stefanie Nolte
Dr. Arend Oetker Holding GmbH & Co. KG
Dr. Arend Oetker
Jeane Freifrau von Oppenheim
Portfolio Concept GmbH
PROVINZIAL Rheinland Vers. AG, Die Vers. der Sparkassen
Ulrich Reininghaus
ROWA Wagner GmbH + Co. KG
Sal. Oppenheim jr. + Cie.KG, Köln
Dr. Albrecht Sommer
Sparkasse KölnBonn
Dr. Wolfgang Strobel
STOLL Wohnbedarf + Objekt GmbH & Co. KG
Ströer Außenwerbung & Co KG
Vertical Vision GmbH & Co KG
Villeroy & Boch AG
WDR mediagroup GmbH

Impressum/Imprint

Diese Publikation erscheint anlässlich der Ausstellung Roman Ondák
„Spirit and Opportunity" im Kölnischen Kunstverein, 1. 5.–27. 6. 2004.
This catalogue is published on the occasion of the exhibition Roman Ondák
"Spirit and Opportunity" at the Kölnischen Kunstverein, 1. 5.–27. 6. 2004.

Kölnischer Kunstverein, Die Brücke, Hahnenstraße 6, D-50667 Köln
Tel. +49-221-21 70 21, Fax +49-221-21 06 51
info@koelnischerkunstverein.de, www.koelnischerkunstverein.de

Herausgeber/editor: Kölnischer Kunstverein
Konzeption/concept: Roman Ondák
Redaktion/editor: Kathrin Rhomberg
Redaktionelle Mitarbeit/editorial assistance: Marion Ritter
Wissenschaftliche Mitarbeit/scientific assistance: Akiko Bernhöft
Text/essay: Frank Frangenberg, Hans Ulrich Obrist, Georg Schöllhammer, Igor Zabel
Übersetzung/translation: Stefan Barmann, Kerstin Hall, Martin Ward
Lektorat/copy editing: Claudia Mazanek

Fotonachweis/photo credits: Boris Becker, Vladimír Beskid, Marc Domage, Peter Gauger,
Vladimír Goralčík, Július Koller, Gabriele Kranzelbinder, Martin Marenčin, Mariusz Michalski,
mrs-lee.com, Roman Ondák, Martin Polák, Simon Vogel, Dejan Sarić, Hans-Christian Schink,
Polly Braden, Cover: Good Feelings in Good Times, 2003

Videoaufnahmen/video shooting: Jovan Arsenić, Michael Straßburger
Aufbauteam/installation crew: Dejan Mujičić, Jörg Schlürscheid, Dirk Müller,
Thomas Neumann, Dejan Sarić, Nika Špan, Kruno Stipesević, Simo Stojaković, Jon Weston
Grafische Gestaltung/graphic design: Martha Stutteregger
Reproduktionen/reproductions by: Typocon s.r.o., Bratislava
Druck/printed by: Typo Druck Sares, Wien

© 2005 Roman Ondák, die Autoren, Kölnischer Kunstverein und
Verlag der Buchhandlung Walther König, Köln

Die Deutsche Bibliothek – CIP-Einheitsaufnahme
Ein Titelsatz für diese Publikation ist bei Der Deutschen Bibliothek erhältlich.

Printed in Austria

Distribution outside Europe
D.A.P./Distributed Art Publishers, Inc., New York
155 Sixth Avenue, New York, NY 10013
Tel. 212-627-1999 Fax 212-627-9484

ISBN 3-88375-961-9

KULTURSTIFTUNG DES BUNDES KUNSTSTIFTUNG ○ NRW SLOVENSKÁ SPORITELŇA tranzit www.tranzit.org
is supported by the Erste Bank